WITHIN THE FRAME

THE JOURNEY OF PHOTOGRAPHIC VISION

David duChemin

Within the Frame: The Journey of Photographic Vision
David duChemin

New Riders
1249 Eighth Street
Berkeley, CA 94710
510/524-2178
510/524-2221 (fax)
Find us on the Web at www.newriders.com
To report errors, please send a note to errata@peachpit.com
New Riders is an imprint of Peachpit, a division of Pearson Education

Editor: Ted Waitt
Production Editor: Hilal Sala
Cover and Interior Design: Charlene Charles-Will
Layout and Composition: Kim Scott, Bumpy Design
Color Production Consultant: Marco Ugolini
Indexer: James Minkin
Cover Image: David duChemin

ISBN-13 978-0-321-60502-3
ISBN-10 0-321-60502-0

9 8 7 6 5 4
Printed and bound in the United States of America

Happy Birthday Mads 2013
Love
Cathy + Mads

To my mother,
who gave me my vision of the world and the heart to love it.

Acknowledgments

I'm grateful to so many, and while any list like this is bound to be incomplete, my deepest thanks go to:

My mother who, as I said in the dedication, gave me the gift of me, my vision and heart for the world. My stepfather, Paul, who raised me as his own, lent me money for lenses when my mother wasn't looking, and encouraged my photography habit at the expense of his own sanity. My father who bought me my very first camera and gave me the gift of seeing the world through a frame.

My beautiful wife, Sharon, who is as long-suffering and encouraging as any wife of a traveling photographer can be. She spends a lot of time waiting for me to come home and without her I could not do what I do. I owe her more thanks than I can express.

Dane J. MacKendrick and Reid Barton for reigniting my passion for visual language, and for encouraging me along the way.

Kevin Clark for seeing me through the transition to professional photographer and vision-monger.

My brother-in-arms, Matt Brandon, for encouragement and inspiration. Matt and I teach photography together through our international Lumen Dei workshops, and he constantly motivates and inspires me.

Photographer and friend Gavin Gough, for reading this book while it was still pages of rubbish, for putting in his two cents' worth, and for hosting us in Bangkok.

Daniela, for buying me the airplane ticket that started this whole nutty adventure—what a gift it's turned out to be. Erin, for being such a brilliant sounding board, kind source of encouragement, and beta reader extraordinaire.

Lyric, for taking a chance and becoming not only one of my favorite clients but one of my favorite friends.

Gary Dowd, my producer and travel companion on World Vision assignments, a brother-in-arms, and the guy you want at your side when things go south. We've

traveled the world together and Gary's made me a photographer who's more capable and more confident.

My editor, Ted Waitt, my publisher, and my esteemed book team, for believing in this book from the beginning and putting in the work you did. I just had no idea how much work these things really took, and how much of it was done by others.

Scott Kelby, for being a big brother on this project and believing in it enough to put your reputation on the line. Vincent Versace, for being kind enough to write the Afterword and preaching some of the same sermons about vision as I do, but with greater eloquence and credibility. Joe McNally, for writing the Foreword and saying such kind things about my work and my words. If no one ever buys this book, your encouragement will be reward enough for me. (If that's the case, I hope it's also enough for the publishers 'cause I'll have an advance to repay!)

Henri Straforelli, for undertaking this journey, and others, with me. For watching my back and testing my food, and being the most laid-back, reliable travel companion and friend one could ever want. I've always wanted a friend of whom I could say, "We were in 'Nam together." Now I have one.

I am sponsored by some truly excellent companies—leaders in the imaging industry—and I owe them a debt of gratitude for their belief in me and my work. Lexar, Think Tank Photo, Adobe, Evrium, Zink, BlackRapid, Lensbaby, Acratech, and Gitzo have been very kind to me, and I'm proud to be connected to them.

Leo's Cameras in Vancouver has looked after me since I switched to digital and I'm grateful for them, particularly to David Donaldson, who is a fount of knowledge, patience, and great stories. They remain one of the reasons I will choose a local supplier over a cheaper price every time.

Finally, God, from whom my vision and the gifts to capture it come. Be Thou my Vision, oh Lord of my heart.

About the Author

David duChemin is an international assignment photographer specializing in humanitarian projects and world photography. His work has taken him around the globe. From braving Mongolia in the middle of winter to shooting killer bees in Africa; catching malaria in Ethiopia to catching typhoid in Peru; being thrown off a camel in Tunisia to being abducted by street kids in India and forced to play cricket, David's adventures have only deepened his love for this world and the people who inhabit it.

Photo: Kevin Clark

Contents

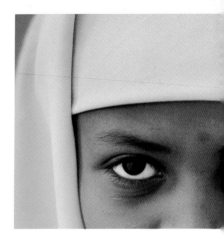

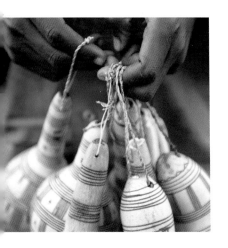

CHAPTER FOUR

Storytelling 74

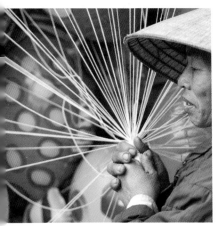

CHAPTER FIVE

Photographing People. 96

CHAPTER SIX

Photographing Places 150

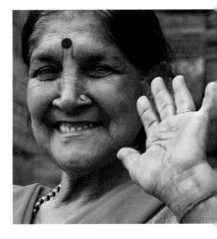

CHAPTER SEVEN

Photographing Culture208

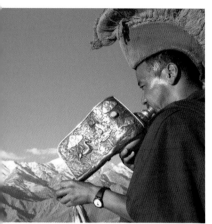

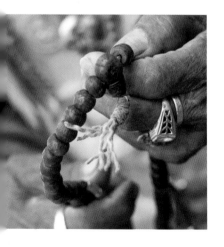

CHAPTER EIGHT

Final Thoughts

Foreword

By JOE MCNALLY

This book is like a great photograph. It is seamless, intuitive, and filled with minor details blended with larger themes. It has impact—the color play is so strong it's like a hard and fast punch to the visual gut. Still, there is nuance and subtlety that shimmer like a catchlight.

It is sympathetic, warm-hearted, and decent. But, just like any effective photo, it is unflinching and sparse, and it hones in on the essentials. Interesting and vivid, it pulls the eye, and then, once the eye is intrigued, it directs and shapes where it needs to go and what it is supposed to look at.

It is vibrant and quiet at the same time. It teaches you without dogma or bombast, and it leads you on a journey that you are so engaged to take that you look around at the end of it and can't really believe how far you've come. It looks and feels effortless, which masks the intensity, sweat, dedication, and hard work that went into its creation.

And, just like a great photograph, once you view it and let it filter into your eyes, your head, and your heart, you will never, ever be the same.

It is a book filled with color, light, and learning, which is no surprise, given the author, David duChemin. He is a photographer with a purpose, hence this book. He knows, and states right up front, that the world does not need another pretty picture book, or another set of stylish, attractive, brittle pictures. His counsel to photographers about photographing places—go deep rather than broad—perfectly describes this book.

Both the pictures and the writing on these pages don't stay on the surface of things. They both go deep, to the heart of the matter, to the core of both the purpose and method of making great photographs. He is a wanderer, to be sure, but it is a sure-footed wander, and he takes you on every step, explaining the principles of good photography, offering practical and surprising advice, and making sure that, as a reader, you stay inside his head and therefore his vision, right from the moment he shoulders the camera bag and heads out the door.

You are right there with him as he articulates the reasons for his choice of lens or f-stop, his compositional approach, his techniques about exposure, and his grasp of light and how to use it. He throws open his camera bag and lets you peer inside to see what he takes and why he takes it, right from essential hardware like the telephoto and the tripod to the pocket fillers like sun block, local currency, and extra eight-gig cards. The book is brimming with real-time, practical advice on how to make storytelling pictures about culture, faith, food, people, and places—in short, the world.

If the book simply stayed right there in the realm of how-to, go-to advice, it would be a wonderful book indeed. But it crosses the line from useful to inspired because David opens up much more than his camera bag. He opens his considerable heart and mind, both of which belong to a masterful storyteller driven by an acute sympathy for the human condition, coupled with an intense curiosity and respect for both the differences and the sameness of the world.

He openly talks of the interior conflict common to all shooters—that of the artist and the geek. As he says, gear is good, vision is better. That discussion, honest and open, separates this book from so many currently on the shelves that are more than happy to tell you the right f-stop.

It is far harder to figure out how to make a good picture. It is far harder to know how to intuitively work a street, and, with respect and care, get inside people's fences and boundaries to create images that matter. It is hard to be in the mix of color and light and people—this noisy, fast-paced world—and be able to distill that cacophony into a simple, powerful photo that makes the reader feel like they were right there in the din, in the market, in the temple, in someone's shop or home.

It is in this realm that David centers so much of the discussion, and a valuable discussion it is. He talks about how vision and technique combine to make art and craft. He shows the artist plenty about the gear, to be sure, and he explains very well the buttons and dials of all the digital machinery. But he also beckons to the geek in all of us, and pulls us beyond shutter speeds and white balances into the heart of the matter—pictures that speak, pictures that tell true stories, pictures that inform the mind and move the heart.

As he mentions on his website, David is an inveterate do-gooder with a camera in his hand. He has traveled the world to all manner of places, distressed and otherwise, working with relief organizations, bringing back pictures that cannot be ignored. He describes his mission:

"Anyone can take a picture of poverty; it's easy to focus on the dirt and hurt of the poor. It's much harder—and much more needful—to pry under that dirt and reveal the beauty and dignity of people that, but for their birth into a place and circumstance different from our own, are just like ourselves. I want my images to tell the story of those people and to move us beyond pity to justice and mercy."

How do you make pictures that move people? How do you work in unfamiliar places, without the convenience of language, and achieve understanding and common ground quickly? How do you come back with images that are real and true, deeply human and connected? How do you photographically explain and interpret the world instead of making a snapshot of it?

Within the Frame is a book that, in plain but eloquent language, grapples with the core issues of how to make great pictures. You go out into the world with a seasoned traveler and a keen observer who understands people and places as well as he understands the camera. He shows you not how to resolve the conflict between artist and geek, between storyteller and technician (that struggle will always be with us) but rather how to embrace it on all levels. He gives you the tools and information that enable you to make the camera—a machine—an extension of the human heart and mind. Then he gives you a road map to his own, and invites you on the journey.

This is a trip well worth taking.

Introduction

THIS IS A BOOK ABOUT the passionate photography of people, places, and cultures. It is a book about chasing your vision and telling your stories as clearly and passionately as possible with compelling photography. It's a book for everyone who's wanted to shoot images of the places and people they love, whether or not they ever go around the world to do it.

▶ Canon 5D, 135mm, 1/3200 @ f/2, ISO 800

Delhi, India. Two men drinking chai at a Nizamuddin shrine. The half-figure of the woman to the left still speaks more to me than the men themselves.

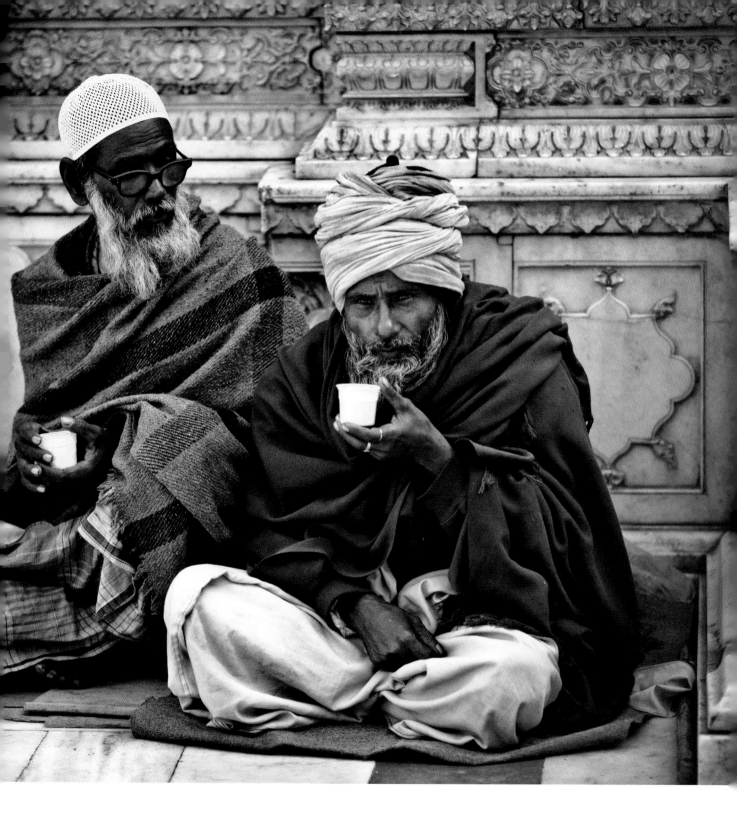

> "It is a book about chasing your vision and telling your stories as clearly and passionately as possible with compelling photography."

You should also know what this book is not. It is not a manual; your camera came with one. It is not a book that tells you exactly what to shoot or how. And it is most decidedly not a book about "travel photography." Those books have already been written, and the last thing anyone needs is another book telling them to put film into lead bags. In my research for this project, I read a great many of those books, and I can safely say the need for another one is precisely zero.

Surely the needs of a photographer who travels are different from one who does not, but the art of expressing an encounter with people, places, and cultures remains the same whether or not you get on a plane. The details of gear and traveling belong in a book that addresses traveling, not expressing vision.

I wrote this book because it's the book I wish I'd had. The cyber-shelves of the internet are full of how-to books and conspicuously thin when it comes to why-to books. I'm aware of just how insanely presumptuous it is to write a book—in so doing, we authors, among whose ranks I am a newborn, are saying we have something to say that is so valuable that you, the reader, should shell out $40 to hear it. Crazy. So I'm putting this one out there with, I hope, a great deal of humility, and the hope that it does for some of you out there what my early influences did for me.

I use the word "vision" too much in this book. It's in the subtitle. It's in the section headings. It's in the text over and over again, and it's not the result of forgetfulness on my part. It's not even an effort to pad the word count to make my editor happy, though don't think for a minute I didn't consider it. But give me some credit—had I chosen that route, I would have used much bigger words. They say repetition is a good thing. They say repetition is a good thing. Sorry, bad joke. But you get it, right? This book is about the passionate photography of people, places, and cultures; without vision and a desire—even a burning need—to express it photographically, there's just no point. If you come away with anything from this book, I hope it is a renewed resolution to seek and serve your vision through this elegant craft. And I hope this book gives you a few more tools that make your craft equal to the task.

This book is a result of my own journey as a photographer who, like all photographers, is learning to see, and learning to find and express my vision in clearer and clearer ways. It is, I hope, a book that you find both instructional and inspirational in your own journey.

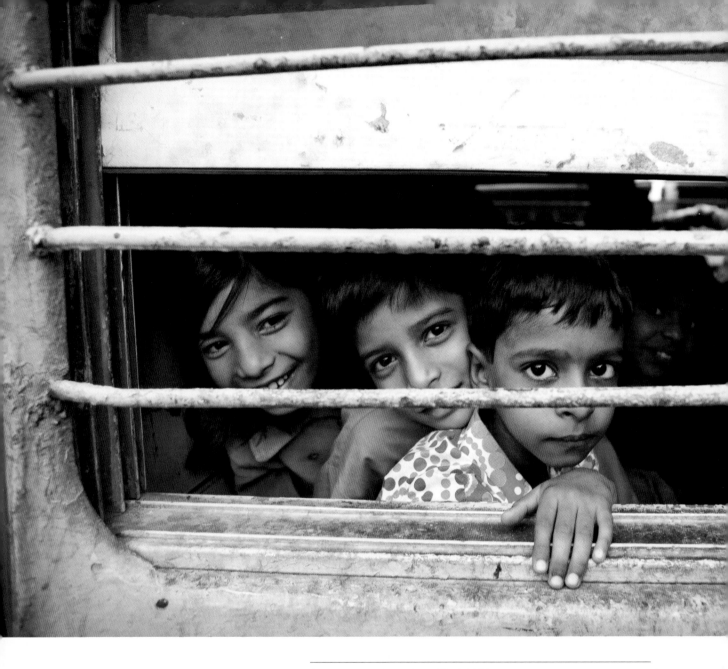

△ Canon 5D, 24mm, 1/60 @ f/4, ISO 800

Agra, India. Exchanges with children remain some of the best moments I have with my camera. The juxtaposition of playfulness and the bars, behind which these four seem contained, still amuses me.

It's About Vision

VISION IS THE BEGINNING AND END OF PHOTOGRAPHY. It's the thing that moves you to pick up the camera, and it determines what you look at and what you see when you do. It determines how you shoot and why. Without vision, the photographer perishes.

▶ Canon 5D, 40mm, 1/50 @ f/5.6, ISO 640

Hanoi, Vietnam. I have a thing for decaying walls and man-made stuff, perhaps because it speaks to the temporary nature of all we do. Or it could be just the texture and color.

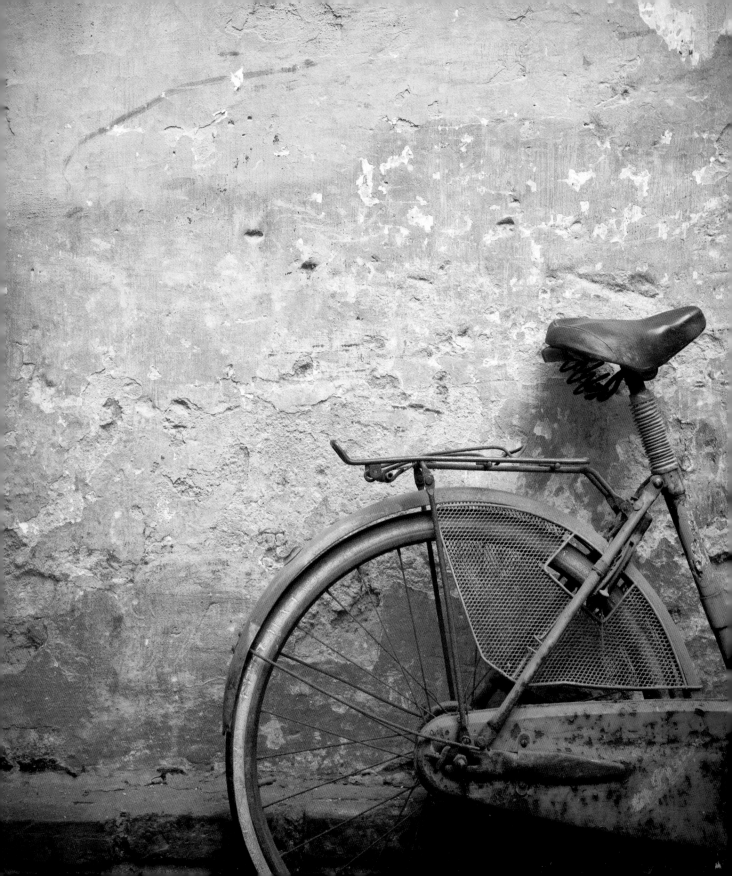

Vision is everything, and the photographic journey is about discovering your vision, allowing it to evolve, change, and find expression through your camera and the print. It is not something you find and come to terms with once and for all; it is something that changes and grows with you. The things that impassion you, that anger you, that stir you—they are part of your unique vision. It is about what you—unique among billions—find beautiful, ugly, right, wrong, or harmonious in this world. And as you experience life, your vision changes. The stories you want to tell, the things that resonate with you—they change and so does your vision. Finding and expressing your vision is a journey, not a destination.

You can spend a lifetime chasing your vision, learning not only to see with more clarity, but to express that vision in stronger and stronger ways. It's important to remember this because it fights against the discouragement that all artists inevitably face. The feeling that we're seeing nothing new, have nothing to say, or have created our last good photograph. When that happens it's helpful to remember that the journey isn't over yet. As long as we're alive and interacting with life, the world, and the people around us, we'll have something to say. And as we learn and practice our craft, we'll have stronger ways—better ways, even—of expressing it.

Vision can be elusive. We may not always have an immediate conscious reaction to the world around us, may not understand our feelings about the story in front of us. In these times, it is often the case that the camera becomes more than a means to record our vision; it becomes a means to help clarify it. The act of looking through the frame, of excluding other angles and elements, of bringing chaos into order, can bring our vision to the surface. This ability to help us see means, in some way, that the camera is a partner with us in the process, and it is what separates photographers from painters. We have a symbiotic relationship—not with the camera technology but with the frame, which, for all the technological changes photography has been through, remains the constant.

▶ Canon 20D, 17mm, 1/60 @ f/10, ISO 800

Vancouver, Canada. Chambar is one of the best restaurants in Vancouver. Each day the kitchen crew sits outside and has a meal before opening for the evening rush.

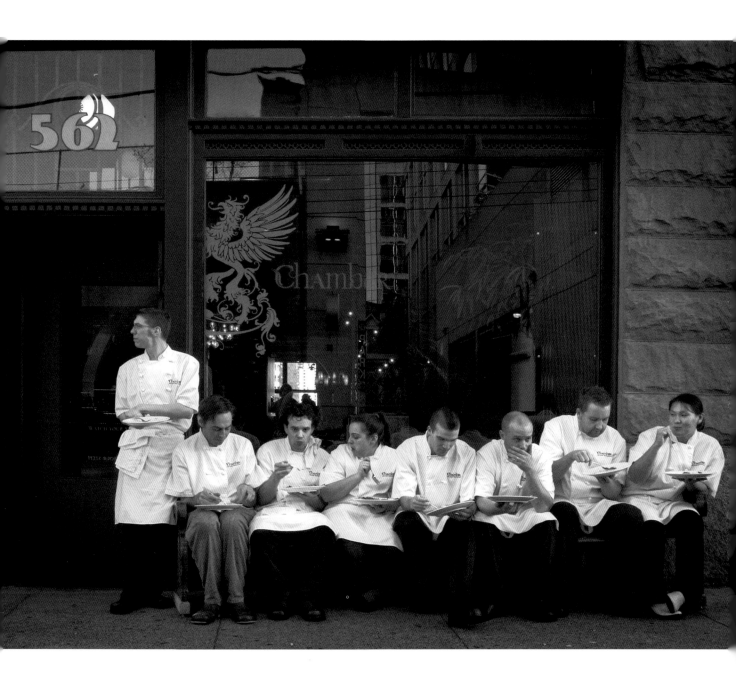

Our vision often grows to match our skill. As we gain new tools and skills with which to better express our vision—in deeper and more complete ways—so our vision is given the room to grow deeper and more complete. Furthermore, I think our vision always slightly outpaces our tools. For this reason, we'll always be a little frustrated by the inability of our tools, or our technique, to match that vision. That's the journey of the artist, and it's the reason why our craft sometimes feels so difficult to master. If you don't love photography for the sheer act of trying to express yourself, and will only find joy in it when you finally get there, yours will be a disappointing journey. Not only will you likely never "get there," but you'll have missed how beautiful and exhilarating the journey itself is.

Vision itself, like our eyesight, can be neglected and allowed to degenerate, or it can be made sharper, brought into greater clarity. The more we engage the world and examine our own thoughts and feelings about it, the clearer our vision becomes. We become able to describe feelings and thoughts that were once unconscious. For those of us whose medium is photography, we do that visually. The clearer our vision becomes, the more able we are to find means of expressing it through our choices of optics, exposure, composition, or the digital darkroom.

Chasing Vision

The photographic life is one of discovering your vision and expressing it in purely visually terms. Sometimes our vision finds us; sometimes we need to chase it down.

In the case of this book, it's a little of both. The images and stories found here come from the last four years as I've traveled and photographed around the globe, as well as a one-month trip around the world taken in January 2009. I visited five countries—Cuba, Egypt, Nepal, Thailand, and Vietnam—in search of encounters with people, places, and culture, and the chance to find and express my vision in a single, month-long, creative endeavor. The book is about finding and expressing vision, not about the fact that I travel around the world to do so. It might just as easily have happened by staying in my hometown of Vancouver.

My own vision is a global one; I am most excited by people, places, and cultures that have not yet been overtaken by the creeping homogeny of the west. I love the color and texture of those places, the vitality of life, and the ritual and symbolism of cultures not yet tyrannized by the need to wear the same jeans and believe the same things. My images, too, are affected by that outlook and passion and, I hope, reflect it. Had someone else written this book, it might have been shot entirely in New York City or Prague. But I'm chasing my vision, and you will chase yours in the places best suited to that. What's important is that you chase that vision intentionally and with passion, refusing to let it be anything but yours and yours alone.

Within the Frame

THERE IS ONLY THE FRAME. That is our craft. Painting with light, in slivers of time, within the frame of our image. It becomes art when that combination says something in a unique way. And to think, when I learned about photography it seemed like it was merely a matter of pointing the camera at something and pressing the button. If you're reading this

 Canon 5D, 32mm, 1/5 @ f/9, ISO 800

Jodhpur, India. I shot this at dawn, leaning on a construction scaffold I dragged into the street because "I'm sure I won't need my tripod this morning." The woman in red appeared like a specter and was gone as fast. A faster shutter speed would have lost the magic.

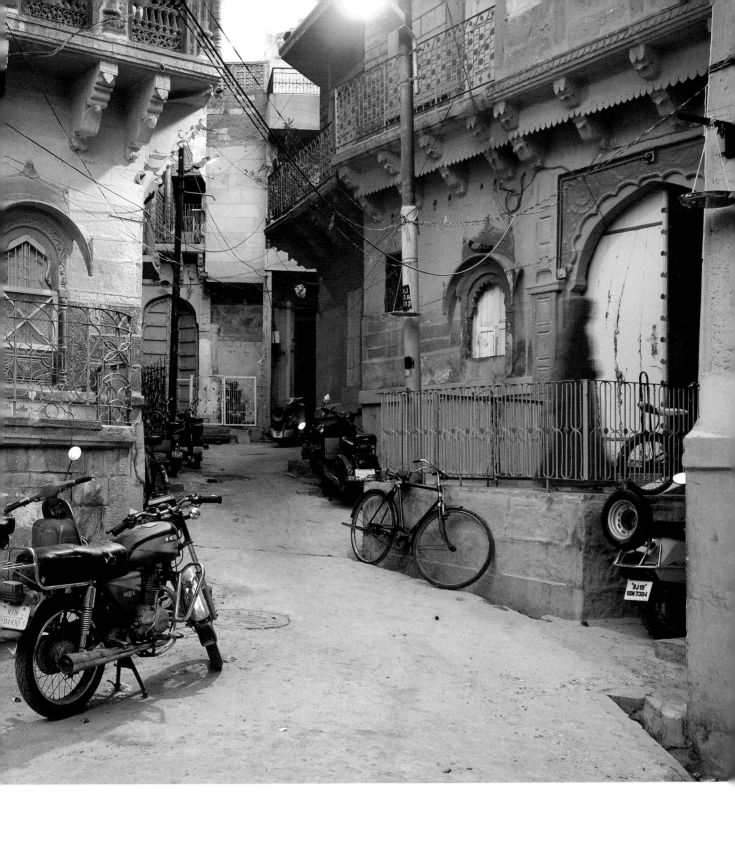

▼ Canon 5D, 85mm,
1/125 @ f/5.6, ISO 100

Delhi, India. Nizamuddin shrine. A woman prostrates herself in prayer. Her shackles are symbols of promises to which she's bound herself until the saints, or Allah, will answer.

book, and you've mastered pointing and pressing, and you're longing to see if you can't just express something a little more than "I was here," then it begins with the frame. And one by one you put the elements in, move them around until they please your eye—and your heart—and something inside says, "Aha!" And you want to make other people say "Aha!" as well. That's photography: the discipline of cramming your vision into a frame and making it fit.

Shoot What Moves You

When vision is spoken of in photographic terms, it is not spoken of merely as the things you see but how you see them. Photography is a deeply subjective craft, and the camera, wielded well, tells the stories you want it to. It will tell the truths you want it to, and certainly the lies. You are central to your photography, and the camera is merely the tool of interpretation—not the other way around. The most compelling photographs you take begin with the things about which you are most interested, most passionate, and most curious. When those photographs are taken in a way that communicates your unique perspective, they translate into images that say something. They are more than a record of "I was here and saw this." Instead, they become "I feel this way about this. I was in this place and saw it like this." They are not acts of representation as much as they are acts of interpretation.

The photographs that move me to laughter, to tears, or to get on a plane and see something for myself are the ones where the photographer has done more than shoot with her eye; she shoots with her heart as well. This is more than just an artsy-fartsy effort to get in touch with your emotions. It's about creating images that others will care about, be engaged by.

So it is my intention to shoot only that which moves me. That might mean an image of a mother with HIV/AIDS clinging to her son, or it might be the pattern of rocks on the shore, but it's something that leaps at me and moves me to turn and say, "Hey, look at this!" When no one else is there, the camera becomes my means to that end, to say to a wider audience, "Did you see that? Look at this!"

When I wander around a new city or village and finally stop trying to be clever with my photographs, and just become aware of what is moving me, it is time and time again those photographs that not only continue to move me later but that move others. The clever shots, the ones I felt I should take—but that didn't move me beyond anything more than some sense of obligation to duplicate similar shots I've seen elsewhere—have only ever failed. They come off as disingenuous, false efforts that don't resonate.

Taking stock of the things you care about and are drawn to is an excellent ongoing exercise in recognizing and refining your vision. My list grows and changes, but always includes children, laughter, play, color, textures, simple graphic lines, irony, odd juxtapositions, interesting faces, and expressions of faith. I am not

"There is only the frame. That is our craft. Painting with light, in slivers of time, within the frame of our image."

▲ Canon 5D, 85mm, 1/100 @ f/1.2, ISO 800

Kathmandu, Nepal. The butter lamps around the stupa at Boudhanath throw out some beautiful light. Combined with the devotion for which they are lit, it's hard not to be captivated—and glad you brought your fastest lens.

drawn to wildlife or ducks; I just don't love their forms and shapes enough to want to photograph them well. I don't like shooting events. I find them chaotic, and it's hard to take my time and order elements within the frame, so I generally avoid them or find a way within them to shoot what I love—the humanity and color of them. Knowing what you love to photograph, and what you do not, is the first step in the recognition and refinement of your vision. It's this that makes our craft so diverse; you and I can stand on the same street corner and see it, and respond to it, in such different ways that I would later look at your images from the same moment and place and wonder aloud, "I didn't even *see* that!"

Make Me Care

Shooting from the heart and telling the visual stories you love and care about is the first step in making your viewers care. If we do not tell stories in a way that people care about, we've failed. We've failed to create an image that connects on some level, failed to pull the viewer into the frame and show them something new. This doesn't mean we shoot only those things that others want to see. It means we shoot the things that move us in ways that will move others. From simple vacation images to shocking images of genocide, an image succeeds or fails based not only on the subject matter but on how that subject matter is expressed. If you think of it as a cinematic film, it is not only the story told but the way in which it is told.

The recognition of visual language, and the beginnings of visual literacy, allow you to tell your photographic stories with much greater clarity. Telling your stories with the most appropriate visual tools is simply better communication, and it gives your viewers a much better chance of being moved, informed, or inspired—whatever your hopes for that image are.

Think of this visual language as much the same as spoken language. Your mother tongue is composed of vocabulary, grammar, and syntax that allows you to speak, write, and be understood. Once you learn English, you are able to clearly communicate your thoughts and feelings to others. The more you master the tools—the broader your vocabulary and the more nuanced your use of grammar—the more powerfully, subtly, or detailed that communication can be. It would be convenient to dismiss this, but it's hard to disagree with the statement that the best poets, playwrights, songwriters, and authors have moved us deeply because they were able to skillfully use their language to tell the stories they were burning to tell.

So it is with the visual language of photography. It too has a vocabulary, a grammar, and syntax. The more intentionally you study these, the more powerfully you can communicate through light, color, and gesture. Remembering that communication is not only what you say but how you are heard, this shared visual language is our key. Like a child learning to speak, it allows us to move from babbling incoherently, to speaking simply but brokenly, to one day being able to clearly ask for that thing we want. We may already photograph the things about which we are passionate, but until we do so in a powerful way, using

> "Knowing what you love to photograph, and what you do not, is the first step in the recognition and refinement of your vision."

the visual language tools available to us, we're only babbling passionately and not communicating.

Passionate stories told passionately: that's the goal of my image-making. I want to go to new places, see new faces, and discover new stories that I can share with the world in the clearest, most powerful way possible. So what are those elements of visual language? Well, that would be the subject of another book entirely, but we'll touch on some of them. In short, it's everything that is within the frame, and everything that gets it there. Light, lines, shades, contrasts, optics, apertures, shutter speeds, ISO, and the combination of these things, would make a short list.

Putting It in the Frame

As a visual storyteller, you are responsible for every element within the frame. If it's in the frame, it's because you allowed it to be. If it's missing, it's because you chose to exclude it, or you neglected to include it. For example, take a place like India. It's a chaotic place full of smells and sounds. Those are not easy things to capture, but if I want people to later look at my images and get a sense of my experience of the place, I can rely only on the visual clues I provide within the frame. It's natural to look at a photograph we've taken and be instantly transported by the power of memory back to that place, to re-experience the sounds and smells and connected memories. If we judge the photograph to have succeeded on that basis only, we've forgotten that the people looking at the image have no such memories. They can only be guided by the clues we give them within the frame.

The world within the frame is all that exists to the people who will one day look at your images. Sure, some of them might have been there, and for them that photograph will have special meaning—in the way that an inside joke is funny to only a few and bewildering to others. To allow your images to communicate to the broadest audience possible, you need to be obsessively aware of what

▶ Canon 5D, 85mm, 1/100 @ f/1.2, ISO 400

Cairo, Egypt. Khan el-Khalili houses a coffee shop called El-Fishawi. Over 200 years old, this place is full of characters. I had my friend prolong negotiations over a scarf he didn't want just so I could get the right moment.

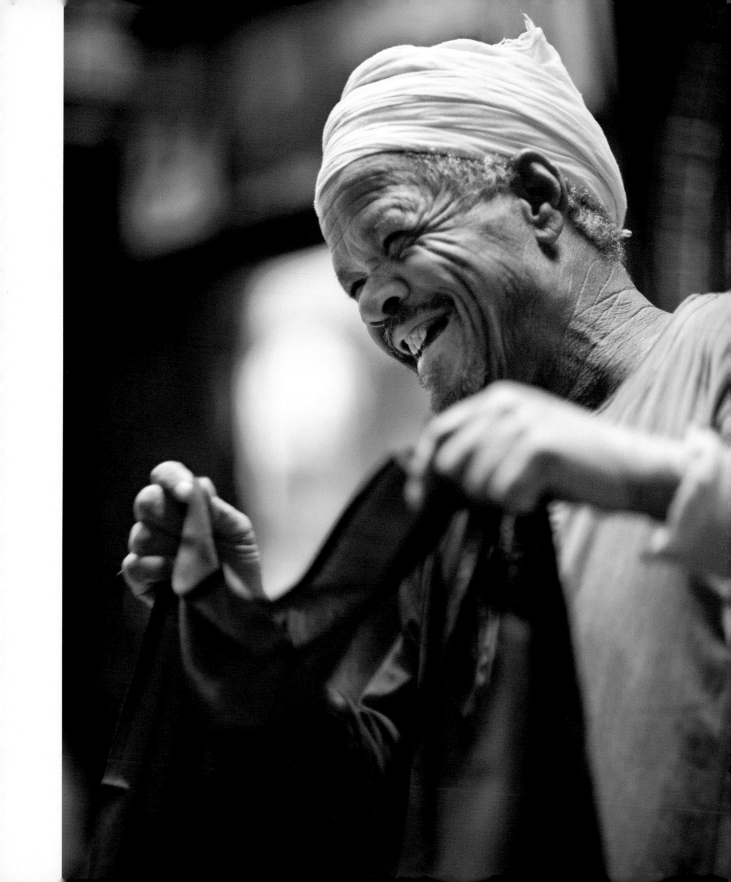

is within the frame. As you press the shutter, ask yourself, "What is it about this person, this place, that compels me to capture this image? Am I capturing this in a way that most clearly communicates that? Have I placed every necessary element within the frame? Is it all there? Will my friends or my photo editor feel what I want them to feel, or will they stare blankly and wonder what they should be looking at?"

I have found it helpful to look through the lens and think about the image projected onto the ground glass shown in the viewfinder rather than thinking of it as simply a window onto the scene before me. It's only a way of thinking, but it allows me to see the elements within the frame in relation to the frame itself, creating more intentional compositions. Have you ever shot an image of a building and only later been surprised to notice the building leaning in dramatically because of the distortion of the wide-angle lens? Why had you not noticed this at the time you shot it? Most likely it's because you're *used* to seeing buildings, and your brain does the perspective correction unconsciously. The frame allows you no such luxury. And so it is with other details that we overlook due to familiarity. Look through the viewfinder—at the frame itself—with careful scrutiny and you'll begin to see distractions at the corner of the frame, or lines that are not as parallel as your mind led you to believe. I do that by tricking my brain—telling myself I am looking at an image in a frame, not a scene through a lens. That might work for you, it might not—but the principle is important. Do what you have to in order to become aware of the frame and the way the elements within it interact.

Furthermore, not only are the contents of the frame important, they are important in relation to the frame itself. How you choose to frame the image—oriented vertically or horizontally—contributes as much to your storytelling as what you put within the frame. A vertically framed image draws the eye up and down, to tall lines, buildings, and people standing. A horizontal frame draws attention to the left-to-right dynamic and is generally stronger as a storytelling format. Whatever way you choose to orient your frame, it's important. It gives your viewers a visual clue—you corral their eyes and attention into a certain direction in the same way a magician says, "Look here," while doing the dirty work with the other hand. It's attention management, and by choosing to place your story within one frame instead of another you are saying, "Look here. Look in this way."

> "Become aware of the frame and the way the elements within it interact."

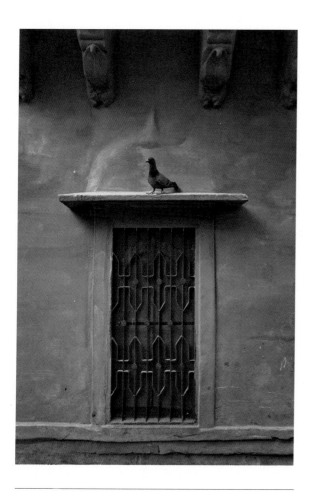

▲ Canon 5D, 23mm, 1/25 @ f/5.6, ISO 800

Jodhpur, India. A blue wall. And a pigeon. Sometimes an image needs nothing more than symmetry and color. And a bird.

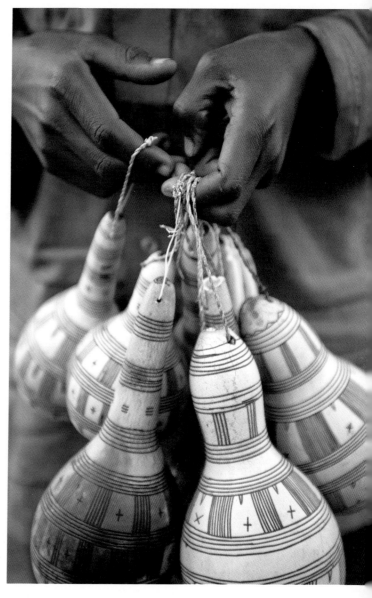

▲ Canon 5D, 70mm, 1/400 @ f/2.8, ISO 800

Awash, Ethiopia. A roadside vendor selling decorated gourds, of which one can never have too many.

It can, of course, be chalked up to aesthetics. Some framing just "looks better," and some photographers make their decisions based on an intuitive "it just felt right" kind of feeling. That doesn't diminish the need to carefully consider the orientation of the frame. If it's intuitive for you, great. But in the end, it's all about what tools make your photographs "just look better." The important question is, "What does 'better' mean?" I suspect it means that your image communicates your vision more compellingly. A second question, equally important, is, "How do I get there?"

> "Exclusion is a powerful tool for increasing the impact of your image."

Excluding It from the Frame

As important as it is to get every element within the frame, it's equally important that you exclude the rest. You know how they say "less is more"? Well, sometimes less is just less, as when the story you are trying to tell within the frame is missing a key character or element. But when you've got it all there and the visual story is complete—and your vision realized—anything extra has a subtractive effect on the impact of your image, and more is less.

The story is told of Michelangelo being asked about his methods for sculpting. He replied simply that he worked on a block of marble, removing all that was not part of the sculpture until only the sculpture remained. I suspect this oversimplifies the art of sculpture, but it's an excellent analogy for photography, which is essentially an art of exclusion.

Famous Spanish Civil War photographer Robert Capa is often quoted as saying, "If your photographs aren't good enough, you aren't close enough." What matters here is not only the proximity of the lens to the subject matter but the principle of exclusion. Elements that are not an important part of the story you are telling diminish the power of that story. Exclusion is a powerful tool for increasing the impact of your image. How you choose to exclude those elements will differ from context to context. Sometimes it's the choice of a longer lens, taking advantage of the tighter angle and the compression of a 200mm focal length. Sometimes it's moving yourself to the left or right, keeping your subject in the same place but effectively switching out a distracting background for something else, or a generic background for one with more character. Perhaps it's simply dialing your aperture up from f/8 to f/2.8 to take advantage of the

blurring effects of a shallower depth of field. And, again, sometimes it's just moving your subject or shooting with a tighter crop.

As you shoot, be aware of the stories you are shooting, as well as the emotions and thoughts you want to capture. Then remove every element that does not contribute to that vision. Does a straight line distract less than an oblique line? Remove the oblique line by moving your point of view. Do the colors in the image work together? If not, plan to remove those colors in your post-processing and present it as a duotone or monochrome image. Keep removing elements until you've removed that one element without which your image fails and the story disappears—and then put it back. You've just discovered the simplest, most elegant way of telling your story.

With time this becomes an intuitive process—not a formulaic process you work through, but a way of seeing. Like all techniques, it is the principle—the *why*—that is important. If you find a way that works better for you, and that still accomplishes the telling of your story with powerful economy of composition, then do that.

A photograph can communicate a couple things— and sometimes only one thing—very well. The more you try to say with your photograph, the greater the chance that you will say nothing at all. Better to recognize the one thing that is most important and work with that. Is it a feeling? Is it the character of a person? Is it a particular reaction you have to a place? Zero in on that. Two or three strong images that achieve your vision are better than one image that tries to do it all and fails on all counts.

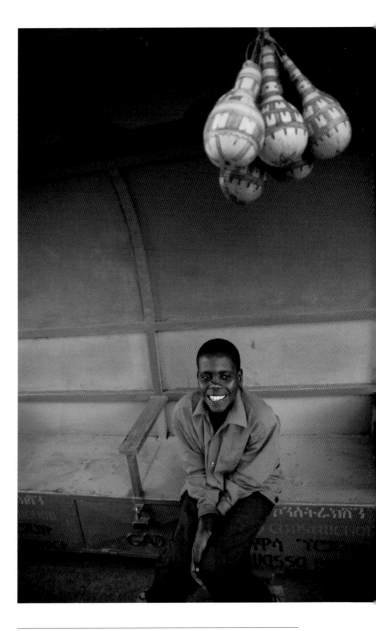

⏶ Canon 5D, 26mm, 1/160 @ f/2.8, ISO 800

Awash, Ethiopia. The colors and the contrast between the sparse stall and the cheerful boy make this a strong complement to the detail shot of his hands.

I love duotone and monochrome images. They bring a focus to lines, shapes, and tones that color images often can't. My process for deciding which images work best in one or the other is simple: I try them out in both versions using Adobe Lightroom's Virtual Copy function. And then I stare at them and see which one resonates most, which one leads me straighter and with the most economy into the heart of the image. Usually it's a clear decision, and it often comes down to this: if the colors themselves in the original capture do not obviously contribute to the image, then I begin playing with duotones using the Split Toning function in Lightroom until the mood of the image and the intention of the photographer collide.

As photographic storytellers, it is our job to ruthlessly exclude every element within the frame that is not part of the story. The results will be more powerful images.

Indecisive Moments

Henri Cartier-Bresson first expressed the theory of the "decisive moment." It's an injustice to him that I'm going to oversimplify it here, but this isn't really about the decisive moment. It's about indecisive ones. But first: the decisive moment.

Cartier-Bresson had this notion that in any photographed event there was a moment when the action unfolded within the frame in such a way as to express that event in the strongest possible visual way. He was not saying some moments are better than others, but recognizing that some are more visually dynamic and tell a story more clearly than other moments within the same event. While there's no shortage of opinions about this theory, to dismiss it outright is to dismiss the notion that some compositions are simply stronger than others; soon it's photographic anarchy, and I'm just too much a control freak to live with that.

But this isn't about that. This is about the indecisive moment: in every possible photographic opportunity, there is a moment when the light, color, or gesture

▶ Canon 5D, 33mm, 1/125 @ f/5, ISO 200

Kairouan, Tunisia. This woman and the cat hit their marks at exactly the same moment. In a perfect world, this orange cat would be white to mirror the woman. As it is, the cat blends in and remains a hidden surprise.

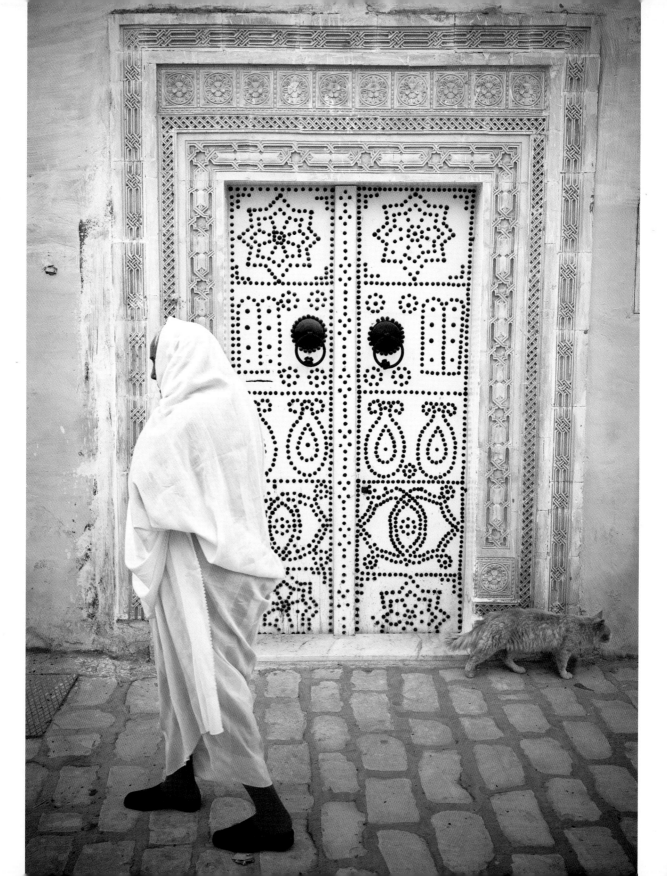

is just perfect, as it realizes your vision with the greatest clarity or simplicity, and sometimes you'll miss it because you're just not ready. That's the reality of working in a medium that is expressed in fractions of seconds and requires an intricate dance between your brain, eyes, hands, camera, subject, and 20 other things well out of your control.

Here's the thing about those indecisive moments. Unless you're a journalist covering once-in-a-lifetime events, they just don't matter. Because they will come again. And again. I will hesitate and the moment will be lost. That's what makes these moments so precious—their fleeting nature. But no one knows which moments you've missed. They only know the ones you've captured. No one sees the photographs that don't express your vision, no one sees the junk and the misfires, and the blurry shots. They don't matter. What matters is the images you have taken, the times when the stars align with the moment and the long hours of practicing your craft, and you capture your vision so well that you sit back and wonder if it was really you who shot that image.

Let it go. Learn from it. Miss enough shots because you couldn't access your EV compensation fast enough and it should motivate you to sit in your living room for four hours doing nothing but practicing your EV compensation. Build the muscle memory so that the next time the decisive moment comes, you won't miss it. Failure can ground you and prevent you from growing as an artist, or it can move you to identify the barrier to capturing your vision and tear it down.

I can't count the times I've missed the decisive moment. Or the times I thought I had it, only to later discover I'd rushed the moment in my fear of missing it and failed all the same. Professionals are not marked by how much money they make at their craft but by their dedication to it and the way they recover and learn from the ones that got away. Don't sweat it. Anxiety makes for poor creative motivation. Relax and focus on the shots that are there now, not the ones that just got away. Now, having said that, a professional will learn to anticipate these moments, and if they still miss it, they'll make it happen again. There is no shame in waiting it out or asking someone to repeat a gesture or pose.

In the end, as long as you're not shooting for a client who demands a certain image, no one knows which ones you didn't get. You're only as good as the images you create, not the ones you miss. So go easy on yourself; regret and self-loathing do nothing good for your creativity.

It's All Subjective

The subject of a photograph is not, for example, a Kashmiri man in front of his family. That's the subject *matter*. The subject itself is the emotion, thought, or intangible that you are trying to express through the image. In this case, it's the general concept of family and the specific concept of family dynamics in Kashmir. The subject of the photograph can be simple: family, beauty, color, or wonder—that intangible thing that you responded to when your inner photographer said, "Oh! Oh! Shoot that!" or whatever it is *your* inner photographer says. Mine tends to be overly dramatic.

This is more than hair-splitting or semantics. Looking at things this way has profoundly changed the way I shoot. It has given me a paradigm through which I can more easily identify the story I'm trying to tell. When I am shooting an image

▽ Canon 5D, 24mm,
1/100 @ f/7.1, ISO 800

Srinagar, India. This man is a baker, and while I stopped to photograph him I had the unexpected surprise of having his family appear as well.

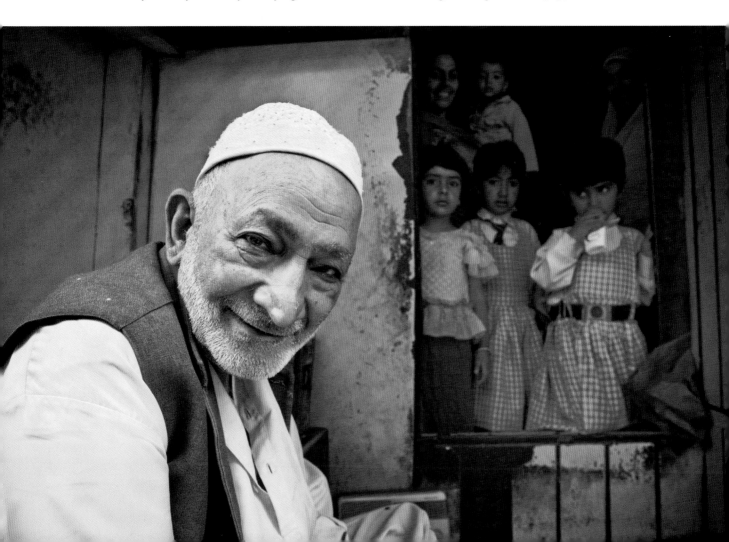

of people in the rain in Vancouver, and I understand that, for me, in this moment, the subject is not the people in the rain, the subject is *wetness* itself, I can shoot this in the way that best communicates wetness. I might choose to drag the shutter and blur the rain. I might choose to shoot through the window of a coffee shop and capture the people in the rain through the raindrops themselves. I might make sure I capture a couple with umbrellas, or wait for a bus to drive past and shoot the resulting spray—all ways I can better shoot wetness. It's an image *of* people in the rain, but it's *about* wetness.

You might find a similar example on the banks of the Seine in Paris. Two lovers sitting on a bench kissing with the Eiffel Tower in the background. The subject of the image is—or might be—love, romance, intimacy. The objects that express that would be the lovers and the Eiffel Tower, icon of Paris, the City of Love. Seeking to best express the subject (love) through the objects (lovers), you will choose the best position from which to most clearly tell this story. You might want to make the subject more specific—like secret love—in which case you might choose to obscure the lovers a little as they kiss. Whatever your decision, it comes from understanding what the subject is and how it might best be revealed.

▶ Canon 20D, 200mm, 1/1250 @ f2.8, ISO 400

Vancouver, Canada. This is a composite of two shots taken one after the other. One is focused on the woman with the umbrella, the other on the raindrops themselves.

The Illusion of the Exotic

Making photographs of unusual things—exotic places or people, novel subjects—is the low-hanging fruit in photography. While there is plenty of value in photographing the unusual, merely filling the frame with something exotic does not make it a good photograph; it makes it merely a photograph of the unusual or exotic. Whether it is a *compelling* photograph must be judged on other criteria.

Subject matter alone—separated from the craft of photography—rarely carries a photograph, and when it does it remains merely a mediocre photograph of a fascinating subject, hardly the goal of most photographers. If by creating an image of the exotic you are hoping to say, "Look at this!" then by all means center it within the frame, set the camera to automatic, and take the photograph. But if you want to communicate something more, if you want to bring something new to the table, and put your own thoughts, feelings, and personality into the image, then you need to photograph your subject matter as though you've seen it a thousand times and then suddenly see it in a new way. Does that make sense? You need to see it with something like spontaneous familiarity, moved by the actual subject matter and not just moved by your seeing it for the first time.

Seeing the stupa at Boudhanath outside of Kathmandu for the first time, my initial reaction was to shoot it from the first angle from which I saw it. I was so impressed by the size, the color, the sheer exotic nature of it that all I wanted to do was shoot it. Don't ever lose that awe-inspiring reaction—there is a sense of wonder and curiosity that can infuse an image with similar magic for the viewer.

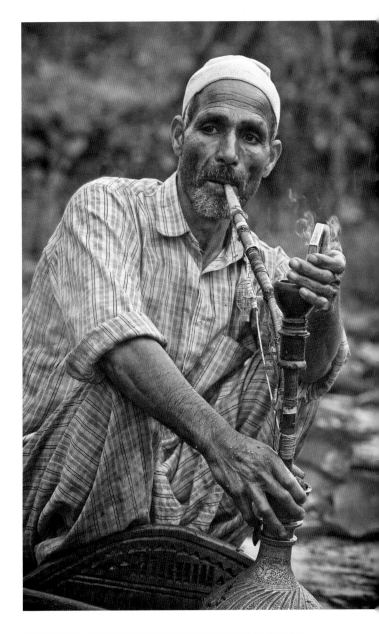

▲ Canon 20D, 135mm, 1/125 @ f/4.5, ISO 800

Srinagar, India. Kashmiri man sitting in the rain, on his shikara boat, smoking his water pipe nonchalantly—this guy has cool to spare.

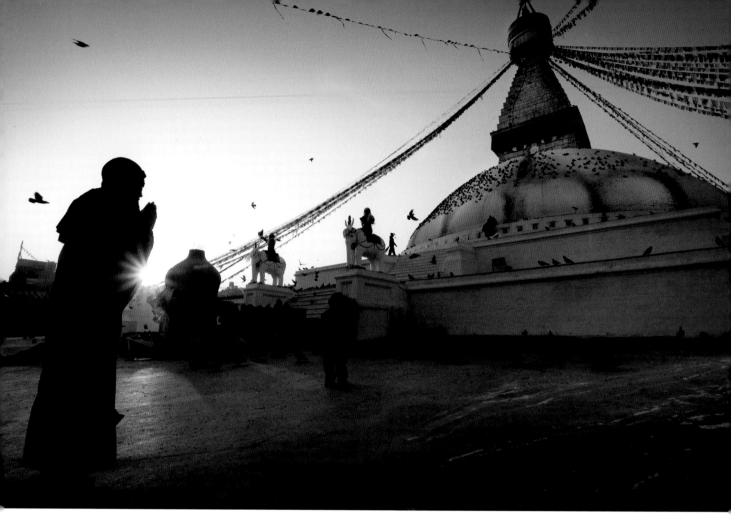

▲ Canon 5D, 17mm, 1/250 @ f/16, ISO 400

Kathmandu, Nepal. The Boudha stupa at 7 a.m. It took me three
trips to Kathmandu to get the timing right on this one.

But between that initial wonder and it rubbing off on your audience lies your
craft. The photographs don't just happen, and if I want a *good* photograph of
the stupa and not merely a mediocre one, I need to both hang on to my wonder
and explore it from every angle until I've found the one that best allows me to
communicate my vision. It might mean trying many different lenses, returning at
several times of the day, or waiting until a pilgrim paces through my frame and
hits his mark.

I've found it helpful to make a mental list of nouns and adjectives that describe my reaction to a place. In the case of the Boudha stupa, those words might be: large, peaceful, monks, prayer flags, colorful, search for the sacred, constant motion, and others. It is those words that help me nail down what is otherwise a pretty vague and hard-to-describe reaction to a place. They help me become more aware of my vision and more able to create an image that best expresses it. Those words lead me to consider which elements are vital to the image, and which tools of composition I need to use to help my viewers catch my vision.

As much as we are blinded by the exotic, we are equally blinded by our own familiarity. For the photographer shooting a new place, the challenge is to hold on to the wonder while becoming familiar enough to more fully capture something. For the photographer shooting something with which he is more familiar, the challenge is to rediscover the wonder and shoot with new eyes. Same coin, different side, and just as challenging. But either way, a compelling photograph needs to be evaluated on more than the novelty or exotic nature of the subject matter.

> "I need to both hang on to my wonder and explore it from every angle until I've found the one that best allows me to communicate my vision."

Putting Time Within the Frame

As photographers, our most elemental raw materials are light and time. Simply by virtue of the technology with which we make our images, we are bound to carefully consider time in our process. Of course, the immediate consideration is the shutter speed, which is our capture measured in length of time. But at least as important as how long the captured moment is—$1/250^{th}$ or $1/1000^{th}$ of a second, for example—is *which* moment we choose to capture.

Length of Time

The necessity of exposing the sensor to light in order to create an image, and the restriction of having to do so in varying lengths of time, has given us an ability to express, or imply, time in our images. With a turn of the dial, our choice of shutter speed can capture the passage of time or create an image that appears to stop time entirely. Shutter speed is not only a means for creating the right exposure, but for making a photograph that says precisely what you want to say

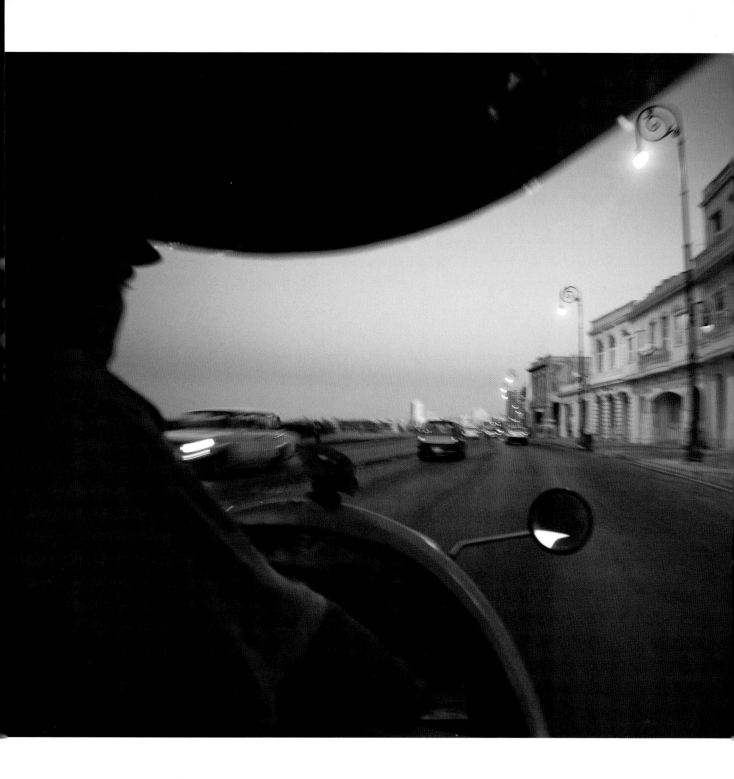

and gives the feeling you want. Rethinking the role of shutter speed and its aesthetic effects can have a profound influence on the images you create. It's not magic, and there's no great secret here; it's just the decision to become more intentional about your choices, to consider the look of your image beyond just getting the exposure right.

Where this relates to creating stronger photographs of people and places is in recreating mood. Standing at a busy intersection of Old Delhi, the traffic goes by in an endless blur that is terrifying to an amateur pedestrian. A slower shutter speed captures this blur and chaos whereas a faster one merely freezes that action. Perhaps spending some time on that corner and panning with a passing cyclist will create feelings of both motion and "old-world-meets-new-world," giving you a photograph that is more expressive of your feelings than a capture made at a faster shutter speed would.

Suppose you are photographing rituals involving water. You might choose to try both a slower shutter speed and then a faster one, and decide later whether the sense of mystery you've expressed in the slower capture is more suited to how you experienced that moment than the one you took at 1/500th of a second, which froze the falling, splashing water. Both might appeal to you for different reasons, but it's undeniable that both say different things and that your selection of the shutter speed made all the difference. Being conscious not only of the role of time in an image, but also of how you want the final image to look, allows you to put the element of time's passage into the frame.

> "Consider the look of your image beyond just getting the exposure right."

◀ Canon 5D, 17mm, 1/25 @ f/4.5, ISO 400

Havana, Cuba. Shot from the inside of a tourist cyclo taxi, only the frames shot around 1/25th of a second, capturing the sense of motion, really worked. This one, shot on the Malecón heading toward Old Havana, in front of Havana's classic architecture, was my final select.

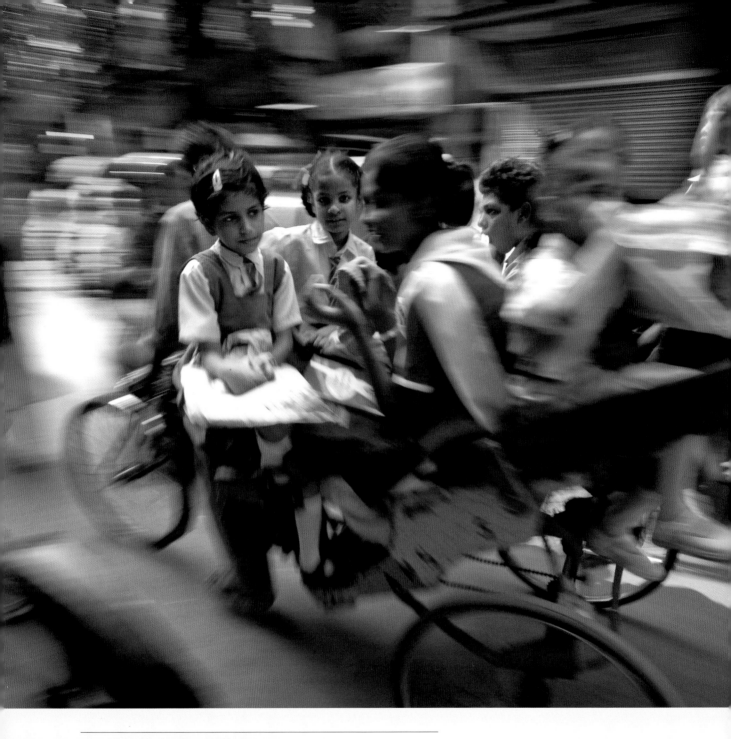

▲ Canon 5D, 17mm, 1/8 @ f/22, ISO 400

Old Delhi, India. In between frames I played a counting game called "How Many Kids Can They Cram into a Cycle Rickshaw?" The winner had 10.

Panning

Panning is a great way to imply movement or the passage of time, but it's not one of those techniques that comes easily to most people. The secret to great panning is practice, but here are some hints to guide that practice.

- The key to panning is a slow shutter speed that allows you to capture more time in one frame, and therefore to capture more of the motion that occurs in that length of time. I find my best panning shots use a shutter speed of 1/30th to 1/15th of a second, but that, of course, depends on how fast your subject is moving. You'll have to stop down the lens if you're shooting in daylight, but since anything not being tracked by your lens will be blurred, depth of field is less of an issue than it is with stationary shots. In fact, the smaller aperture will give you a better shot at nailing your focus on a moving object.

- Using autofocus while panning can present more problems than it solves. I set my focus to manual, pre-focus the lens where my subject will be, and rely on my larger depth of field to help me out.

- Panning relies on a smooth tracking of your moving subject, and I've found the best way to do this is to take a wide stance with my legs and plant them in the position I will end up in as my pan comes to an end. It means you start panning standing a little wound-up, but you'll end the pan in a natural posture, which helps keeps you stable through the critical parts. Follow-through also helps. Like with a golf swing, you don't stop moving when you hit the ball; you follow through and that makes for a smoother swing.

- Pick a great background. You're going to be here for a while. You might as well be shooting against a background you really like.

- Practice, practice, practice. Panning is a lot of fun. Good thing, too, because it takes a lot of work to get it right, and even more to get the perfect shot. The next time you're in a place with lots of yellow cabs, rickshaws, or other horizontally moving subjects, take some time to play.

WITHOUT THE FRAME

VARANASI, INDIA. Varanasi is one of the holiest cities in India. It sits on the banks of the river Ganges, a holy river choked with pollution, decay, the remains of the dead, and the rotting offerings of marigolds placed in the river every morning and night by the faithful. Along her banks run the ghats, stone steps that descend into the river and form the meeting place between the Ganga and her devotees. It is a chaotic, noisy, colorful place crowded with people who come to pray, wash, sell, buy, teach, and be taught. It is all at once a beautiful and an ugly place, a place of serenity and cacophony.

I spent my time in Varanasi walking up and down the ghats at all hours. Early morning, late evening, high noon. Trying to get a feel for the place, and to get an image or two that summed up not only the spirit of the place but how my spirit felt and thought about the place. And then I saw this boy. He was leaping from one boat to another, as a paper kite fell from the sky (the sky was full of them). He was trying to gauge the trajectory of the kite, to catch it. My last frame was this one. He'd stopped and raised his hands as if in supplication, and he waited, motionless, for the kite to fall.

It fell slowly, like a leaf on the wind. It missed his hands, fell into the water, and dissolved. It was both a beautiful and sad moment, one that defined the city of Varanasi for me. I sat there a while and thought about it, about how sad it was that he'd waited and waited and jumped from boat to boat, only to have the kite fall out of his grasp and dissolve. But the boy went back to jumping and waiting and jumping some more, and something told me that it was the running and the jumping that mattered to him, that I was wrong to think the purpose was the kite itself. Much like life, I suspect.

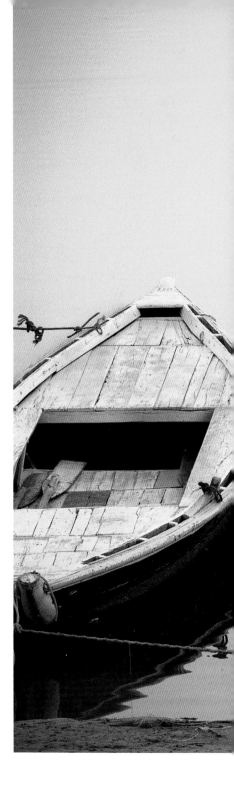

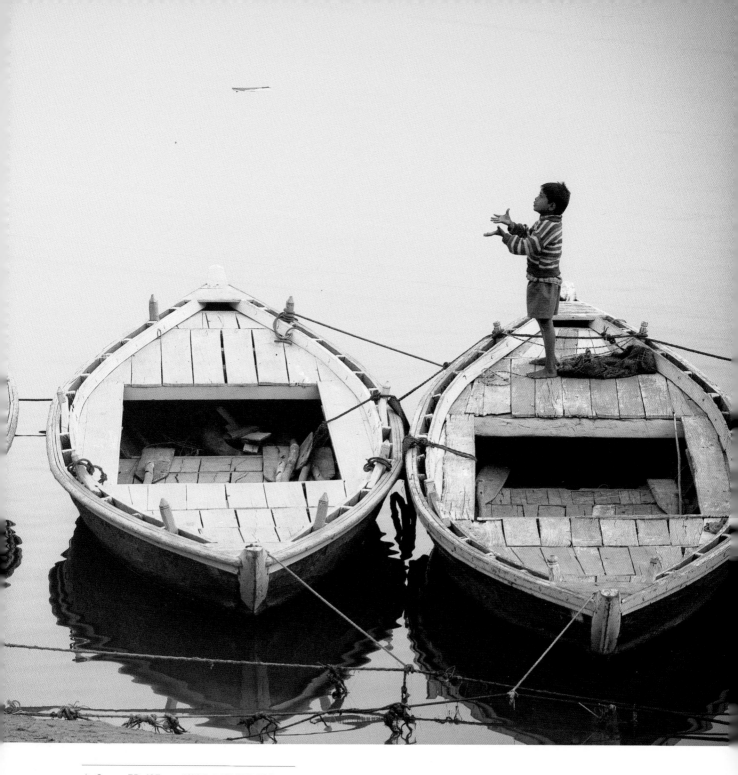

Canon 5D, 135mm, 1/200 @ f/8, ISO 800

Knowing your camera so well that you can change the most important settings without looking up from your viewfinder—or better, without thinking about where the buttons are—allows you to put more attention into seeing and creating your image.

Pulling the camera from your eye so you can change the ISO, aperture, or focus point is a sure way to lose the moment. Imagine creating images without the camera and technology getting in the way. Imagine the camera being an extension of your arm, doing what you ask of it with no more than a thought.

Give yourself a week and you can do this. Sit down with the camera, close your eyes, raise it to your face (which is where it'll be when you shoot), and run your fingers over every button. As your fingers touch a button, see if you can identify it. When you can do that, put the whole thing in reverse. Raise the camera to your eye, keep your eyes open, and see if you can find settings without looking. Can you change your ISO without bringing the camera down? Aperture? Shutter? Focus mode? Focus point? Go slow, take your time.

As you become more familiar with your camera, you will be able to do this without thinking. Before you know it, the whole process will be automatic, which will leave you with more time to think about your composition and timing.

Choice of Moment

A friend of mine once expressed her understanding of Henri Cartier-Bresson's decisive moment this way: the moment when the height of tension in the scene you are capturing intersects with the height of composition. It is often judged "decisive" only in hindsight, and it has often generated a lot of discussion as to the exact nature of what Cartier-Bresson was on about. One thing is certain: the intention behind the decisive moment theory is that timing matters. To deny this is to deny that composition matters; both timing and composition intersect better at some moments than others. Shoot 100 frames of two people having a discussion at a streetside café—all from the same angle—and some will be

much stronger than others. Some will be downright boring, some filled with gesture and tension, some with emotion. In some the lines lead the eyes nowhere, in others the lines formed by their arms and eye-lines draw your viewer deeper into the story. A few draw your audience into the story, but most end on the digital version of the cutting room floor. Why? Timing.

Timing is developed. You learn it. Sometimes through practice, sometimes through a familiarity with psychology that allows you to anticipate a look, and sometimes with, for example, the knowledge of a sport that allows you to predict where the ball will be, when the coach will react, and when the fans/hooligans will riot. You learn this as you shoot image after image. You learn it as you lose one too many images by staring at your LCD screen the moment the shutter closes and the subject relaxes. With time, you learn to pay attention all the way through the moment you are shooting, the photographer's equivalent of following through on a golf swing. You learn to watch, to wait, to shoot first and ask questions later. You learn to keep the camera on, the lens cap off, and the camera in hand. You learn to think through your settings as you raise the camera to your eye, rather than after it gets there. You learn to be ready a split second before the moment happens rather than a split second after it's gone.

Sometimes the difference between a mediocre photograph and a great one, between a snapshot and an icon, is a fraction of a second—either the length of that fraction, the choice of that fraction, or being ready when that fraction occurs.

> "Learn to pay attention all the way through the moment you are shooting."

The Artist and the Geek

I'M TEMPTED TO SAY that this is the chapter about the meeting of craft and vision, technique and artistry. But the whole book is about that—at no point does one get the spotlight to the exclusion of the other. It's that very imbalance in photography that needs to be corrected, not encouraged.

▶ Canon 5D, 28mm, 1/6400 @ f/2.8, ISO 400

Kairouan, Tunisia. To the end of my days I'll wish a man in a red fez had poked his head out the bottom-right window.

The technique stuff here is critical. All the vision in the world fails for lack of means to express it. There's technique-related material all the way through the book; the information in this chapter needs to be here because it applies in broader strokes than the stuff in the other chapters. By this point, the geeks are skipping ahead to get to the geekery, and the artists are probably slowing down a little, wondering if they should skip ahead to the end and see what happens. Stick with me, folks. I promise I'll make it painless for all of us.

Gear Is Good, Vision Is Better

Photographers, like few other kinds of artists I can imagine, have an insanely personal relationship with their gear. There is a geek factor with photography that I can't imagine applying to painters or writers. We can't help it if our craft is so dependent on gear, but it's scary how quickly our gear becomes not the means but the end. One of my favorite authors, C. S. Lewis, once said something along these lines: it is the great temptation of storytellers to love the telling of stories more than the stories themselves. I'm paraphrasing, but I don't think I'm at all far from the sense of what Lewis was saying. Applied to photography, I would rephrase it: photographers run the risk of spending more time thinking about gear than using it to create great images. In short, we become addicted to the *how* of photography, and when that happens, the *why* and the *what* suffer. The result is a glut of photographs that are technically perfect but lacking in emotion, depth, symbolism, and passion. They appeal to photographers who gawk in stunned awe at the bokeh, but to the world beyond our well-framed walls, well, they see through all our devices, clever techniques, and gear—people just want to see something that moves them.

It's as though photographers are afflicted with a chronic split personality. One personality is the Artist, the other the Geek. One is Vision, the other Craft, or Technique, and in the middle where they meet is the art of photography—the expression of our unique vision through practiced technique. Great photography happens where craft and vision meet.

Despite the cameras, computers, and vast arsenals of lenses, software, and assorted geekery, photography is an artistic pursuit. At the heart of that pursuit is our vision and the need to create an image about which we are passionate— something that communicates the ineffable in color, light, and gesture. What

▶ Canon 5D, 85mm, 1/60 @ f/1.2, ISO 400

Lamayuru, Ladakh, India.

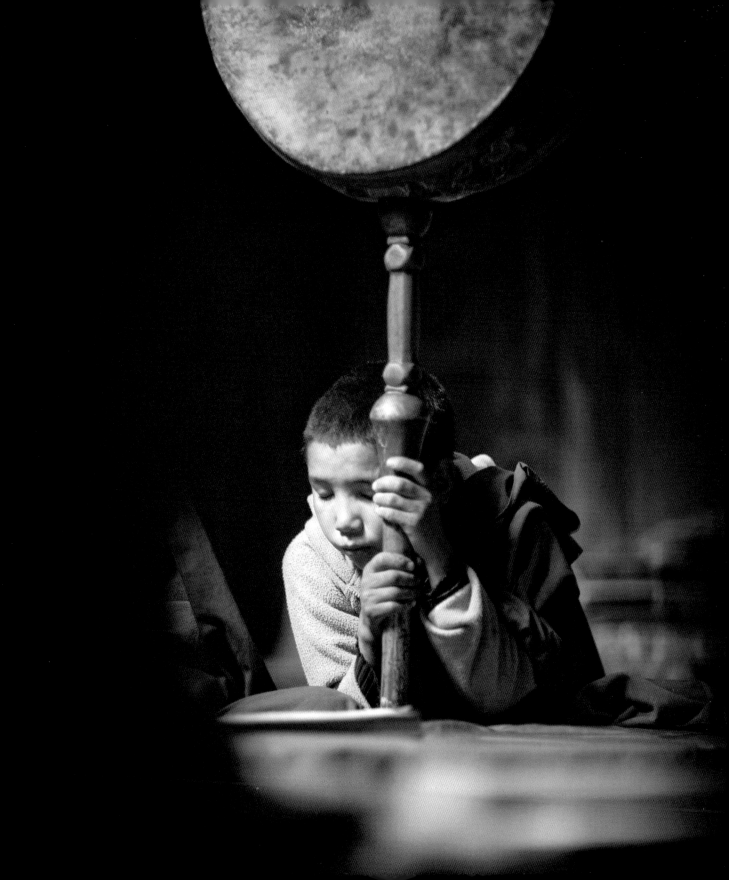

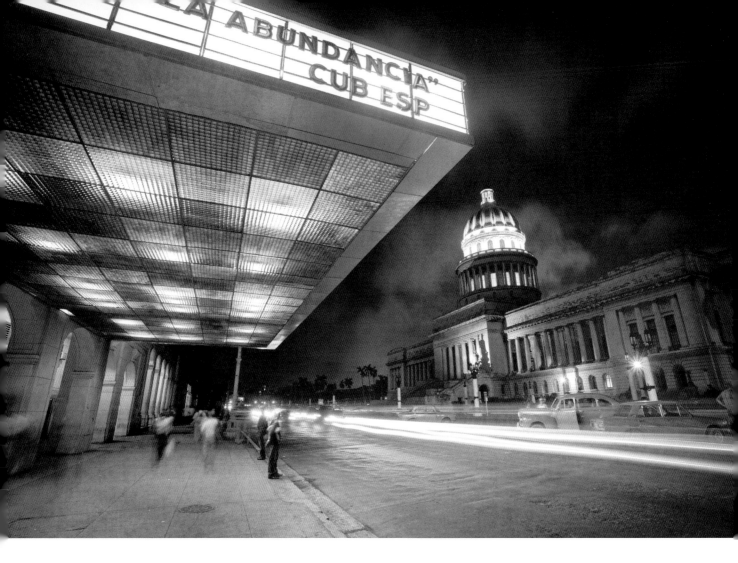

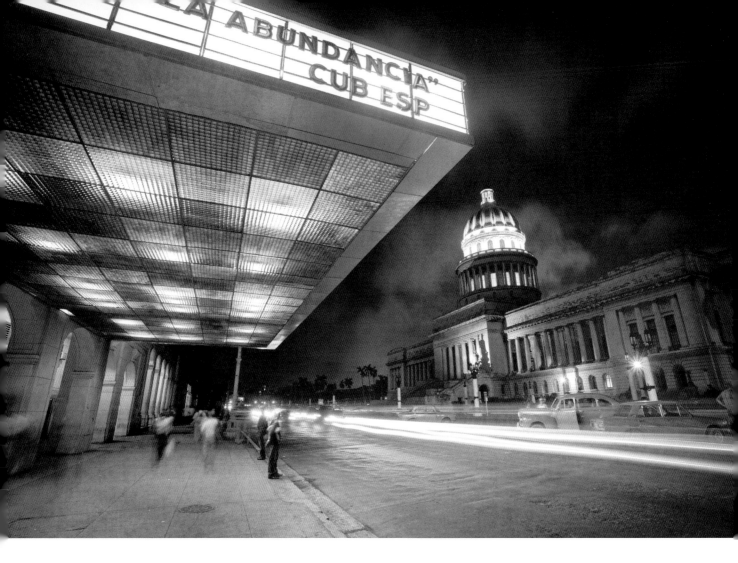

▲ Canon 5D, 17mm,
13 seconds @ f/11,
580EX flash, ISO 200

Havana, Cuba.

stands in the way of creating those images are often the very tools by which
we ought to be aided. Our vision and the image it creates can quickly become
servant to the technology, excuses for our addiction to technique and tools.

Photographers, like artists in all disciplines, face a temptation to fall more
deeply in love with the way we create our images than with the images them-
selves and the reasons for those images. It's tempting to react to this addiction
with a manic swing to the other side and embrace an artsy-fartsy, to-hell-with-
technique attitude, but it's when the artist and the geek/technician are both
held in tension that our vision has the greatest chance of being realized.

How does that balanced tension come about? It begins with our own self-awareness, knowing to which side of this split personality we most naturally fall. To those of us who tend to hide behind hyperfocal distances and Photoshop filters, we need to learn to feel and speak visually with greater passion and less reliance on our tools. Perhaps an ongoing personal project that involves the simplest of tools—an old manual camera, one lens, and some black and white film—would be helpful. Give the geek a personal retreat and some time to learn to express himself with the simplest of equipment. Don't have simple gear? Set your digital SLR to manual, use one lens, and shoot JPEG. And no Photoshop. As painful as this low-tech exercise can be for the natural technician, it serves a greater purpose: to help you see past the words and grammar of the visual language and find a story worth telling.

For the natural artist, the road to serving your vision might be even more difficult. The geek has only to fast from his addiction and learn to feel a little more deeply. You, the poet, the artist, may need to learn the nuts and bolts of your craft—take a course in lighting, learn about histograms and adjustment layers. For an artist, this can be truly difficult. It might be time for a workshop or a month's worth of video tutorials. The goal is not to abandon or even neglect your artistic side; the goal is to provide you with the greatest possible grasp of the available tools so you're as capable of expressing your vision as possible.

Three images go into making your final photograph. The first is the image you visualize—the story you are compelled to tell. The second is the scene you capture with the camera. The third is the image you refine in post-production. The better we are at all of these, the closer our final photograph will come to reflecting our initial vision. The more harmoniously the artist and the geek can coexist, and the better they both are at what they do, the more powerful and powerfully communicated our vision will be.

By all means, geek out on the gear, but don't forget that without vision the whole thing falls apart and devolves. It stops being photography and just winds up as an addiction to expensive, soon-to-be-obsolete gear. Your vision, and the photographs you take, will last much, much longer. No one cares if you create your images with a Canon or a Nikon; they care if the photograph moves them.

"Great photography happens where craft and vision meet."

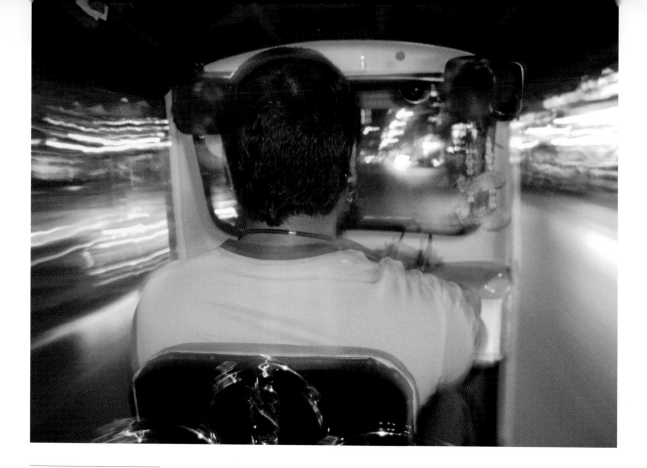

▲ Canon G9, 7.4mm,
0.8 seconds @ f/2.8
with flash, ISO 80

Bangkok, Thailand.

Decent Exposures

I don't shoot on Program mode. Camera technology just keeps getting better and better, and while it can be suspiciously accurate with exposures, it can't make decisions about how I want my image to look. And isn't that what photography is about? The look? The old photojournalist mantra of "f/8 and be there" is great for a photojournalist whose priority is getting the shot, but not for photographers wanting more specific control over the aesthetics of their images.

Every setting used to control the quantity of light that enters the camera to give you a perfect exposure also has an effect on the look of your photograph. If your vision is vague and you're okay with the camera choosing how the photograph looks, knock yourself out. The rest of us are going to want more control over our images. We might also snicker about you out by the bike racks during recess.

There are often several ways to achieve the right exposure but only *one* way to achieve your vision, so your decision process must give priority to this question: what do I want my image to look like? You can avoid an overexposed image by cranking down the aperture from f/2.8 to f/16, but the resulting gain in depth of field might be so contrary to your vision and the means you need to achieve it that, with that one technical decision, you've lost your image. The same can be said about shutter speed—a decision based solely on the quantity of light without considering the impact on the look of the image can prevent you from realizing your vision. Likewise, ISO changes will give you more latitude with shutter speed or aperture, but raising your ISO too high will introduce noise. And while film grain resulting from higher ISO films will always be kind of cool and grungy,

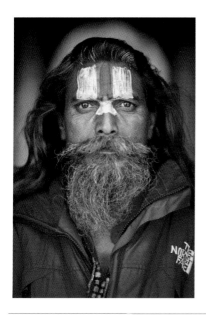 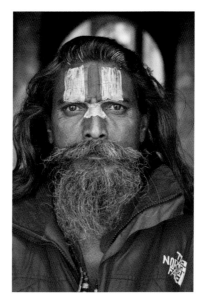 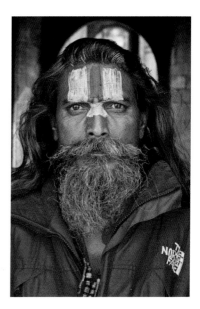

▲ Canon 5D, 85mm, 1/640 @ f/1.2, ISO 100 ▲ Canon 5D, 85mm, 1/80 @ f/7.1, ISO 400 ▲ Canon 5D, 85mm, 1/50 @ f/13, ISO 800

Kathmandu, Nepal. I shot these portraits with a decent exposure, but the change in aperture size resulted in a change in the depth of field. The first is shot at f/1.2 and results in a depth of field so shallow his eyes are in focus but his nose and ears are soft. The second is shot at f/7.1, resulting in a well-focused face but the shapes in the background are coming into focus as well, taking away that great halo effect present in the first frame. The third shot was exposed at f/13 and results in an even sharper background. Which one you prefer is a matter of taste and vision. An out-of-focus nose might bother you, but distracting backgrounds are no better. In this situation, an aperture as wide as f/2.8 or as deep as f/4.0 would be my own preference. Which aperture is right? That's not the point. What matters is the recognition that each setting has a profound effect on the look of the image.

digital noise always looks crappy. The day is coming when noise will no longer be an issue, but until then, changing the ISO will affect the look of the image.

You have a great deal of latitude when it comes to getting the right amount of light to your sensor. You have much less latitude when it comes to creating an image that best serves your vision. Do you want your motion frozen or blurred? Do you want your backgrounds sharp or soft? Choose your settings based on their behaviors and how they work aesthetically to express your vision.

The Best Digital Negative

Beyond that, a proper exposure means a better-looking image, so an understanding of digital exposure is important. Simply put, the best digital negative—assuming there will be some work in post-processing—is the file with the most amount of data. Your camera's histogram, the graph displayed on your LCD with the spikey mountains on it, is the key to this. This graph represents the capture of the scene you just shot—from shadows without detail on the far left, to highlights without detail on the far right. In between is your scene, represented as tonal values. What is important is not the height of the peaks—you can't do anything about those—but where the mountains are situated from left to right on the histogram. Too far right and the graph—your data—goes off the edge and into the abyss. This is seen in your image as hot spots, burned-out areas of white with no detail. It's okay for specular highlights, but not for areas where there should be some detail. Too far left, and the data goes off the edge and you'll have shadows with no details. Recovering plugged shadows in post-production will generally result in increased noise. Recovering burned highlights is usually impossible beyond a stop, even when shooting RAW.

The fear of losing highlights often results in overcompensating and intentionally underexposing images. After all, you'll be doing some post-processing anyway; why not avoid the whole thing and just pull the exposure up later? The answer, in short: image quality. The amount of actual digital data that is represented on your histogram is not evenly spread across the graph. There is exponentially more data available on the right side of the histogram than on the left. Underexposure, even when not plugging up the shadows, captures the image with less digital information available and gives you much less raw material to work with. And less data from which to pull needed information results in noticeably increased digital noise and a poorer digital negative from which to print.

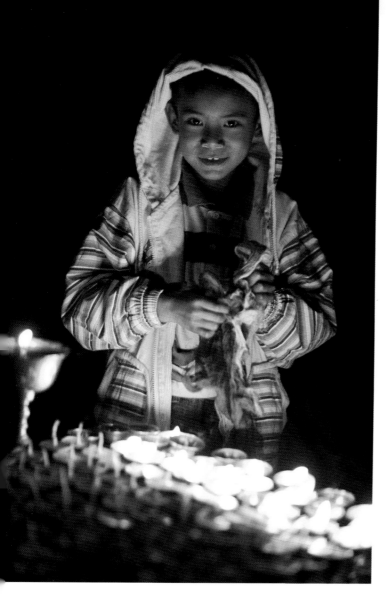

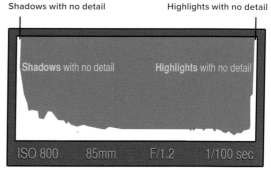

Shadows with no detail **Highlights** with no detail

ISO 800 85mm F/1.2 1/100 sec

◀ Canon 5D, 85mm, 1/100 @ f/1.2, ISO 800

Kathmandu, Nepal. Notice how the histogram for this image goes strongly off the left side, indicating shadows with no details, and similarly goes strongly off the right side, indicating highlights with no details. This is one of those cases that illustrates the fact that there is no universally perfect histogram. At first glance, this appears to break the rules, but isn't it just what you'd expect? Of course there's no details in these shadows; it's pitch black outside in this scene. And there are blown-out highlights, but you can't expect detail in flames—or the sun, for that matter. They're specular highlights that will always blow out.

The common mantra is "expose for the highlights." All other things considered, and studiously avoiding a discussion about high dynamic range imaging, start by exposing your images so the bulk of the scene comes as close as possible to the right side of the histogram rather than the left, without allowing the data to slide off the graph entirely. You may later have to push the black values back where they belong, but it's an easier matter to make blacks blacker than it is to move the histogram the other way. RAW gives you far more flexibility than JPEG

in this regard, but it's no magic wand. RAW will give you greater latitude to compensate after capture, but it's not unlimited.

There is no substitute for a good exposure. In the digital world, this means a capture that doesn't blow out highlights or plug shadows, and that contains the largest amount of digital data possible. Where your scene contains a dynamic range that is impossible to capture in one exposure, consider bracketing your exposures over multiple frames and blending them later in Photoshop.

If you are new to digital photography—and especially if you've transitioned from film—I encourage you to read up on exposure. There's no need to geek out; just become comfortable with your histogram and what it means. If you've been shooting a while, you already know how important the histogram can be. You also know how untrustworthy today's current camera LCD screens can be in regard to seeing your exposure, so don't trust the preview. Trust the histogram.

> "There is no substitute for a good exposure."

The Exposure Triangle

Your exposure is accomplished in camera by three means: ISO, aperture, and shutter speed. This creates a triangle with three moveable points. It's called, not surprisingly, the Exposure Triangle.

The Exposure Triangle helps you choose the camera settings that will give you the best exposure while affecting the aesthetics of the image in the way you envision it.

First, choose the setting that most directly affects the look of the image in the way that you envision. For me, that's often the aperture. Then choose the second setting. It's usually a compromise between the remaining two, but in any compromise it's easier to make if you know what's most important to you. For me, it's often ISO, but if the light is low and I need a faster shutter, then I choose that. The Exposure Triangle isn't rocket science, but it's helpful. Pick the first, then find the best compromise between the remaining two, keeping in mind that, as long as you do it right, there are probably a couple different combinations that will give you a proper exposure. But there might be only one that gives you the look you want. Choose your settings—even the compromises—based on your vision.

Seeing the Light

For a craft that is so uniquely dependent on light, I am constantly amazed at how little attention is given to the quality of light. I shot for well over a dozen years before it occurred to me that quantity of light is nowhere near as important as quality of light. Quantity of light is what we learn first—how to control the amount of light striking the film or sensor through a combination of shutter speed, aperture, and ISO. We can add strobes to increase the light or a Neutral Density filter to cut it, but in general it's easier to make up for the quantity of light than for its quality, particularly when it's natural light.

Having learned the basics of exposure, anyone can quickly make an image with *enough* light. Camera technology makes this easier and easier, and while I don't want to downplay the importance of making good exposures, it is the intensity, color, angle, and texture of light that has a more dramatic effect on the aesthetics of your image, and which takes far longer to come to grips with.

It should first be said that there is no such thing as "good light" or "bad light." That kind of thinking only limits your creativity and forces you to discount certain light as useless and other light as universally useful. There is only light that helps or hinders your vision. If, given your vision, the light is inappropriate, you'll want to modify it or change your vision to see things in a different way. Inversely, if the light is appropriate to your vision, you'll want to make the most of it, but that by no means implies that the same light will work for a different image tomorrow. The sooner we think of light according to its behaviors, and not by labels like "good" and "bad," the sooner we'll be more able to use that light to our advantage.

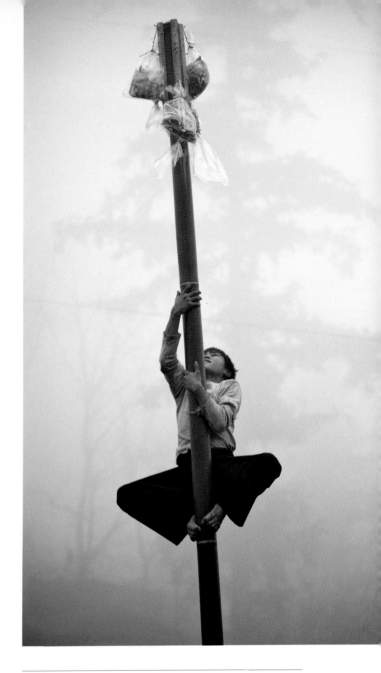

▲ Canon 5D, 125mm, 1/1600 @ f/4, ISO 400

Sapa, Vietnam. It was Tet, the lunar New Year, and the Montagnards of the Sapa region were celebrating with feats of skill, including climbing a greased pole. The fog created a mood that would be impossible to capture in any other light.

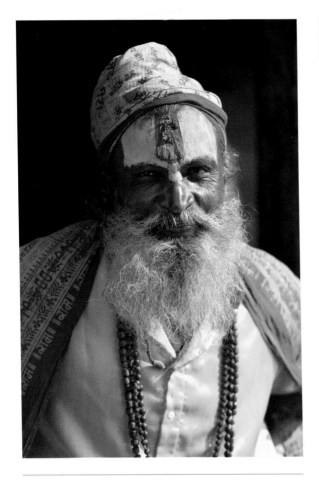

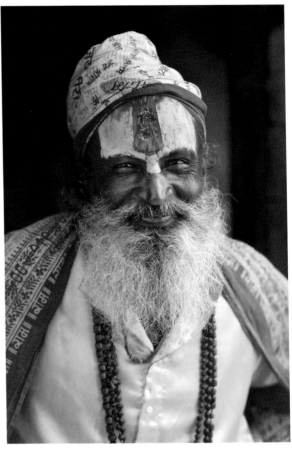

▲ Canon 5D, 85mm, 1/1000 @ f/2.8, ISO 100 ▲ Canon 5D, 85mm, 1/400 @ f/2.8, ISO 100

Kathmandu, Nepal. These two frames were shot three seconds apart, just enough time to get a large diffusion panel positioned between my model and the sun. The difference between the look and feel of these two images is not a small detail. Is one better than the other? That depends only on what I was trying to accomplish. Both have specific characteristics. The hard-lit frame on the left is also side lit, revealing the texture of this saddhu's skin, beard, and forehead tikka. The soft-lit image evens out the light, reducing the contrast and allowing me to better see his eyes and his personality. I prefer the soft light for this image, but it's a question of vision and artist's prerogative.

Light can be described in several ways. It can be described qualitatively as hard or soft. It can be described in terms of its directionality—front, side, or backlighting. It can be described as textured, diffused, or indirect. Light is often described in terms of its color temperature—warm or cool. Your choices in how you use these kinds of light should be determined by your vision; becoming aware of them and how they work is the first step to making them a fluent and useful part of your visual language.

Hard light is the straight, undiffused light of midday. It's light provided from a small, distant light source in a direct way. It produces hard shadows and bright highlights. It often makes for a scene with a dynamic range too great for your sensor to capture in a single image and forces you to choose between deep shadows with no details or burned-out highlights. Sometimes both. It also tends to wash out colors. Not a very flattering light, right? True, but it is dramatic and stark, and it produces a certain look that softer light can't provide. Used right, where it helps you express yourself more fully, it's better light than the softer stuff.

Soft light gets all the glory, and there's a good reason for that—it's more versatile and gives you, the photographer, a broader range of expression with its use. But that doesn't make it better light overall, just more versatile. It's only better if it's the light you need to create your image in the way you've envisioned. Soft light is smooth, diffused, and often bounced around a lot before it gets where it's going. Soft light is the sunlight that's had the power knocked out of it by a light cover of clouds—the sunlight still gets there, but it's been diffused by clouds that are much closer to your subject than the sun, making a softer, larger light source that allows for more flattering portraits, more saturated colors, and images with a more manageable dynamic range. The sun, in this case, is no longer your *source of light* but the *origin of light*. The source of light becomes the clouds, and the closer the source is to the subject, the softer the light produces. The same is true of light bounced off a wall or reflector; once it hits the wall, the wall becomes the source, and the resulting light is softer than the direct sun.

The *direction of light* works significantly for or against you, depending on what you're trying to achieve. Light's directionality primarily affects the shadows that it creates. A model lit from above will have shadows under her eyes, nose, lips, and chin. The harder the light, the harder those shadows—very dramatic, even

"The closer the source is to the subject, the softer the light it produces."

sinister. Sidelight is particularly good at picking up textures and emphasizing them. Backlight—light coming from behind your subject—can be the hardest light to master but is also some of the most beautiful when used well. Backlight can present difficult exposure and lens flaring, but can also rim your subjects with light and, in some subjects—like a flower or glass of wine—give the subject the appearance of being lit from within as the light shines through it rather than bounces off it. If you want that glass of wine to look luminous, backlight will get you there.

This isn't meant as a primer on light. It's simply intended to convey to you the importance of light's quality in your image. Light isn't magic, so there's not much I need to tell you—all you have to do is look, be observant. Ask yourself, "What is the light doing to my image?" And then look for the shadows, look at the colors. It's not just an afterthought that can put a little sparkle into your image any more than a painter's choice of colors is simply a small detail that makes the painting a little better. It's a significant part of the vehicle through which you are communicating your vision. By all means, expose your images well, but give at least as much thought—maybe more—to what the light looks like. Few things will immediately improve your photography like beginning to pay attention to, and harness, the quality of your light.

Choose Your Lens Based on Behavior

My youth was spent in pursuit of the longest lens possible. This occurred for several reasons, not the least of which was the lack of a social life. Another reason was the status of a longer lens. It was as though there was an unspoken understanding that the longer your lens, the more serious you must be as a photographer, ergo the better you must be. And another reason, the only one I'd be likely to say out loud, was to "bring far things close" or "to make small things big." Likewise, a wide-angle lens was for "getting as much big stuff into my tiny little frame as possible."

When I look back now, I wonder why I was never taught anything more nuanced about the behavior of optics. I mean, the choice of lens is not only part of the look of the image; it has an effect on the aesthetic of an image that no other choice can produce. Understanding the behavior of your optics is as critical as

a painter understanding the difference between his brushes and why to use which one for which purpose. Reducing the choice of optics to a simple matter of "Well, how far away is your subject?" is not only bizarrely simplistic but also robs you of the chance to subtly affect the look of your image. And that, after all, is what achieving your vision is about. The look. Your choice of optics has a direct impact on composition—specifically, on the geometry within the frame.

With some notable exceptions, your feet can get you closer to your subject cheaper than a new lens can. But your feet can't affect the look of the photograph the way a lens can. Every lens behaves differently—in terms of magnification and angle of view as well as compression. Compression is the visual effect of compressing the apparent distance between elements in an image, from front to back. This affects the foreground and background, but also changes the look of a human face or the appearance of perspective.

In broad terms, normal angle of view and compression is somewhere equivalent to a 50mm lens on a full-frame sensor or 35mm frame. Lenses at focal lengths longer than this—85mm, 135mm, 200mm, for example—are considered telephoto and have the appearance of compressing things. Focal lengths shorter than this—35mm, 24mm, 14mm, for example—are considered wide-angle and have the appearance of expanding things within a frame, pushing the elements further apart.

What's important to remember is that professional photographers choose their lenses based on their behaviors. In the case of wildlife photographers or sports shooters, the ability of a telephoto lens to "get closer" to the action is an attractive behavior of a longer lens, but the way your lens choice affects the look of your image in other ways can't be understated.

Years ago, Kellogg did an ad for Corn Flakes, and the slogan was "Taste them again for the first time." Why not see through your lens again for the first time? Take an inventory of your lenses and learn to see through them in a different way as you ask, "What does this lens, at this focal length, do to the elements in the frame? How does this lens affect the look of my image?" The more familiar you are with your tools and the effect of each, the more readily you'll be able to draw on them as you serve your vision.

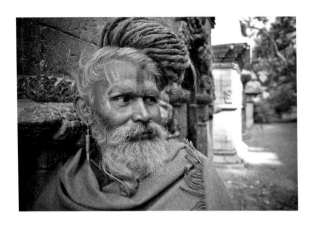

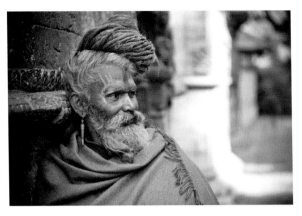

▲ Canon 5D, 32mm, 1/100 @ f/6.3, ISO 400

▲ Canon 5D, 70mm, 1/2000 @ f/2.8, ISO 800

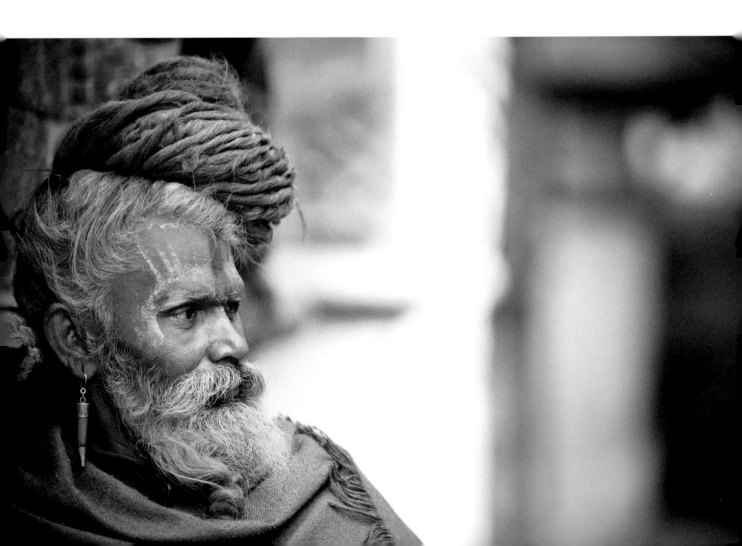

Telephoto Lenses

As noted earlier, telephoto lenses, those lenses with a focal length longer than our standard view—usually considered a 70mm lens and higher—share one characteristic: compression. Not only will a 200mm lens make the distant subject closer, it will also make everything in the frame appear closer and tighter, including the gaps in between elements within the frame. The tight angle of view characteristic of the telephoto lens isolates your subject from distractions to the sides, and the compression will pull together your foreground, midground, and background. This is neither a good thing nor a bad thing; it just is. You need to understand the effect, and know when to call it out and use it to accomplish a certain visual purpose in the making of your image.

Portrait photographers have long favored the shorter telephoto focal lengths for their compression; the subtle compression effect on the human face is often flattering. Where a wide-angle lens exaggerates the length of a nose or protruding chin, a shorter telephoto will downplay those same things. Lenses in the 85-to-135mm range have long been considered excellent portrait lenses. Anything longer begins to compress the face in ways that can be unflattering. These aren't rules, only principles. And when the principle is understood, the right tool can be chosen for the right job, as determined, not by convention, but by your vision.

Shooting on location, a longer lens can pull the elements of your visual story together, placing people tightly within their surroundings. Pulling the background signage or architecture in toward your foreground subject transforms it from a distant background distraction into an important layer of detail, even when blurred by a low depth of field. Elements need not be in focus to provide this visual texture in an image—in fact, the photograph is often much stronger when those details are implied or hinted at, rather than made blunt and obvious.

> "A longer lens can pull the elements of your visual story together."

◀ Canon 5D, 200mm, 1/2000 @ f/2.8, ISO 800

Kathmandu, Nepal. While I should have kept the aperture—and, therefore, the depth of field—constant on these images, the compression is obvious. Notice how the peaked building at the end of the row appears to move closer, and spaces between elements compress, from 32mm to 70mm to 200mm. The longer lens also produces a more flattering portrait than the portrait shot at 32mm, which produces a rather comic look.

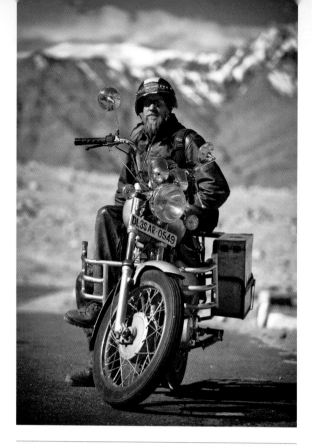

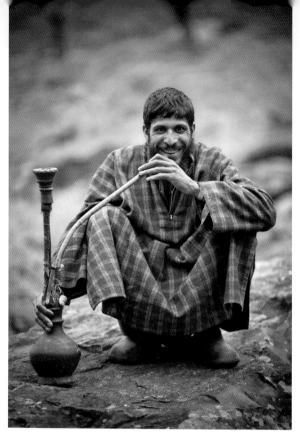

⚊ Canon 5D, 125mm, 1/3200 @ f/2.8, ISO 100

Ladakh, India. My buddy Russ on his Enfield Bullet. A wider lens just wouldn't have allowed me to bring those distant mountains as close. A longer lens would have brought them closer but not allowed me to keep the same framing or the blue sky. It's all about compromise and knowing how your available focal lengths behave.

⚊ Canon 5D, 135mm, 1/1000 @ f/2, ISO 400

Lidderwat, Kashmir, India. A couple years ago I was at a lecture with Vincent Laforet, and he said something so succinctly it stuck: "Thou shalt keep thy backgrounds clean." Longer lenses and shallow depth of field allow you to do this. In this case, it prevented the rocks, trees, and passing cattle to distract from this environmental portrait.

I've often used longer focal lengths in my assignment work with World Vision. When photographing children with their animals, a longer focal length pulls them together, creating an implied intimacy while allowing me to pull out-of-focus background elements, like banana trees or village huts, closer, which places the children in their context. Again, when the shape and color of those trees or homes are obvious but the focus blurred, it allows me to imply elements of the story rather than heavy-handedly lead the eye of viewers or bog them down with too many details, which would surely happen if I set my aperture to f/16.

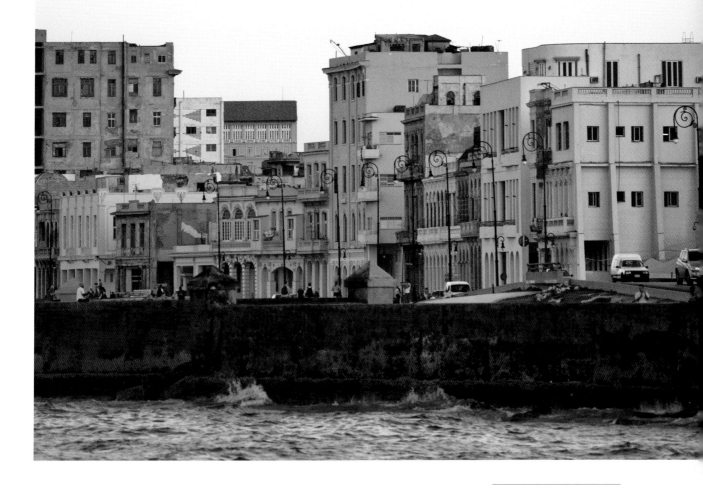

▲ Canon 5D, 200mm,
1/250 @ f/3.5, ISO 200

Havana, Cuba. The
buildings of Havana's
Malecón compressed
against each other
at sunset.

Landscapes, too, benefit from the compression effect of longer lenses. A
200mm lens allows you to compress mountain ranges or place a foreground
palm tree against a striking cloudbank at sunset. A wide-angle lens would likely
diminish the impact of these elements, and would not imply the interconnected-
ness or juxtaposition that a telephoto would. Where a wider lens can capture a
much greater angle of view, the elements within the frame are all correspond-
ingly smaller, and the impact of the image diminishes. Several frames captured
with a telephoto lens and stitched together into a panorama with Adobe Pho-
toshop can allow you to retain—even emphasize or exaggerate—that impact,
and is a good example of the importance of your vision as you consider what
role your in-camera capture and your post-production have in the creation of
each image.

Pushing the Wide

There was a time in my photographic life when wide-angle lenses had very little use. I suspect this was because it took a little more work for me to get my head around them and find a way to incorporate them into my vision-making process. For me, photography is the organization of chaos into order through the austere discipline of the frame, and while telephotos can have a tidying effect on the world visible within the frame, a wide-angle lens used indiscriminately can throw the whole world into greater chaos. It's taken a long time for me to learn to capture my vision with wide and ultra-wide lenses. Apparently, I have control issues. Telephotos are tidy, and wide-angles messy.

But the more I work with wide-angle lenses, the more my vision expands to their use. A wide-angle lens has the ability, through its apparent expansion of elements in the frame—the opposite of compression—to create sweeping lines and exaggerated relationships between elements that help tremendously in the storytelling process. Where a telephoto lens would pull elements together, a wide-angle lens does the visual opposite—helpful when the story you are telling is about distance, not intimacy, or about the difference between large elements and smaller ones. Wide-angles emphasize perspective and, for this reason, have a necessary place in the toolbox of the visual storyteller.

Where conventional wisdom has always held that wide lenses were not appropriate for portraiture, that wisdom needs to be qualified. Although many portraits would not benefit from the use of a wide-angle lens, the question "Which lens is better for a portrait?" is putting the proverbial cart before the horse. Rather, the questions should be, "What do I want my portrait to look like? What is my vision? And which lens is the best one to achieve that?" I've often used wide lenses for portrait work—with children to emphasize their size and relation to their environment, or to imply a greater sense of playfulness and wide-eyed innocence. I've used it with adults involved in a task, when pushing the wide lens in tight has allowed me a close-cropped portrait while still providing enough background to fill in the question of context for my story. An 85mm might have given me a more flattering and formal portrait of one of these Cuban gentlemen (p. 58), but the wider lens pushed in tight allows me a portrait of the men in their context. In this instance, the wide-angle lens draws the audience into the image and creates a greater feeling of being there. Now place a guitar in his hands and the wide-angle lens exaggerates the perspective of the

▶ Canon 5D, 27mm, 1/500 @ f/2.8, ISO 100

Lidderwat, Kashmir, India. Using a wide lens and pushing it in close allowed me to capture all the detail of these saddle bags and still keep the pony—and the sweeping line of his neck—in the shot.

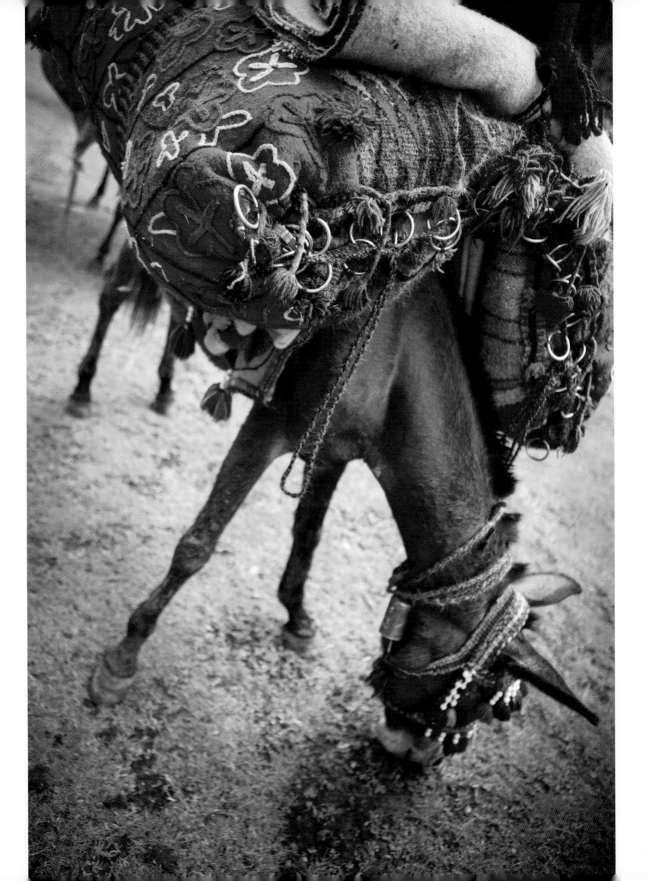

▼ Canon 5D, 17mm,
1/80 @ f/4, ISO 200

Old Havana, Cuba. Sitting
on the Prado, these
gentlemen and I had a
great time together. They
played, I shot, we all
laughed. The world was
as it should be. And then
they asked for money.
Sigh. Any time I see the
long neck of a guitar, it just
begs to be shot in close
with an ultra-wide lens.

neck, creating a more powerful diagonal line, which lends the image a greater dynamic balance. A longer lens simply wouldn't behave this way.

The key with a wide-angle lens is to pay particular attention to both your foreground and your background. Images that make the best use of a wide-angle lens are those with a strong foreground and background. Weaker images are generally those where the photographer has clearly used the lens to cram as much stuff into the frame as possible, has achieved no control or order with the elements, and has no clear subject.

The question is not, usually, how close am I to my subject—in fact, with a wide-angle lens I'm more prone to pushing in closer, and with a telephoto to stepping back. It's a question of which lens has the best effect on the image that you envision.

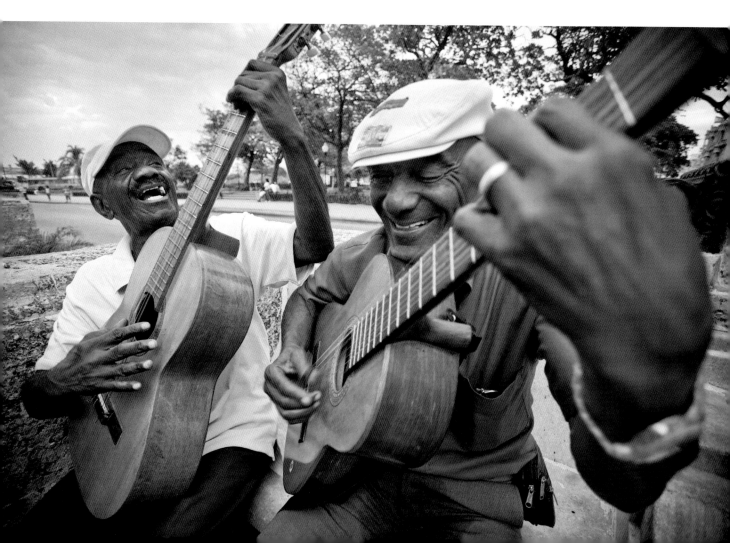

The Rule of Thirds

Like so many things, the so-called Rule of Thirds is a principle that can either be a compositional aid to achieving your vision or a rigid constraint that robs your images of life and spontaneity. It's all in the approach. Rule or principle? Rules seldom encourage the question "Why?" Principles can't live without the Why. So let's look at Why.

Imagine your viewfinder divided into three columns vertically and three rows horizontally. The principle (you see how I snuck that in there?) of thirds is a compositional principle that simply states that elements placed on the intersecting lines draw the eye of a viewer more powerfully and allow a greater balance of elements within the frame than elements placed elsewhere—exactly in the middle, for instance. It's a powerful principle based not on some art teacher's random need for control but on how we look at an image, how we perceive balance and tension. If your vision for an image is aided by sticking to the principle of thirds, then it's an appropriate rule. If not, then that rule needs to be stretched and pulled in a direction that suits your vision.

If you want an image that implies perfect symmetry, then placing key elements in the middle of the frame might be much more appropriate than placing them

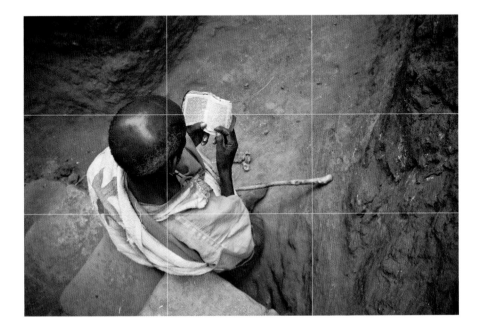

◀ Canon 20D, 21mm, 1/80 @ f/5, ISO 800

Lalibela, Ethiopia.

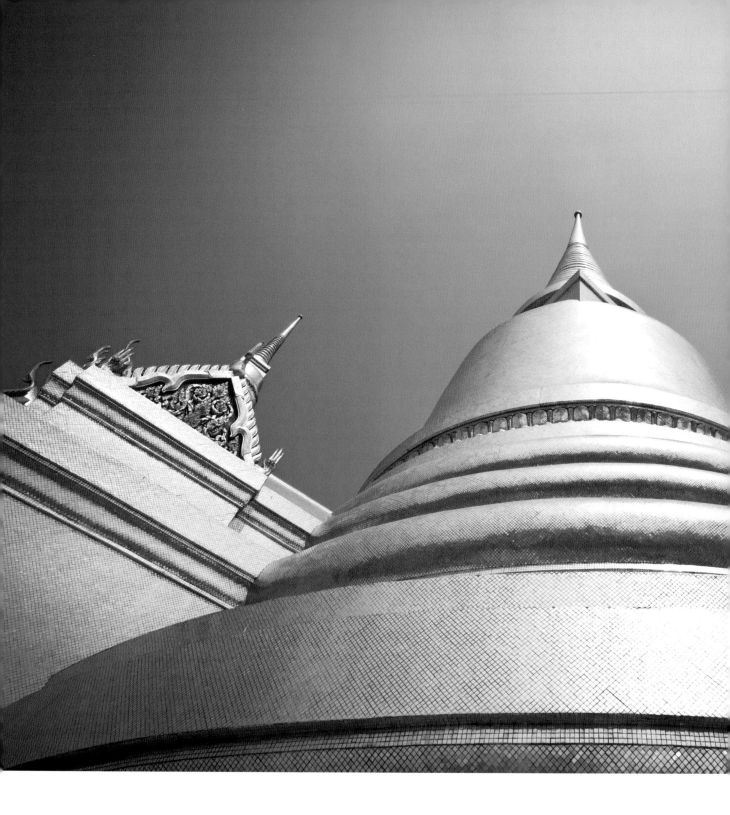

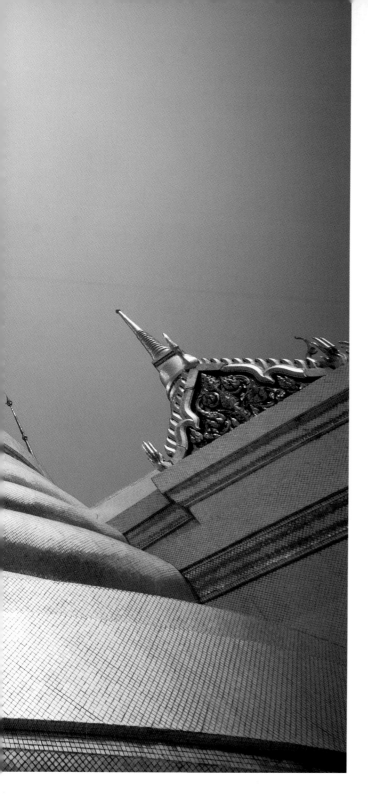

to the sides, nearer the thirds. If your vision for a photograph is one of extreme visual tension or imbalance, then your subject might be more appropriately placed in a corner of the frame—in total defiance of the principle of thirds, but in total conformity to your vision.

Placement of elements within the frame is about geometry and implied relationships, about lines and shapes. How you manipulate those, and whether you embrace the principle of thirds strictly or loosely, is determined first by your vision and then by an understanding of the way in which your chosen composition will be read by the viewer. Your vision determines your course, but without knowing how to express it—without grasping the grammar of the visual language—your vision knows what it wants to say but not how to say it. Studying composition and the way in which people read a photograph is not an option for photographers; it is a vital part of our craft. And while many photographers have an intuitive sense of composition, most will develop a deeper grasp of the visual language if they study it more. With that deeper grasp of composition comes the tools to tell our stories in more subtle, powerful, or uniquely personal ways.

By all means, master the principle of thirds, but do so for the *why* once you've nailed the *how*. Once you really grasp the why, you'll be able to break and bend the rules with abandon—and with purpose— and your images will come closer and closer to reflecting your vision.

◀ Canon 5D, 17mm, 1/1250 @ f/9, ISO 400

Bangkok, Thailand, The Grand Palace.

There Is No Un-Suck Filter

Photography has changed so much since I first took up the craft. With the advent of digital imaging and the incredible pace of its progress, we're really just making it up as we go along. And as we do, the various purists and holdouts take one position on the role of programs like Adobe Photoshop or Lightroom in the digital darkroom, and the technophiles take another. Very few of the arguments made one way or the other ever seem to touch on topics like "vision," and that's when I lose interest in them.

As discussed, three images go into a final photograph—the image you envision, the image you capture in camera, and the image you refine in post-production using software-based darkrooms like Adobe Photoshop Lightroom or Apple Aperture. The better you are at the second two, the closer the final photograph will be to the first, i.e., your vision. And the better you are at refining and communicating that vision, the stronger your photographs become.

A role exists for both the camera and the digital darkroom in the creation of a digital photograph. The camera does certain things well, and where it does those things better than the digital darkroom, it should be allowed to do that task. Where post-production does a task better than the camera, it should be allowed to do that. The right tool for the right job.

When that understanding gets inverted, photography becomes less a process about serving your vision and more an exercise in salvage techniques. So often Adobe Photoshop is turned to for the task of making a photograph less bad, and it's remarkably good at that task. Sometimes. But Photoshop doesn't have a revision filter that will make a poorly conceived and poorly executed photograph sparkle with vision. Lazy vision can't be recovered in Photoshop. There is no Un-Suck filter.

Where Photoshop shines is in refining an excellent digital negative and making it even better. When digital photographers look at post-production and the in-camera capture as partners in the act of creation, we are better able to assign them the roles they are best suited to. This is important because it changes our perspective—it assumes that we have a certain workflow—from shooting in RAW to developing, refining, and printing in post-production, and it allows us to choose the right tools for the task at hand. The digital darkroom has put the control back in our hands again, making it that much easier to serve our vision.

"A role exists for both the camera and the digital darkroom in the creation of a digital photograph."

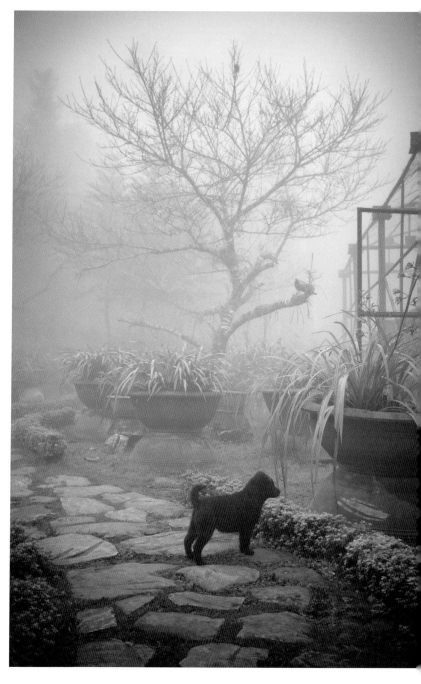

▲ Canon 5D, 40mm, 1/60 @ f/4, ISO 800

Sapa, Vietnam. This image (above) was run through Adobe Lightroom using a preset I call Bamboo to bring the mood I felt back into the image (right). But filters on lenses, darkroom techniques, and now digital manipulation are no substitute for an image that just wasn't well conceived in the first place. As Bruce Percy, a brilliant landscape photographer, once said to me, "You can't polish a turd." Wise words.

But it means a commitment to learning the basics, not so we can make our images look *less bad*, but so we can bring them into closer alignment with how we see the people, places, and cultures we photograph. Here's an example: digital cameras have weaknesses in the areas of contrast and sharpening, and allow you no control over either, though both can dramatically affect the look and feel of an image. It is for things like this (and more) that we turn to post-production tools like Photoshop or Lightroom—but it begins with getting the best capture possible.

Inspiration and Perspiration

As a photographer, you live and breathe in the creative world, but when the creative juices run dry it gets much harder to create anything, much less a good photograph. The more we understand the creative process—particularly the process of inspiration—the easier it becomes.

The ancient Greeks attributed creative inspiration to the muses. Classically, there were nine of them, and should you fall into their good graces, your creative efforts would be rewarded with brilliance. If only. How often have I been to a new city, or wandered through my own, totally uninspired, totally unable to see anything new, or anything old in a new way? Stupid recalcitrant muses.

▶ Canon 5D, 17mm, 1/160 @ f/7.1, ISO 200

Quito, Ecuador.

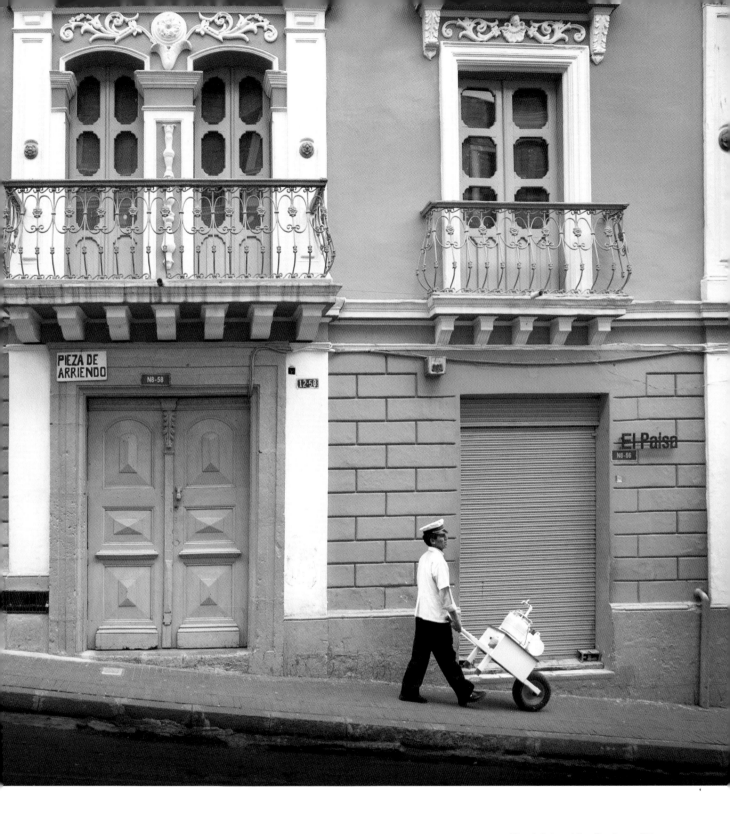

WITHOUT THE FRAME

CAIRO, EGYPT. I can't explain why, as a Christian, I feel more comfortable walking into a mosque than into most churches. Perhaps it's the casual atmosphere or the mandated hospitality, but I think it's something more. This was the third or fourth mosque in Islamic Cairo that I walked into quietly, though usually to the protests of the men who guard the shoes and want a little baksheesh on the way out (I keep my shoes and then place them elsewhere). Aside from the men at the door, the mosque was empty but for this man sitting in the perfect center of a sunbeam reading his Koran. I sat down quietly, crossed my legs, placed my camera in plain sight in front of me, and then watched. I'm fascinated by the search for the divine and enjoy tremendously the serene moments in which it often happens, and this one was beautiful. The man looked at me several times, smiled, and eventually asked where I was from. I moved closer, spoke with him to the limits of our language, and then pointed to my camera, gestured to him, and asked, "Okay?" with a questioning look. He smiled, indicated it was okay, and I spent 10 minutes shooting. I never found the angle I wanted, and looking back I wish I'd done a closer portrait, but the resulting selects perfectly capture, for me, the feeling I had in this place with this kind man. When I was done, I quietly printed him an image, did the same for the men at the door, said my ma' salaamas and moved back into the harsh sunlight and noisy chaos of the streets.

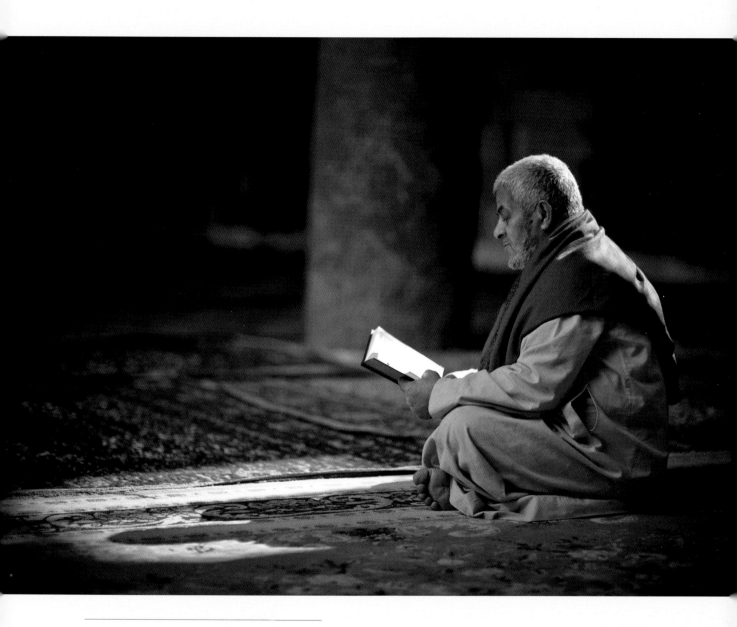

▲ Canon 5D, 85mm, 1/500 @ f/1.2, ISO 200

The creative muse is a bit of a mystery to me. Truth be known, I often fear her the same way I feared girls in the seventh grade. I worry that just as I get my hopes up, I will discover her giving more attention to someone else, leaving me with nothing to do but wander aimlessly with sad Charlie Brown music playing in my head.

I have often gone shooting without inspiration, thinking to myself, "What if I've shot my last good image? What if I can't find my muse, and all I come back with is a hard drive full of failure?" The pros do this as much as the amateurs—maybe more, because the stakes are higher. It's part of the life of an artist. Of course, it doesn't usually happen. The total failure, I mean. If you spend enough time with your muse, you come to realize a few things and begin to trust them as a constant. We fear what we do not understand, and the more you understand the process of inspiration, the more comfortable you can be with her seeming inconsistencies.

> "The more you understand what inspires you, the more readily you can put yourself in its path."

The first thing to realize is that the creative process is not so simple that it can be reduced to a formula—go here, wait for muse, shoot brilliant image. It is not a reactive process dependent on a magic fairy appearing and beating you with an inspiration stick. Creativity is something you can actively work at, and the more closely you know your own process, the more reliably the muse appears. Having said that, I think we all know that some days just do not go the way we want, and we often chalk that up to being uninspired, or bored, or lazy. Probably the latter two.

I believe that the more you understand what inspires you, the more readily you can put yourself in its path. I know what gets my creative juices going. For me, the low-hanging fruit is great light, interesting people, and exotic places where things are different than they are at home. No strip malls, no shiny retail outlets. Some people love shooting that; I do not. So putting myself in a place I connect and resonate with, getting out early in the morning and staying until late in the evening, wandering aimlessly—that inspires me. As Joe McNally would say, "Put yourself in front of more interesting stuff." Sage advice, that.

But that's the low-hanging fruit—the easy stuff. What about when you are asked to shoot something that does not inspire you? Ask yourself how you feel and

how you think about this thing about which you are so uninspired. Find an opinion; find something in there that you *are* passionate about. Maybe it's just a passion for great light, or tones, or lines—whatever it is, shoot that.

And then there's the times when your inspiration is just a general malaise, preventing you from getting out there and discovering your muse. Sometimes you have to chase it down, hunt for it. Sometimes we just need to stop making excuses and get out there and start seeing. Make a conscious effort not to see things as "a bicycle" or "a tree" but to see shapes, shadows, lines, textures, and just play until it all comes together. Creativity is about receptivity, and that doesn't happen until we let go of ourselves for a while. Nothing kills creativity, inspiration, or motivation like self-pity, self-doubt, and self-preoccupation.

▲ Canon 5D, 75mm, 1/100 @ f/2.8, ISO 800

Sapa, Vietnam. Bamboo. Fog. Perfect light. The next day the fog lifted and these stalks vanished against the distant mess of the town.

Lack of inspiration is not an excuse for bad photography or no photography; it is a reason to get up in the morning, grab a camera, and go shake the cobwebs out of your mind, your eyes, your spirit. Forget the absence of the muse. Head out without her. Wander until your eyes open; then you'll find the muse is already there, waiting.

The other way of looking at all this, Greek goddesses aside, is by considering the word "inspiration," which means "to breathe in." Sometimes, all we need to do is breathe in some fresh air. Increasing the inputs is a great way to do this. Here are some suggestions for increasing your inputs, climbing out of a creative rut, and finding inspiration as a photographer:

1. **Pick up a book.** Look at the work of one of the classic photographers, preferably someone whose style is different than your own—even someone whose work you do not care for—and take it in. Just let your eye and your mind wander. More inputs mean more raw materials for the creative side of your brain to play with.

2. **Look at your favorite images** from the last year or last month, and make a list of the similarities. Do they all share a same basic framing, basic narrative, or color palette? Were they all shot with the same lens, same lighting, the same basic settings? What you are doing here is finding a palatable way of asking, "What's the rut I have fallen into?" On its own, this is a great exercise. But taking some time to shoot the opposite is even stronger. Go shoot something you would never normally shoot in a style you would not normally shoot in. Get out of your rut. If you are shooting horizontally, shoot vertically (and *only* vertically) for a day. Creativity functions best within confines, so impose some rules. If you always shoot with that 85mm f/1.8, then slap on your 24mm and don't take it off, maybe for a week. Always shoot color? Stop. Always shoot in soft light? Go out at high noon and shoot something garish.

3. **Break a rule.** Screw the rule of thirds or the golden rectangle. Use a slow shutter speed. Stop focusing. Blow out the highlights. Point the camera in the wrong direction. Do something, anything, to silence that inner rule-monger who is so afraid you'll create an image that you can't even salvage in Photoshop with the Un-Suck filter.

4. **Give yourself an assignment.** This is most helpful when lack of inspiration strikes when you are traveling and don't have time to wait around for the muse to come back to work. Go out for a walk and shoot something specific. You might choose to work on a technique, like panning, or choose something specific to the place you are in and limit yourself to shooting that. In India this might be rickshaws; in Vietnam it might be bicycles. Or cast the net wider and shoot only aspects of faith, religion, or ritual. Shoot it like an essay, or shoot it as you please, but shoot it. Focus only on that, and as you do, one of two things will happen. You may come back with a great set of images that more deeply explores one aspect of that culture or place that you might have otherwise neglected or not seen. *Or*, you may be distracted by something really great—you'll start shooting and forget your assignment, but you'll get inspired and rediscover your vision, which was the point of the whole thing to begin with.

Other artists grieve endlessly over the means to express their vision. They shed blood, sweat, and tears in the effort to find their vision, to express it perfectly. Writers and painters are notorious for brooding over their work, driven to insanity by their search. Why should our inspiration come any easier? It's an effort. That should come as an encouragement to those for whom this "expressing your vision" stuff doesn't come easily—it means you aren't alone. It means that your lack of inspiration is not an indicator of failure or lack of talent. Expressing your vision just takes work. It is a result of flexing your creative muscles and keeping them toned by getting out there and practicing your craft in new and creative ways, of watching the new inputs and new experiences combine to form the spark of an idea or the renewal of your vision.

WITHOUT THE FRAME

HAVANA, CUBA. Sometimes my greatest motivation is not the prodding of my inspiration or muse; it's a firm kick in the ass from someone else. We'd been in Havana for four days and I was struggling to find my own vision of the place. I'd been out shooting some night shots the evening before and really enjoyed it. I was shooting images I hadn't seen before, ones that felt like the Havana I was experiencing, and I remarked about this to Henri, the friend who travels with me, watches my back, and, I'm ashamed to say, helps me haul my gear. So, when the next evening came and I was trying to decide between heading down to the National Capitol Building or just staying put and having another mojito, Henri threw down the gauntlet—probably started calling me names—and I decided to go out, shoot some junk shots, and come back for a mojito. I had this idea that shooting the Capitol at night would be pretty cool, and with the old cars parking on the boulevard I might be able to combine some long exposures and some flash photography to come up with something I liked. This is one of those rare occasions I wish I had lugged a couple more strobes and wireless remotes. But you work with what you have—not with what you don't—and this is one of the frames I like best. The gentleman in the car was gracious and patient with me as I fiddled and fussed with my tripod and strobe. I learned a long time ago that if people are giving you their time to make an image, you owe it to them to take as much time as necessary to get it right, but to do it as fast as you can. So you balance the two, work with what you've got, and cross your fingers that the pieces come together and capture what you're feeling before your model gets bored and roars off. Sometimes you don't need inspiration. You just need a friend to get your feet moving, to get you out there and shooting.

▶ Canon 5D, 17mm, 6 seconds @ f/11, 580 EX flash, ISO 200

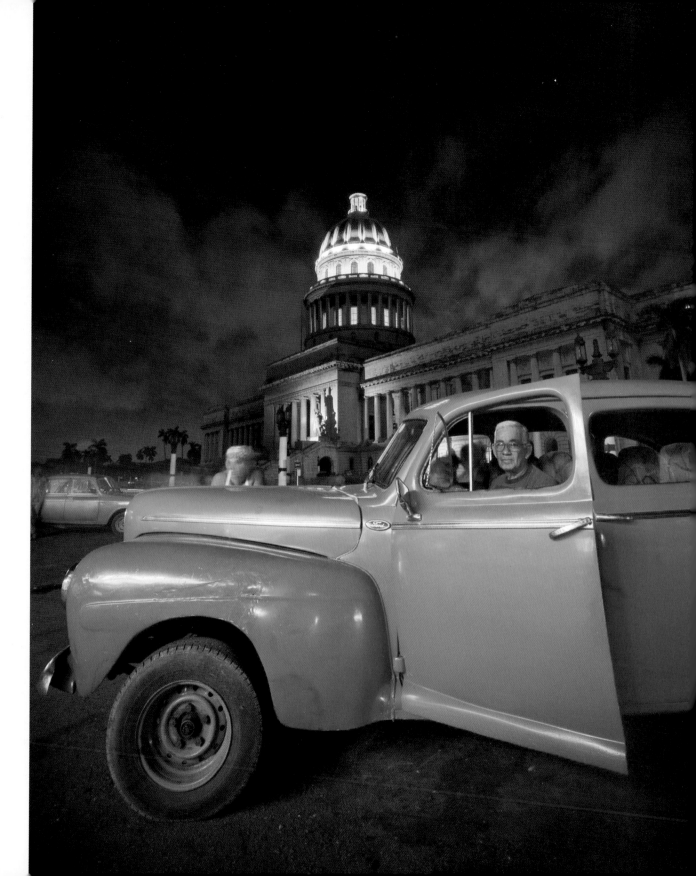

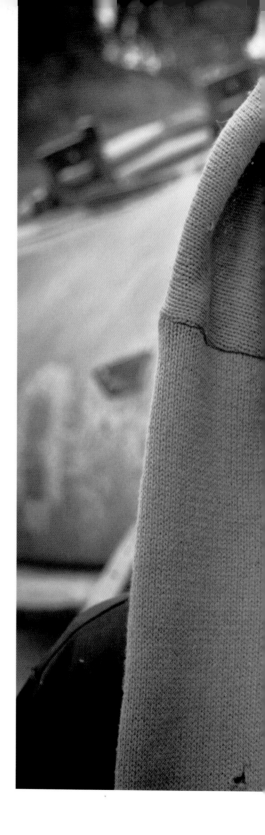

Storytelling

THROUGH THE AGES, myth and story have been the primary vehicles for communicating meaning and truth. They are not merely the stuff of bedtime tales. The primary storytelling medium in our culture is the cinematic film, and given the billions of dollars attached to the film industry—as well as the royal status of its stars—it should be clear how important story is to us. An understanding of the elements of story and how they can be incorporated into your photography will make stronger images.

▶ Canon 20D, 20mm, 1/400 @ f/4, ISO 400

Northern Ethiopia. This girl was playing on the rusted-out shell of a tank. I asked about her parents. "Father killed in war, mother died of AIDS." I heard this story over and over again. I have images of her smiling, but it's this one—capturing an unresolved look of uncertainty—that best hints at her story.

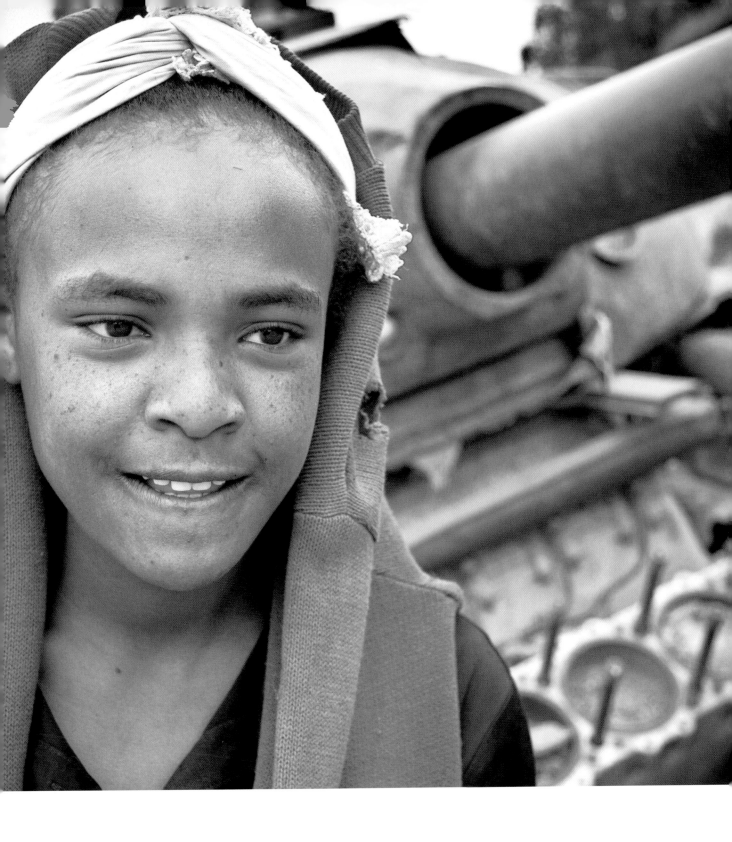

It doesn't matter what you are photographing; a sense of story will make your images more engaging and compelling.

Story told in a single frame of a photograph, and story told in a movie or novel, are very different kinds of story. One occurs over a minute period of time, perhaps 1/500th of a second, while the others are told over longer periods—hours—and reflect experiences or circumstances that span days, weeks, years, even generations. What makes it difficult to tell a story in a single frame is the inability to form a classic plotline, but this doesn't make storytelling impossible; it simply confines us to certain conventions. When those conventions are understood, they allow us to tell, or at the very least imply, more powerful stories.

When I consider the unique challenges of telling stories within the confines of a single photographic frame, two aspects of storytelling come to mind. The first is the study of themes that tie the image to our deeper, more universal human experience. The second is conflict, revealed in the frame by contrasts. With regard to technique, the photo essay is the time-honored means by which photographers have told longer stories, and composition the means within our single or multiframe stories to move the plot forward.

Universal Themes

A story succeeds or fails on empathy, or lack of it. If you don't care, it's not a relevant story. Understanding themes offers a quick way toward understanding how to tell a story about which people will care deeply.

Ask a friend what the last film they saw was about, and the usual answer will be a recap of the plotline. Character X did this, and then this happened, and to get out of it he did this and this, etc. That's plot. But a plotline doesn't describe what a movie is *about*. The plotline is a story of, for example, a boy and girl, but the story is *about* something more. Perhaps it was about revenge or love or the search for meaning—the deeper theme that moves the film from beginning to end. Remember the earlier discussion about subject versus subject matter? Same thing. The theme is what the movie—or photograph—is about; it's the subject. The plot is the way in which it's told, or the way the photograph is composed and shot.

▶ Canon 5D, 17mm, 1/125 @ f/9, ISO 800

Varanasi, India. As the sun rises over the River Ganges, this man does his daily devotion—an act that's been continued by millions of people over thousands of years. His search for absolution and meaning is one of the deepest themes of human existence, and it resonates across lines of gender, race, and creed.

If photographs are to tell or imply a story, they must be *about* something. Truth, justice, love, or the lack of these things, or the search for those things, are strong universal themes. Loneliness, betrayal, our tendency to self-destruct, death, resurrection, the bond of family—all of these are strong themes. And the more universal a theme you echo in your image, the more powerful it will be and the broader the audience. If you're thinking that this is a little too deep for your style of photography, what about themes like harmony, balance, or beauty? What about the old versus the young or new, or the past versus the present?

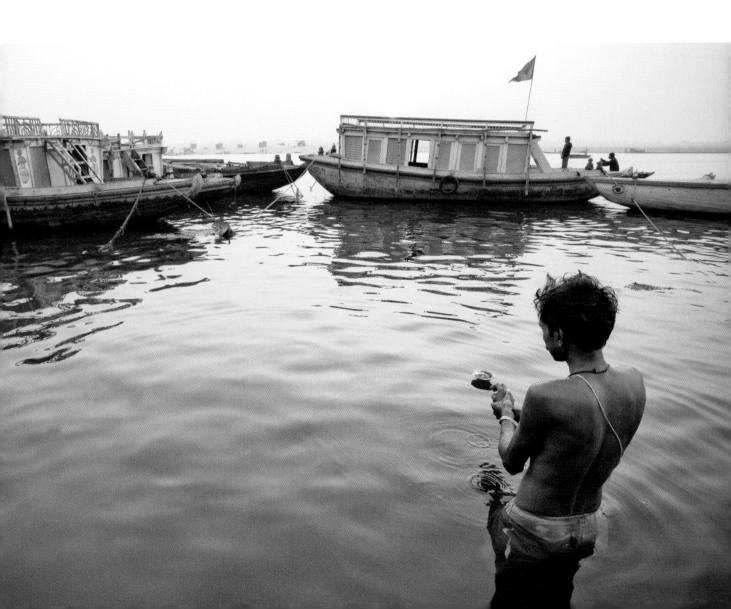

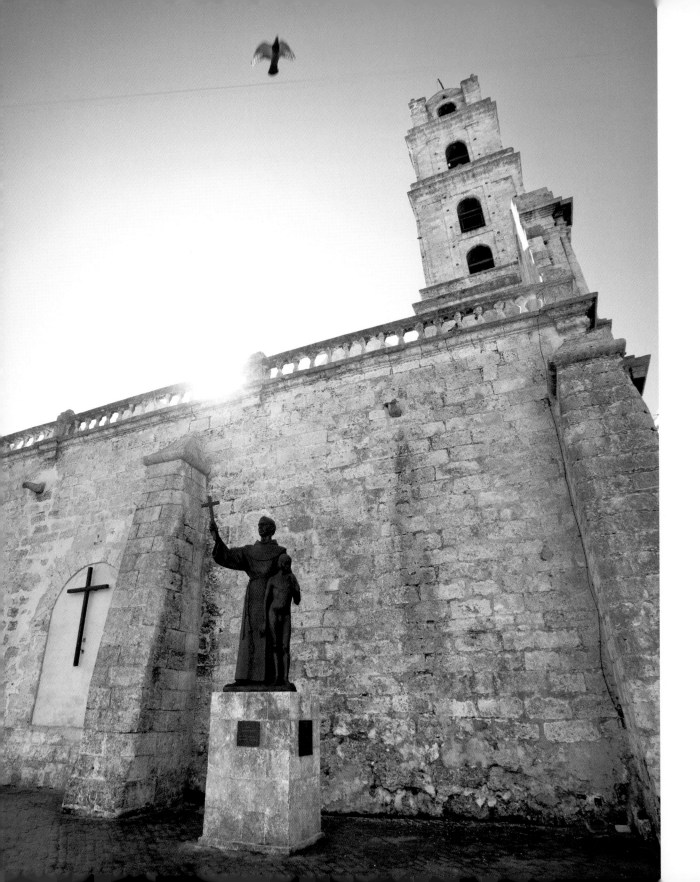

Make your images *about* something. It doesn't have to reflect deep brooding themes. It can be a photograph of an orchid that's about serenity or the wonder of the natural world. It can be about innocence or the simple power of a line. An image of a crocus breaking through the crust of snow and ice can resonate with themes of resurrection and new life. Portrait photographers: make your image about the person you are shooting, reveal the character underneath, and say something about them. Whatever you're photographing, make it *about* something, so the people who see your image feel something, so they care about your image.

This can't be overstated: the more powerful and universal the theme in your image, the more powerful and universal the impact of the image. To put it another way: the more deeply they care, the stronger the story.

I realize that not everyone feels the need to harness their inner George Lucas. Most of us just want to make photographs. I get that. But if our photographs echo something deeper, they will appeal to a greater number of people. Take, for example, a photograph of a child looking very camera-aware and with a neutral expression, wearing traditional clothing—this photograph may tell you something about the child and the culture in which she lives, and that will have some appeal, but it won't be universal. But when that child laughs, she immediately displays a positive emotion that is understood and shared universally, and the photograph is imbued with that universal appeal. Take the example of a Nepalese man—his portrait has general appeal, but when you photograph him praying your image is no longer about the man but about the search for forgiveness or connection with God, a powerful theme that gives your image universal appeal.

> "The more powerful and universal the theme in your image, the more powerful and universal the impact of the image. To put it another way: the more deeply they care, the stronger the story."

◁ Canon 5D, 17mm, 1/250 @ f/7.1, ISO 100

Havana, Cuba. A pigeon flies over the St. Francis of Assisi convent in Havana. A dove occupies a strong place in Christian symbolism, as does the cross, and even St. Francis himself. But on a more universal level, a dove alighting over a sacred place—in this case directly toward the top of the frame—is rich in symbolism and meaning, and therefore has greater universal appeal than if this were a flamingo flying over a hamburger joint (though that's an image I'd very much like to see for other reasons entirely).

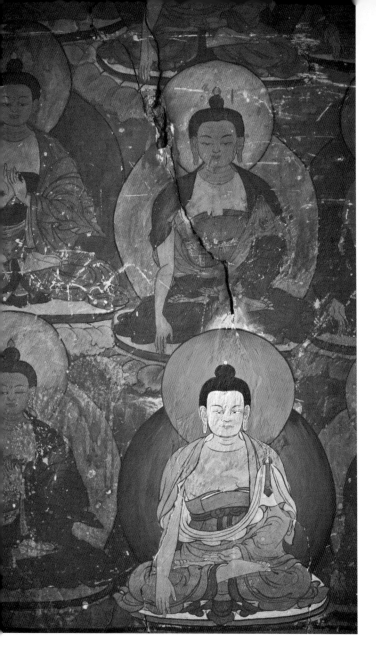

Chemray Gompa, Ladakh, India. The contrasts in this image are what drive it forward and give it a sense of story. The contrast between the old and the new, the past and the present, anchors this image conceptually, even as the contrast between bright and faded, colorful and muted, anchors it visually. The crack provides the clue to the story.

Conflict Within the Frame

Harken back, if you will, to grade 12 English Literature class. Remember the teacher droning on and on about Man versus Man, Man versus Nature, and Man versus Himself while you dreamed about the cute foreign exchange student who would later go on to break your heart and date your best friend, leaving you to wander aimlessly into the wilderness and struggle for your survival while battling your inner demons? You do? Well, that's a great story and it contains some great conflict. In fact, it contains man-against-man, man-against-nature, *and* man-against-himself types of conflict. You had no idea at the time that you would become a classic cautionary tale, did you?

Going back to the droning Lit teacher, conflict is the heart of all story. Without it, there is no story. For a photograph to contain or imply a sense of story, it must have conflict.

But how do we bring conflict to play in a frame? Obviously, we can photograph moments of actual open conflict—guns and fists and angry gestures. But what about stories that are not about open conflict? What about stories that are about something else but still need conflict to move it forward?

Conflict in a still photograph is most often shown in contrasts. Not just the visual contrast of dark tones to lighter ones, but the more conceptual contrasts of big/small, mechanical/natural, smooth/textured. Any pair of juxtaposed or implied opposites creates what I call "conceptual contrasts" that imply conflict.

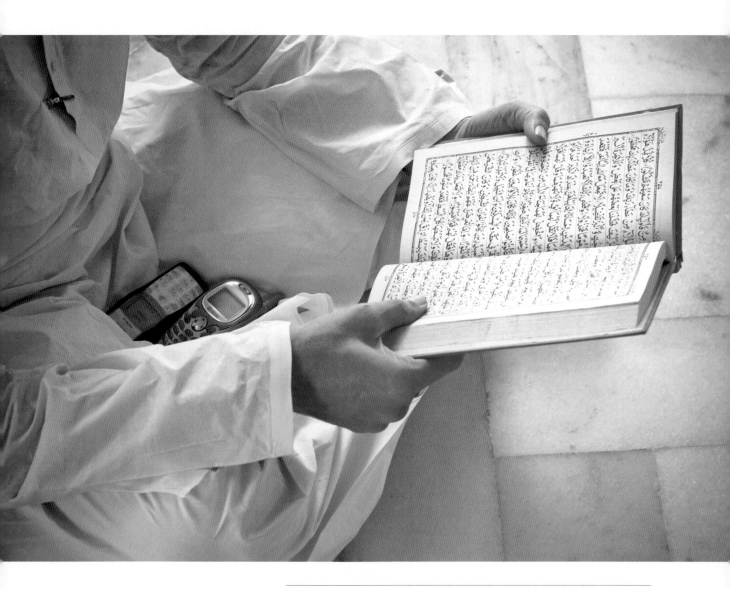

▲ Canon 5D, 85mm, 1/100 @ f/8, ISO 400

Delhi, India. A man sits reading the Koran at Nizamuddin shrine in Delhi. The contrast between the Koran and the cell phones—the ancient and the modern, communication with God and communication with man—provides the conceptual contrasts in this image.

Here's a great way to begin seeing conceptual contrasts.

Exercise 1: Go out and shoot a series of images that contrast with one another. The first might be of a big subject, the second of a small one. The next set might be hard versus soft, the one after that might be land versus water. You're looking for photographs that contain contrasting subjects. Other than that, there are no rules. Come up with your own contrasts.

Exercise 2: Combine these pairs of opposing contrasts into one image. Instead of two images—one wet, one dry—you're aiming for one image combining both wet and dry. One image with both young and old, one with both few and many, and so on.

Exercise 3: Look at other photographs and seek out the contrasts. Not all of them will be obvious. And I'm sure there will be plenty where the contrasts are not conceptual at all, and only appear in terms of contrast of tone or lines, but they too can imply a sense of conflict and imbue an image with a sense of story.

"Conflict in a still photograph is most often shown in contrasts."

This concept applies to all kinds of images. Even a sunset shot contains elements of conceptual contrast—sky versus earth, sun versus water, light versus dark. Strongly opposed or contrasting elements create a compelling sense of conflict, which is the heartbeat of the story.

The Photo Essay

The challenge of capturing or implying a story with photography is made easier when you can photograph it in a longer form—in several frames that tell the story in more detail and more breadth than a single image alone could do. Enter the photo essay, the traditional means by which photographers have told longer stories.

There's a visual language at work here, a convention that's evolved to help us string our story together and give our audience the tools to interpret it. Used well, a photo essay is a powerful means of expressing your vision. And as

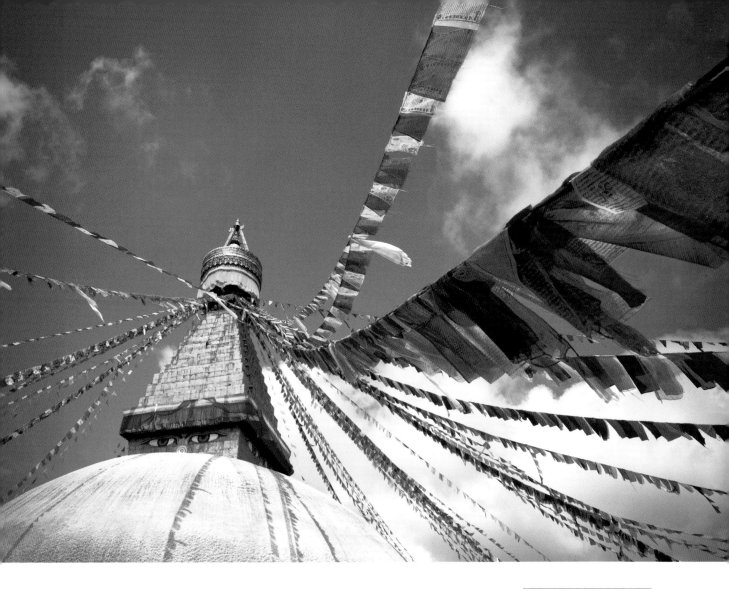

▲ Canon 5D, 27mm,
1/640 @ f/11, ISO 400

The stupa at Boudhanath, surrounded on all sides with prayer flags, is the hub of the Tibetan community in exile in Nepal. This wider shot establishes the scene and is the broader context for the following images.

electronic media becomes increasingly prominent, the photo essay is getting more powerful with the addition of ambient sound, interviews, video clips, and music in the form of multimedia slideshows.

Long-form photo essays generally share the same types of images, and while this is by no means a formula, it provides a framework—a starting point built on established conventions. Here are the usual suspects, accompanied with images from the stupa at Boudhanath in Kathmandu.

▲ Canon 5D, 85mm, 1/50 @ f/5.6, ISO 100

In the inner circle of the stupa, devotees and monks pray, read, and meditate. A medium shot like this brings the action in a little and provides you with a more intimate look into the details of the story. In this case, the robe, the empty shoes, and the sacred text all point toward Buddhism, the faith associated with this place.

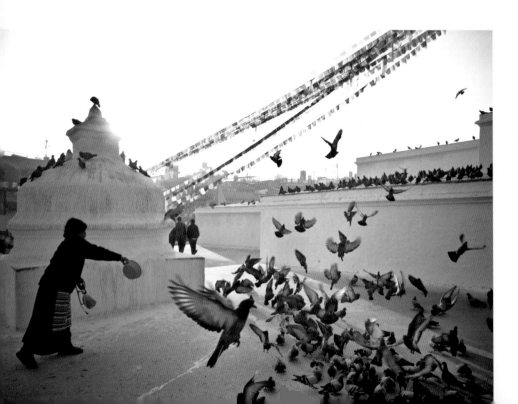

◀ Canon 5D, 27mm, 1/500 @ f/4, ISO 100

A woman feeds the pigeons and sends them fluttering. Not critical to the story, the pigeons remain an important part of my experience at Boudha—always present, always filling the air with sounds of nervous flocks scattering.

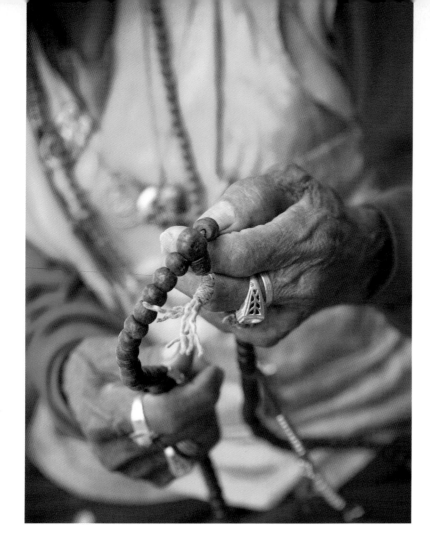

This monk very patiently allowed me to photograph him, both his portrait and his hands. When I edited the sequence of him it was his hands, and the subtle out-of-focus details that constitute the background of this image, that contributed to the story more than his face. The beads, talismans, and worn hands tell more than his otherwise stoic face.

The Establishing Shot: This is the wide shot. These images generally say, "This is where the story is going to take place." It establishes context, setting, and often mood.

The Medium Shot: Images that get closer to the action, these shots generally say, "This is what the story is about, this is who the characters are." Not all photo essays are about people; the characters in your story could be horses, or weather, or boats, for example.

The Detail Shot: A closer, tighter image of details relevant to the story. In the case of a photo essay about horses, it might be the detail of a horse's saddle. In the case of an essay about weather, it might be an old barometer or a car damaged by hail.

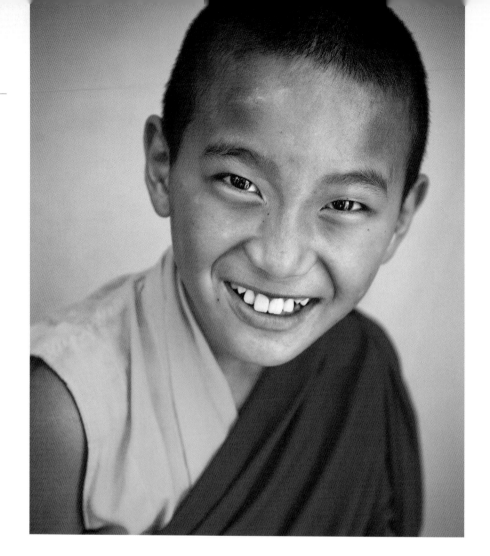

▶ Canon 5D, 57mm, 1/400 @ f/4, ISO 400

A young acolyte, friendly and curious, happily poses for my camera. Of the many portraits I took, this one felt among the most universal—he's a Buddhist monk, but also a child, unguarded and full of curiosity. The portrait brings to an essay its intimacy and connection to the viewer.

The Portrait: A tighter portrait or headshot—often an environmental portrait.

The Moment: A photograph that captures a gesture, an exchange, or the peak of the action. This is the "wow" shot.

The Closer: This one wraps it up, provides some resolution, or just provides a natural place to put the story to bed.

While not every photo essay will have each of these kinds of images, they will have most of them, and certainly they will have the first three. *National Geographic* has made an industry of perfecting the photo essay and is an excellent place to look for inspiration—not only in the quality of the images, but in the kinds of images they choose to tell the story.

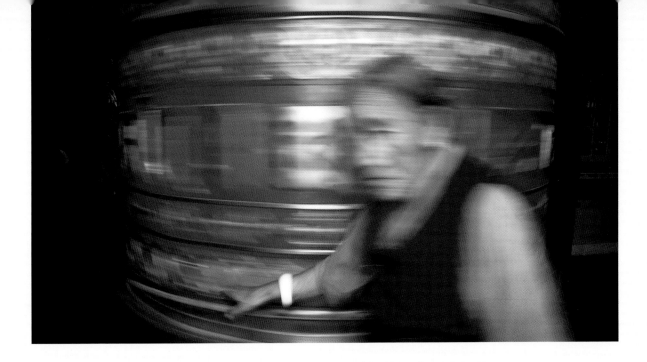

▲ Canon 5D, 25mm, 1/10 @ f/16, ISO 400

The blur of a devotee and the spinning prayer wheel around which she walks implies an unceasing motion. This wheel, and others like it around the Boudhanath stupa, is in motion day in and day out.

▼ Canon 5D, 21mm, 1/500 @ f/8, ISO 400

A man prays as the sun rises over Boudhanath. It might just as easily be sunset. This image could serve as my Moment shot as well, but there's enough resolution and mood in it that it makes a good Closer.

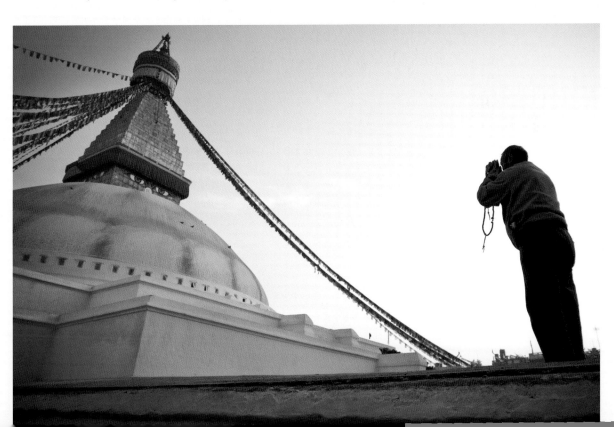

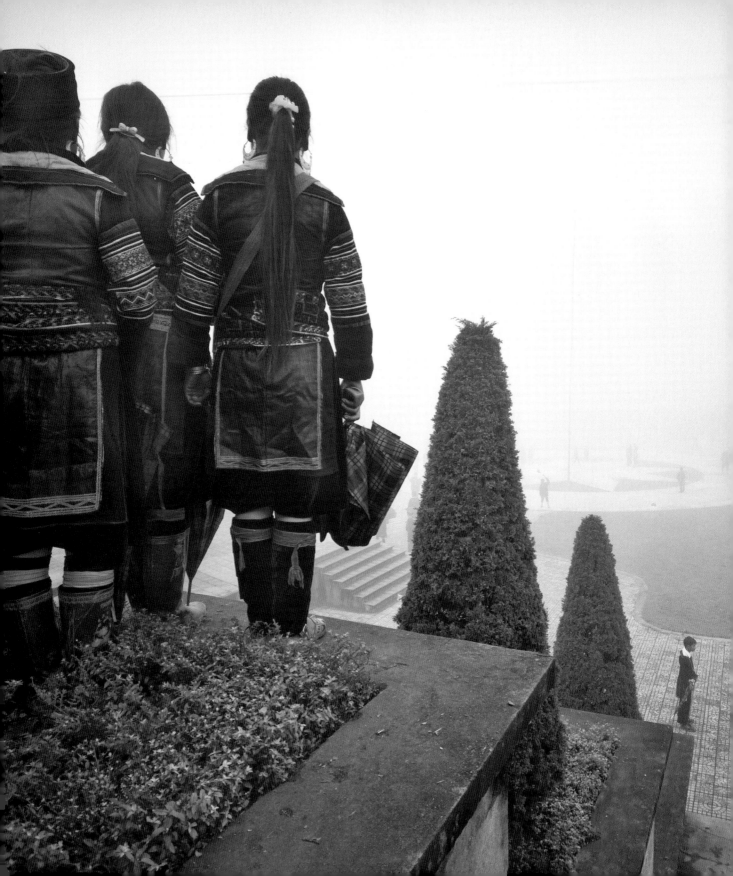

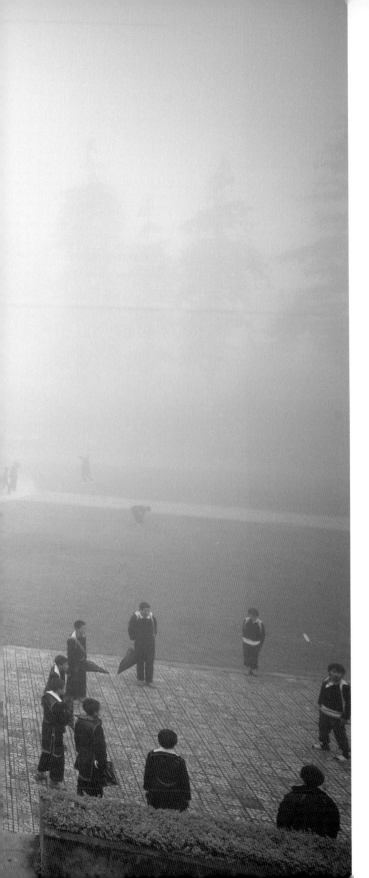

Relationships

How the elements within the frame relate to one another says something about the relationships between them. One object larger than another might imply a relationship of power. The space between two elements or characters within the frame tells something about their connectedness. Objects separated by greater perceived space implies a relationship of distance or alienation, where objects much closer together might imply a relationship of intimacy. While you often can't physically move the objects around, the laws of perspective allow you to do it simply by changing the position from which you make the photograph. By moving to the left or right, or pivoting around your subject matter, you can often create greater or less distance between those elements. Move one way and you bring them together visually; move the other way and you separate them. By so doing, you are choosing to tell this story more directly and with less ambiguity.

◀ Canon 5D, 17mm, 1/160 @ f/8, ISO 400

Sapa, Vietnam. Hmong girls watch schoolboys playing New Year's games. Their obvious distance and clear separation implies differences in gender roles and says certain things about the relationships between males and females in this patriarchal society.

The same is true of vertical relationships—moving your point of view higher can diminish the appearance of height differences and thereby bring an equalizing effect between elements.

Your choice of lens has a significant role in establishing visual relationships. I discussed this in Chapter 3, but it's worth a reminder: the effect of compression that various lenses create can help you tell your story by altering the perception of distances between elements.

Separate from the relationship between objects in the frame, your point of view, or chosen camera angle, has an effect on the implied relationship between the viewer or photographer and the subjects. Looking down on a man sitting at street level can imply a position of power over him—as though you were physically, and symbolically, looking down on him. Making the image from street level implies greater equality and creates a more sympathetic image. One communicates condescension or pity; the other communicates respect, kindness, or empathy. Photographing a statue, you might choose your angle based on how you feel about the statue itself. If you're shooting a statue of a man you feel great respect for, you might choose to shoot from a lower angle, making the statue loom larger, creating the perception of power and grandeur.

Attention Management

Stage magicians and sleight-of-hand artists have something in common with photographers: both deal in perception and use visual clues to lead the audience to certain ends. In the case of the magician, that end might be a sense of wonder created by illusion. In the case of the photographer, it might be an emotion or thought created by the content of an image and the way that image was composed. Either way, both depend on directing the eye of the audience, and the best of them do it without the audience feeling led, manipulated, or aware of the device.

To make full use of this, we first need to understand what people look at. Returning to the magician for a moment, he understands that people see large movements before small movements. So a larger movement on stage might direct attention away from the smaller movement of secreting an object or

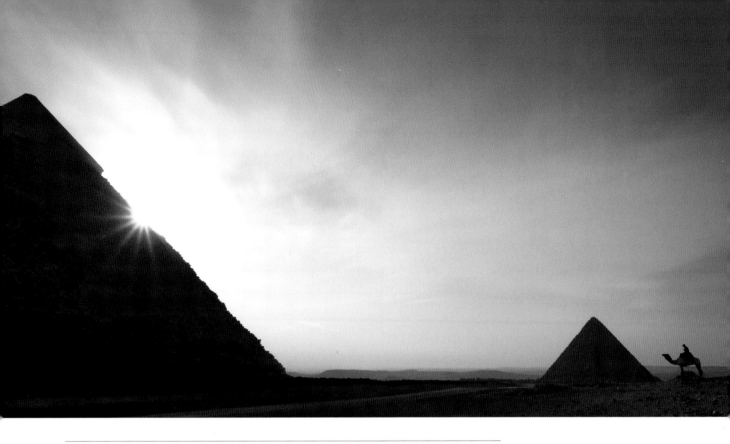

▲ Canon 5D, 20mm, 1/125 @ f/22, ISO 200

The strong, implied line created by the progression from left to right of large elements to small elements guides the eye along the primary diagonal of the image—from left to right, top to bottom—straight to the man on the camel. The fact that the image is predominantly cool, while the man and his camel are sitting on a patch of warm sand, also pulls the eyes. Finally, a human element always has greater visual mass than big piles of rock. All this adds up to create an image with built-in attention management.

pulling a hidden object from its hiding place. It's often called "misdirection," but calling it so is a misnomer that implies something has gone wrong. "Redirection" and perhaps "attention management" would be better terms. The magician studies human behavior and—knowing that we are generally predisposed to look at big movements before small ones, or to relax our attention when we laugh—uses that to his advantage. So it is with photographers.

"What is the eye drawn to, and how can that be used to more intentionally direct the eye through the frame?"

So what do we look at? What is the eye drawn to, and how can that be used to more intentionally direct the eye through the frame? Generally, we notice areas of light before areas of dark, and large elements before smaller one. We look to warm colors before the cooler ones. Here's a short list of elements that draw our eye:

- Large elements before small elements
- Light elements before dark elements
- Warm colors before cool colors
- Focused elements before blurred elements
- Elements in perspective before flat elements
- Isolated elements before cluttered elements
- High contrast before low contrast
- Oblique lines before straight lines
- Recognizable elements before ambiguous elements
- Human/alive elements before inanimate elements

Once we become aware of how the viewer's attention will behave, it's much easier to gently push and pull the eye around the frame—to say, without a word, "Look here," or, "This is less important." Important elements might be lighter, larger, warmer, or sharper than less important elements. Elements that have no relevance at all should probably be cropped right out as you shoot, but hierarchies of importance exist in a visual story, and less important elements are still necessary. Think of it in terms of primary elements and secondary elements.

The photograph of the running monk (primary element) has the Thiksey Monastery as its background (secondary element); the visual clues provided by the architecture and color of the monastery building are important so you don't want to crop them out, but the man is *more* important. The fact that the young man is wearing a more saturated, warmer color than his surroundings immediately helps set him apart from the cooler tones of the stone, and draws the eye naturally toward the intended center of interest first. Similarly, the panning renders the background less sharp than the monk, and the monk in turn is less sharp than the kettle, giving us different levels of visual mass and a natural

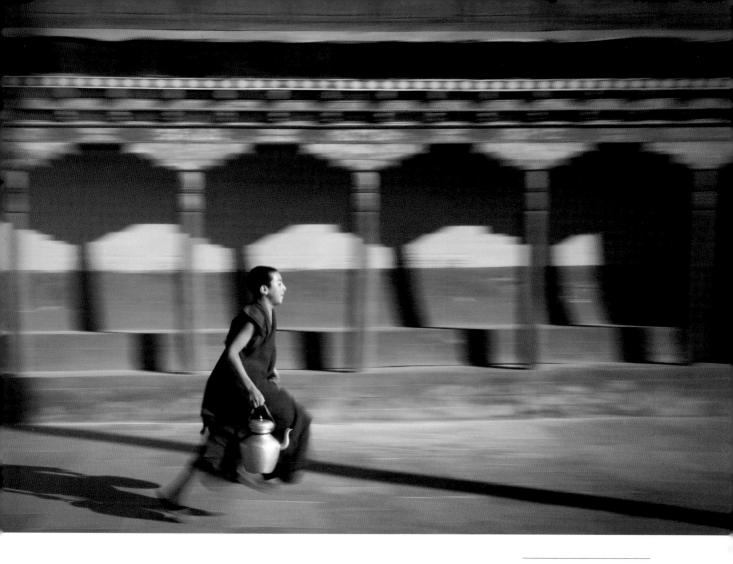

▲ Canon 5D, 33mm,
1/30 @ f/22, ISO 100

**Thiksey Monastery,
Ladakh, India.**

progression for the eye to follow. The eye moves from monk to kettle to background, but always returns to the monk because he holds greater visual interest for us. The photograph is about the man and his kettle—so he needs to be clearly identifiable as the primary element—but part of telling a story about this particular man is his context.

Some of this might be refined in post-production as well, with the digital equivalent of dodging and burning—making areas of primary importance lighter and areas of secondary importance darker. Subtly vignetting an image by darkening the corners can lead the viewer's eye to the center and keep it from drifting into the corners. Slightly desaturating or blurring secondary elements can have a similar effect, reducing their visual mass and lessening their pull on the eye.

This is not the only means by which we can lead the eye. There are others—pointing, for example. For the magician, the simple nonverbal gesture of pointing, or even looking at something, makes the audience look there, too. In the photograph, this might be the eye line of someone in the image, creating an implied line in the direction of their gaze that leads your viewer to look that way, too. It might be leading lines in the images that converge in one direction, also pulling the eye there. Strong diagonal lines in a frame already pull the eye and, with a little foresight while shooting, can be used to pull the eye in the direction you want it to go. Changing your shooting position only a little might result in straight lines becoming oblique, making your image more dynamic and, again, providing subtle but important attention management tools for you to more intentionally guide the eye of your viewers.

Leaving Clues and Provoking Questions

A great storyteller doesn't tell absolutely everything. She tells enough to make you care, to tell the story and move the plot, and no more. Extraneous details don't provide anything more than confusion. In fact, more than just cluttering the story, a flood of details kills the mystery and the engagement. A good story has a sense of wonder, it raises curiosity, and it leaves something untold for us to gnaw on. Perhaps it's a glance out of frame; we're familiar with the look of affection a woman has on her face, but who is she looking at? A face moves into silhouette as you press the shutter, and suddenly a photo of a specific woman is a photo of a woman around whom there is some mystery.

What you leave in the frame must be part of the story, must be part of the visual plot, even if that's simply establishing the setting. Be very selective. Leaving a cluttered background by shooting wide and indiscriminately does not establish setting; it's lazy photography. The more elements there are within the frame, the less power each of them has, and your story becomes diluted.

Leave enough clues to tell the story, and exclude enough to create a sense of mystery. Unanswered questions engage a viewer and create an interaction between the image and the viewer—a deeper level of viewing that allows us to think and feel more connected to the story. Similarly, placing details in the image that are discovered only after looking at it for a while can contribute to a feeling of surprise, even the feeling of being let in on something. It gives the image an extra layer, engaging the viewer longer or more often.

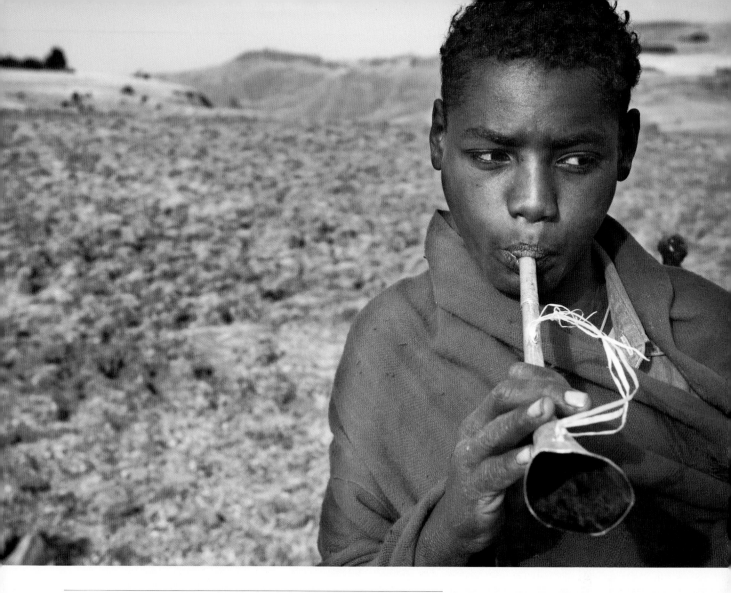

▲ Canon 20D, 32mm, 1/1600 @ f/5.6, ISO 400

Ethiopia. I've always loved this one. I was standing outside the Land Cruiser, taking a needed bathroom break, when this shepherd and his goats appeared out of nowhere. The ambiguity and unanswered questions about what this young man is looking at are what I like most about the image. The fact that he's looking out of frame and leaves little nose room (the space between the nose and the edge of the frame) breaks a general rule that says you should point the gaze of a subject into the frame and not outward. Somewhere inside me there's a maverick who likes breaking rules. I run with scissors, too.

Photographing People

I AM DRAWN TO EXPRESSIONS of human hunger for the divine, for absolution and connection. Walking up and down the Ganges at Varanasi, India, a couple years ago, I spent the bulk of my time photographing the river-deep rituals that represented this, and the last time I was in Kathmandu I just never got around to shooting the religious life of the city in an intentional way. On my most

▶ Canon Digital Rebel, 50mm, 1/80 @ f/6.3, ISO 400

Harar, Ethiopia. This young Muslim girl was on her way to school, cutting through the market, when she stopped to watch me shooting. I shot a few frames, and she never once broke eye contact. Then she smiled and ran off. I love my job.

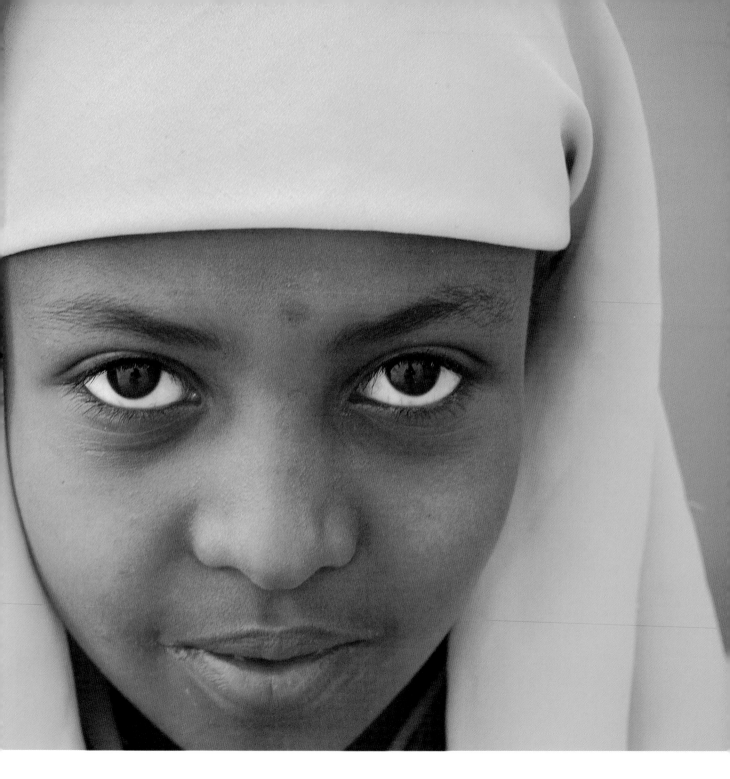

recent trip to Kathmandu, I went specifically to photograph the expressions of faith of Tibetan Buddhists in exile in the small community of Boudha. In particular, I was looking to photograph the people, both in wider street scenes and through intimate portraiture. Nepalis are pretty relaxed people—and the Buddhists even more so. Still, the thought of the week that I would spend photographing people made me a little nervous.

Photographing people is one of the joys and terrors of what I do. In part, I enjoy it in the same way one enjoys skydiving—the relief one feels in the wake of overcoming a fear can be addictive—and approaching total strangers will never be natural or easy for me. I also enjoy it because few things satisfy my muse more than creating a portrait that is truly good—when a moment has occurred, the camera has not been an obstacle, and I've seen a person's soul through my lens.

> "Photographing people is one of the joys and terrors of what I do."

Approaching People

This just never gets easy. This morning, I wander down to the Boudha stupa before dawn. I've photographed here twice before, and I love the rhythm of life and the serenity. At the center of the large round courtyard is the Boudhanath stupa. It is surrounded by shops selling mandalas and beads, tea and postcards, and all the usual tourist kitsch. Pilgrims and tourists mingle with the monks from the monasteries, and each walked rotation of the stupa presents an observant eye with new opportunities. At dawn and dusk, the stupa is circled with butter candles. I'm not sure why I've never intentionally shot images in this beautiful light, but this morning I aim to correct that.

I walk and observe, watching for something that quickens my eye and my heart. I take a wide shot, then go closer. There is always a moment when I can feel I've crossed a line. On one side of that line, a photograph is just a person in a public place; on the other side, it all changes and becomes a personal exchange.

▶ Canon 5D, 40mm, 1/25 @ f/4, ISO 800

Jodhpur, India. This man appeared out of nowhere. One moment I was shooting, the next this odd little man was greeting me. And greeting me. And still greeting me. So I took his photograph and that made him as happy as can be. He stopped greeting me and went on his way. Ten minutes later I was abducted by a gang of street kids and forced to play cricket with them. Who could not love this?

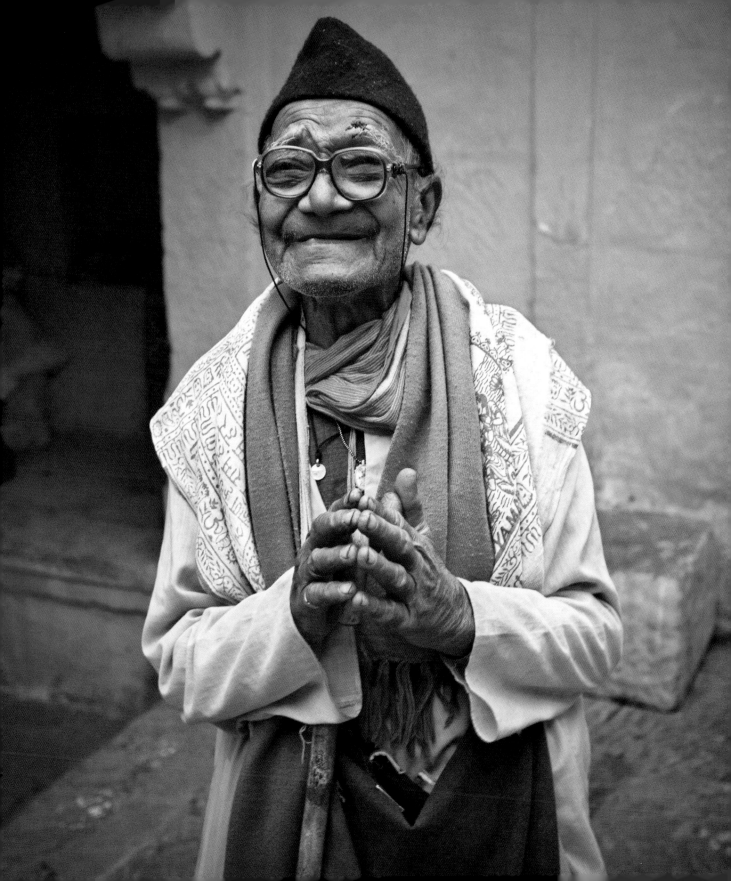

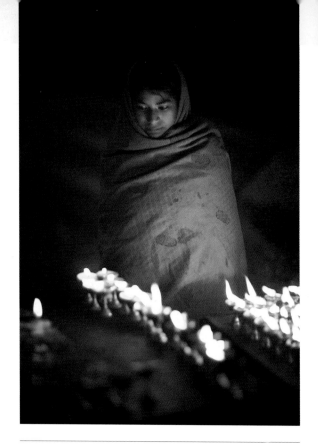

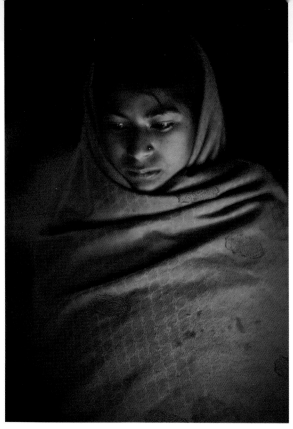

▲ Canon 5D, 85mm, 1/125 @ f/1.2, ISO 400

▲ Canon 5D, 85mm, 1/100 @ f/1.2, ISO 400

"The people we photograph are not props, and they are not theme-park mascots there for our purposes."

There are no rules, no formulas, no guarantee that you will get permission to make this portrait, much less have the time to do it justice. Even then, if you can't connect and create an exchange in which, to quote Steve McCurry, "the soul drifts up into view," the photograph will fail.

Approaching people for an intimate portrait takes practiced confidence. The more you try, the less you fear people will say no, and the more courage you gain to move on. Some places are desperately difficult. I found Tunisia to be very difficult, and in the end, after a constant stream of refusals and nasty looks, I changed my approach and concentrated more on street scenes and candid interactions. Some places, like Kathmandu or India, are much easier. Either way, the approach is similar, and it begins and ends with respect and kindness.

In Bangkok, I witnessed a young western tourist with a camera bossing Buddhist monks around the Grand Palace, telling them to stand here and there,

place their hands in this and that position without once speaking to them politely or even asking them. It was assumed that they'd be happy to do whatever the tourist directed, when in fact they were likely too polite to say no. These young monks were tourists, and I felt deeply embarrassed for them. The people we photograph are not props, and they are not theme-park mascots there for our purposes. Once we're in a relationship with someone, and that person has willingly consented to being part of our process, then we have the freedom to collaborate with that person to create the best photograph—but at no point must they ever become mere props in our images.

I am keenly aware that the person I am approaching has every right to say no, to tell me to shove off. If I were sitting at a coffee shop at home and a tourist asked for my photograph I'd tire of it very quickly, and it's possible many of your potential subjects have had this happen one too many times. Going into this exchange with humility and free of any feelings of entitlement is a good place to start. When someone has a chance to say no, it allows them the freedom to say yes, to make this photograph a gift to you. And when this happens, the resulting photograph is a more genuine expression of that person and the time, however brief, you spent together.

There's no magic technique here. I can't make this easier for you. Approach slowly, assess the situation, and respond in the best way you can. Sometimes it's a smile and a handshake. Sometimes it's just a quiet approach, a gesture with the eyes and the camera. If you know how to say, "May I take your photograph?" in the local language, give it a try. If they've seen you shoot the wide shot and

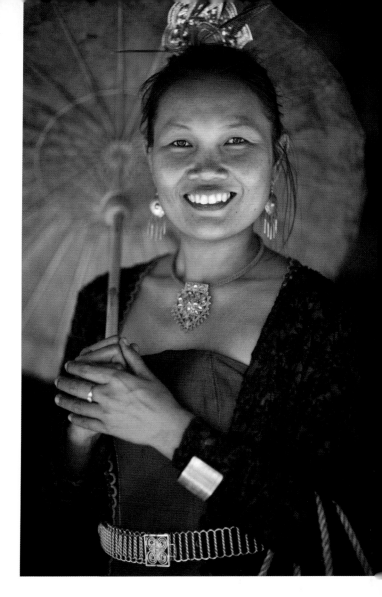

▲ Canon 5D, 85mm, 1/1000 @ f/1.2, ISO 100

Bangkok, Thailand. The Grand Palace. This woman walked past me and caught my eye immediately. I was shooting with photographer Gavin Gough and said to him, "I would love to photograph that woman." Gavin spun on his heels, walked up to the woman, and said, "Excuse me, my friend would like to take some photographs of you, would that be okay?" We spent 15 minutes talking to her and then took photographs for five minutes. Had I been alone, I'd have just as likely spent that 20 minutes wishing I'd taken her photograph. There is no substitute for walking up and asking. These photographs aren't going to take themselves.

haven't hurried off, they know what you're up to, and *what* you communicate is far more valuable than specifically *how* you communicate it. I think kindness, respect, and humility are easily communicated without words and are impossible to fake. The key is trust, and this is built in so many ways, not the least of which is being genuinely kind, interested in people, and spending some time with them.

It's the little things that make an exchange like this possible. Sometimes it's a faltering but honest attempt at language; sometimes it's the care you've taken to observe and respect local culture. Sometimes they've seen you play with the children on the street or purchase something from their stall. Whatever it is, it all begins with your approach, and there's no formula in the world you can follow that will feel as good, or work better, than simply being trusted.

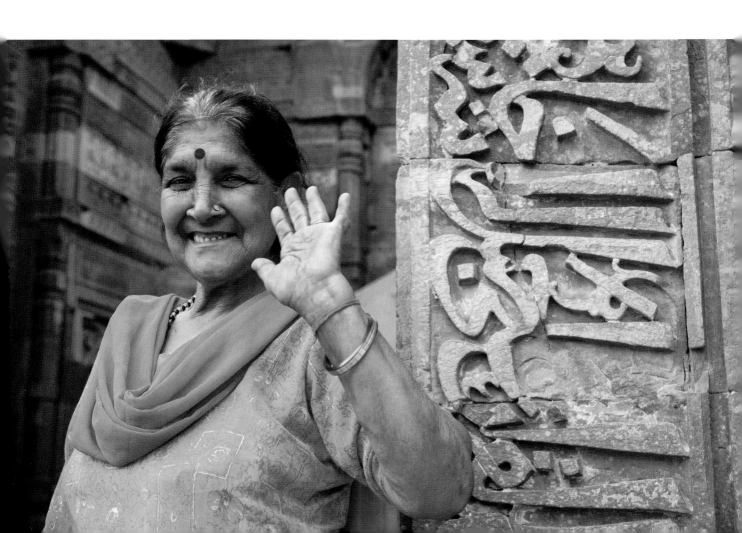

The Language Barrier

I don't believe in totally impenetrable language barriers; I prefer to think that resourceful and creative people can find ways of communicating without spoken language. Sure, I'll have a tough time ordering the penne alla arrabiata without garlic but with extra capers. (Then again, capers are a little weird in any language.) For the rest of the stuff that is important for me to communicate, there's gesture, the power of the human face, and a great deal of humility as I flap about and wave my arms in the streets.

Almost every place I am burning to photograph is full of people who speak a language other than mine. If I rely solely on spoken language to get through my day as a photographer, I will succeed in France, Belgium, and French Africa. I won't get much past breakfast in Latin America—as long as all I order is eggs and coffee with milk—and will barely make it out of the hotel in India. The rest of the non-English world has me over a barrel. Even without crossing a border or leaving my city, I am faced with language challenges when I intend to photograph people, so this is not an issue only traveling photographers face.

Depending on which dubious internet study you read, between 50 and 93 percent of all communication is nonverbal. Even if the truth is closer to the low end, it implies that with a little creativity we should be able to communicate a great deal with nonverbal clues. You're not looking to explain chaos theory or wave/particle duality here—you're just hoping to establish a friendly moment in which you can make a photograph. Even babies can do this, though they have a harder time holding the larger dSLR bodies. I'm betting you can do both.

With just the universally recognized means by which the human face communicates emotion, and the common body language many of us intuit without thinking, we can say hello, ask permission to take a photograph, and let on to others

> "There's gesture, the power of the human face, and a great deal of humility."

Canon 5D, 42mm, 1/250 @ f/5, ISO 400

Delhi, India. Q'tub Minar. This woman is a regular at Delhi's Q'tub Minar monument. She works there, though I'm not sure if it's in an official capacity; show up with a camera and she'll physically push you around to the best vantage point, whether you want to shoot the thing or not. Take advantage of these friendly contacts—it's much easier to pry an environmental portrait out of someone you're already connecting with.

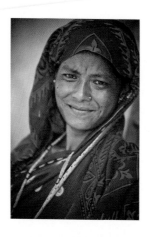
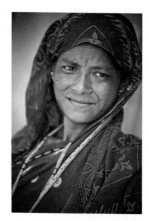
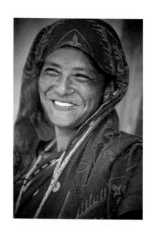
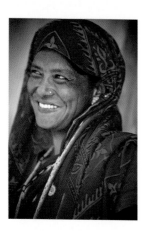
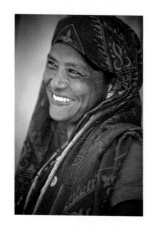
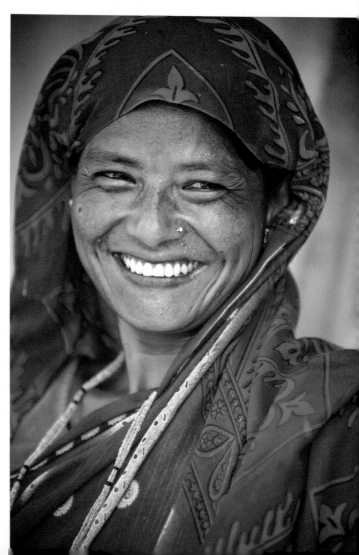

that we are kind and mean no harm. With a little English language, we can tell a stranger our name and where we are from. Sure, you sound like Tarzan introducing himself to Jane, but who cares? If it gets them laughing, even better.

So you improvise, you smile a lot and laugh freely. You play the innocent, and when it all fails you just speak in English, knowing they don't have a clue what you're saying but at the very least will pick up on the tone of your voice. I've had some of my best experiences with people I've never truly spoken with— exchanges that were fun and honest, and which resulted in photographs that number among my favorites. How? Plain old nonverbal communication and the willingness to be a little more childlike than I am normally comfortable with. Lest you think I am an extrovert with incredible people skills, I'm not. It's just that my desire to create images of these people is stronger than my desire to look like a sane human being. When that desire hits you, try this:

1. Take a breath, walk up before you think better of it, and smile. Shake their hand if that's appropriate in the culture you're photographing. Say Hello. Bonjour. Namaste. Mambo. Hola. Win them over with your initiative and friendliness. Sure, they'll talk about the crazy foreigner for weeks. It's only fair; you'll be showing people the photographs for years.

2. Tell them where you are from. If necessary, use one word: Canada. America. England. And then point to yourself.

3. Show them the back of the camera with an image displayed, smile big, and when you've seen their reaction, raise the camera to your eye as you ask, "May I take your photograph?" or simply, "Photo?"—and do so with your kindest face, a cocked eyebrow, or whatever you need to do to look questioning.

> "My desire to create images of these people is stronger than my desire to look like a sane human being."

◀ Canon 5D, 200mm, 1/160 @ f/2.8, ISO 100

Biratnagar, Nepal. I shot these over a 15-second exchange while my subject's friends made jokes at my expense. Initially unsure of the camera, she relaxed as her friends did what I could not. Don't hesitate to get into the fun of these moments, to encourage them. I don't ignore the people who come to watch this photographic circus; I play to them, shake hands, and encourage the moment to play itself out. Often it results in a cup of chai and more opportunities to create more intimate photographs. Not knowing a lick of Nepali shouldn't stop you from connecting.

4. Make the image. Show them the photograph, take a few more, and if necessary, come back later and shoot them more casually. You already have a relationship, so they're likely to look up, smile knowingly, and go on with what they're doing.

See? Piece of cake. Nessun problema. Aucun problème. Es papaya. Kein problem.

The flipside of being able to manage without language is this: even small but sincere attempts to learn the language of another person will reward you exponentially. Say hello, tell them your name, ask about their well-being all in their own language, and their eyes will light up and a door will open that would otherwise have remained closed. Relationships are entirely possible without a shared spoken language, but they open faster if you make an effort.

Learn These Phrases

Almost anyone can learn how to repeat a few key phrases. I'm guessing that if you're traveling to your location, there's a chance you don't speak the language. It's also likely that between the time you'll spend in boarding areas and on the plane, you can learn these key phrases:

- Hello.
- How are you?
- What is your name?
- My name is…
- May I take your photograph?
- Thank you.
- Goodbye.

Look to the back of your Lonely Planet or guide book and you'll find plenty of basic vocabulary, but if you're short on time or struggle with language, start with these seven—they'll open all kinds of doors.

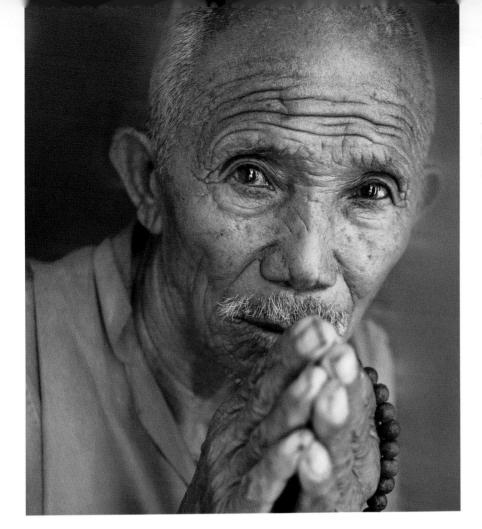

◀ Canon 5D, 52mm,
1/500 @ f/2.8, ISO 400.
Background further softened
in Adobe Photoshop.

Kathmandu, Nepal.

The Eyes Have It

With few exceptions, the eyes are the key to the portrait. They are by no means
the only aspect of a portrait, but they are the one aspect that communicates so
exponentially more powerfully than any other element in a portrait that they de-
serve careful attention. The eyes are so powerful that without looking at the rest
of a face we can interpret the emotions therein. It is not even with the mouth
that we smile, but with the eyes; it is there that we look to interpret a smile—is
it sincere or forced? The eyes can flash with anger or steely resolve. Think of
the Steve McCurry portrait of the young Afghan refugee girl that appeared on
the *National Geographic* cover in June 1985—her eyes powerfully emitting
resolve and strength. That one image has been responsible for many people in
my generation aspiring to become photographers; it's the reason I do what I do.
Those eyes....

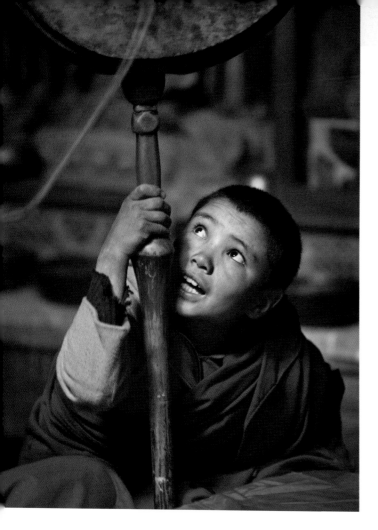

▲ Canon 5D, 200mm, 1/13 @ f/2.8, ISO 400

Lamayuru, India. There are few places more magical to shoot than the gompas in Ladakh.

▶ Canon 5D, 46mm, 1/200 @ f/2.8, ISO 640

Lidderwat, Kashmir, India. In the foothills of the Indian Himalaya, the Gujjars are a transhumant people who follow their flocks of goats seasonally from place to place. After meeting the family and drinking the freshest lhassi imaginable, I shot this in one of their tents. I'm always looking for great light, great subjects, and great backgrounds, and this one had it all.

No matter what your other decisions about your image, the eyes—or at very least the leading eye—must be in focus. Like all rules, this one is not unbreakable, but if you choose to do so you should know that you're willingly sacrificing a source of great emotion and connection. My favorite portrait lens is Canon's beautiful 85mm f/1.2 L lens. Portraits shot at f/1.2 have an astonishingly narrow plane of focus, and often nothing but a couple of centimeters along that plane of focus is sharp—it's critical that at least one eye be sharp. It's not the rule itself that is important, but the why: when we lose the eyes, we lose what the eyes communicate. It is to the eyes we look first, so we're pushing against the nature of our viewers if we don't take advantage of this.

The eyes are also a strong means of directing the attention of the viewer. We generally look where others look. If you are speaking to a friend and they point in one direction but look in the other, we generally look where they look, not where they point. It's instinct; we assume that what has captured their attention is more important than what they're pointing at. In the image, we tend to follow the gaze of the primary subjects—their eye line draws our own gaze along with it. In this way the eyes, and the eye line they form, can be useful compositional tools. If you want your viewers looking out of frame, allow your subjects to look there, too. If you want them looking into the frame, perhaps at a secondary detail, allow your primary subject to look there.

Eyes say so much with so little. A slight movement in one direction or another can change a look from concentrated to distracted, from affection to anger, from interest to boredom. With anything subtle,

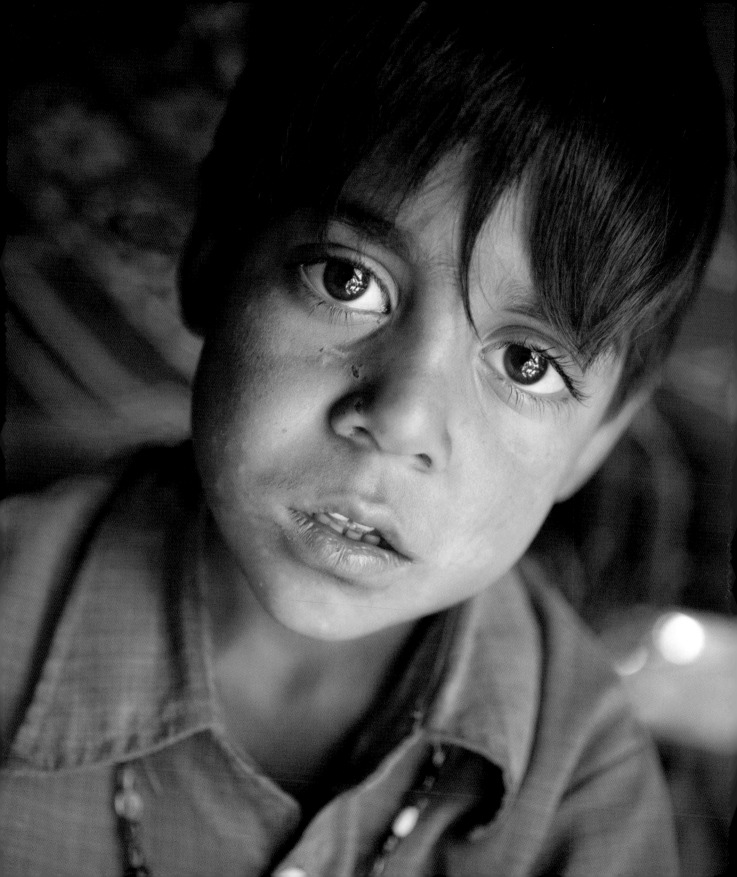

more care is required to get the moment just right, or the whole mood of your image changes. Similarly, a blink—essentially, the movement of an eyelid in fractions of an inch—can ruin a photograph in a way that a half-inch movement of any other part of the body is incapable of. The more powerful the tool, the more care is required in its handling.

"Larger catch-lights seem to communicate innocence, life, and vitality."

In addition to the movement and expression of the eye, the single most important thing you can do to bring it to life and draw attention to it is to capture the catchlight. The catchlight is a specular highlight in the orb of the eye, and it gives life to the eye. Eyes without catchlights are often perceived to be lifeless or sinister. Larger catchlights seem to communicate innocence, life, and vitality. A catchlight is created in the eye when it reflects back to the camera an area of greater luminance than the rest of the eye is reflecting. A portrait taken of a woman looking out at the bright street from her darker doorway will mostly reflect the darker surroundings in her eyes, but a small part of her eyes will reflect the brighter street and sky. This is catchlight. You'll see it as children peek out from auto rickshaws and as vendors peer out from their stalls and umbrellas. If you are posing a person, you might try having them look around, carefully watching where the best catchlight is found, and then repositioning yourself accordingly. In less than ideal circumstances, a large light disc or a flash can provide this spark. Almost any time that your subject is in shade, looking out toward the light, you will be rewarded with a catchlight that brings your subject to life.

Catchlight

Putting your subject into the shade does more than just give them a great catchlight. It also stops them from squinting, which is not only an unattractive expression, but it shuts up the eyes and closes them off to a great catchlight or the possibility of communicating emotion. Simply putting your subject into the shade also ensures a larger pupil, which is more emotive, and necessary for that great catchlight. See? It all comes back down to that catchlight.

Capturing Emotion

Most teachers have a favorite sermon or two, a hobbyhorse they never get tired of riding. Mine are the need to serve your vision, and the need to infuse your photographs with emotion. The former is the subject of this book; the latter will get snuck in here and there. The easiest way to elicit an emotional response to a photograph is to allow that photograph to reflect an existing emotion, one already being felt and manifested by the people in your image. Generally, a photograph of a happy child, smiling or laughing, reflects that emotion to the viewer—there's no interpretation needed. But as the emotions get more subtle, they become harder for the photographer to capture, and harder for the viewer to interpret.

A smile and laughter are the easiest clues that a person is happy. Anger is pretty obvious. So is surprise. But as the intensity of emotions gets more subtle, emotions like boredom, acceptance, love, sadness, anticipation—even joy or suppressed anger—become harder to capture and harder still to intuit. There are several ways a photographer can capture emotion—all of them clues we are used to because we rely so heavily on body language for day-to-day relationships. Simply being more aware of those clues and how to register them within the frame can give our images greater emotional weight.

Happiness, of course, is manifested in smiles and laughter, but it's also shown through open body language, a relaxed posture and muscles, and physical proximity to others. It's a sparkle in the eyes, even when the smile doesn't crack.

▼ Canon 5D, 85mm, 1/640 @ f/1.2, ISO 100

Kathmandu, Nepal. There's a balance between information and impact that plays out in any image, and knowing which elements provide one or the other is an important step in determining which ones need to be primary—and therefore sharp—and which ones do not. In this case, the emotion itself is the subject of the photograph, so choosing a very shallow depth of field and allowing it all to go soft—except for the thin plane that includes his smile and his eyes—was all that was needed to provide impact without being distracted by other elements. The other elements still provide information and context; they just don't need to be sharp to do so.

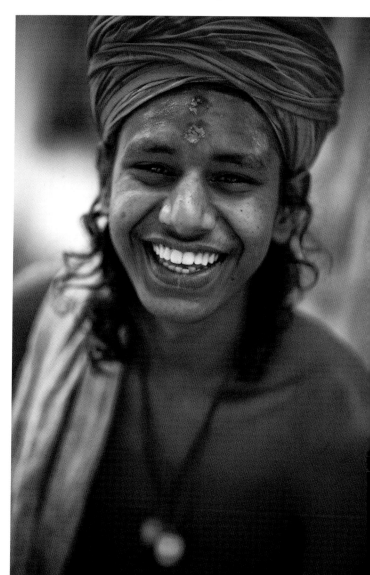

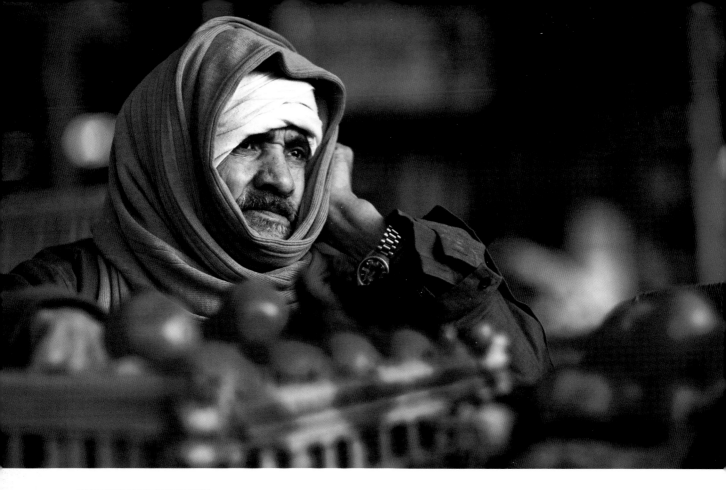

▲ Canon 5D, 85mm,
1/400 @ f/1.8, ISO 200

Cairo, Egypt. While smiles and laughter are easy to shoot, emotions like boredom are no less universally identifiable. Who can't identify with this guy, sitting alone and bored at his stall? Moments later he turned to me and smiled, but it's this undeniably bored look that I prefer.

Sadness is shown with tears, or the dried tracks of tears. It's often exhibited as a trembling lip or a body posture that's gone past the stage of relaxation, like a balloon with the air slowly let out. This is a posture of apparent hopelessness. Often sadness is associated with shame, and the subject will hesitate to make eye contact.

Often sadness and shame lead to fear. Fear is marked by wide eyes, tense or defensive posture, crossed arms, even perspiration. And fear often leads to anger. Anger can be marked with narrowed eyes, furrowed brow, clenched fists, bared teeth, hostile or aggressive posturing with arms, and invasive body placement. It's hard to miss anger. It's also usually not the kind of thing I stick around to photograph. But there's a time and place for everything, I suppose, and if nothing else, knowing how to identify anger might give you your cue to clear out.

Knowing our own emotions as well as we do, it's easier to predict the path they take. In the same way that action is often best captured at its apex, emotions

too are most clearly captured and communicated at the moment of their fullest expression. While every person is different, we also share a certain commonality. Laughter is similar, if not exactly the same, everywhere you go, so you know it's going to peak if it's gaining momentum. Anticipate it correctly and you may get the moment when the head is thrown back and the eyes get that wild fire of unrestrained laughter. Reading the signs that people give off should tip you to the coming moment when that emotion hits its fullest outward expression. Be ready, and don't hesitate when it comes.

Photographing laughter is easy. Photographing the more vulnerable emotions takes sensitivity and sometimes courage. It's not easy to keep shooting when tears are flowing, and sometimes it's not appropriate. If you're there to photograph a story, and it's a story worth telling, then it probably is worth the difficulty of shooting through the tears. If you're shooting a story on behalf of someone who wants and needs their story told, you need to do so with sensitivity and with respect for the courage it took them to tell their story. Honoring the tears or emotions of another person means not pretending they aren't there. Sometimes that means photographing it. Witnessing it, and letting it be an act of love. In a way, it's a small act of solidarity that says to a person, "I care about this, and if you're willing to tell this story to me, I'm willing to tell it to others."

The full range of our emotions is part of what makes us human. It's not always pretty or easy or comfortable, but it's honest, and photographing stories of a wider or deeper range of emotions can touch your viewers in the deepest parts of their humanity. It's these images that most readily become iconic—so broad and deep is their appeal.

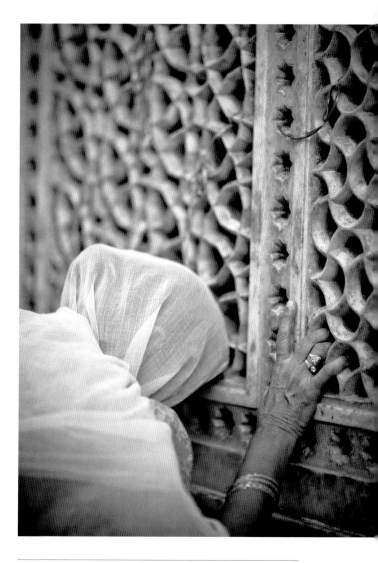

▲ Canon 5D, 85mm, 1/1250 @ f/1.2, ISO 400

Delhi, India. The Nizamuddin shrine in Delhi is a place where people go to petition God for something. It's a place of intense emotion as people make their pleas, and it never fails to move me. This woman cried and begged and pleaded, and while her face is not visible her emotion is obvious through her posture and other clues. These are hard moments to photograph, and they demand respect and much kindness to photograph them discreetly. Importantly, I think these images only work when shot with empathy.

WITHOUT THE FRAME

DELHI, INDIA. Coming out of the Nizamuddin shrine in Delhi on a Lumen Dei Workshop with Matt Brandon and our team, we stopped for chai when this girl walked up to me, fully veiled in her burqa. Not uncommon in this very Islamic part of Delhi, I expected her to put out her hand for candy or to ignore me entirely. So when she threw back her veil, gave me a huge smile, and then hid her laughter behind her hand, I could barely make the image for laughing too hard. This image illustrates something powerful about the smile—that we do it with our eyes and not with our mouths. Our mouths may be smiling but hidden—or grinning falsely for the camera as we're trained to do—but it's our eyes that tell the truth about whether or not we're really smiling.

▶ Canon 5D, 85mm, 1/5000 @ f/1.2, ISO 800

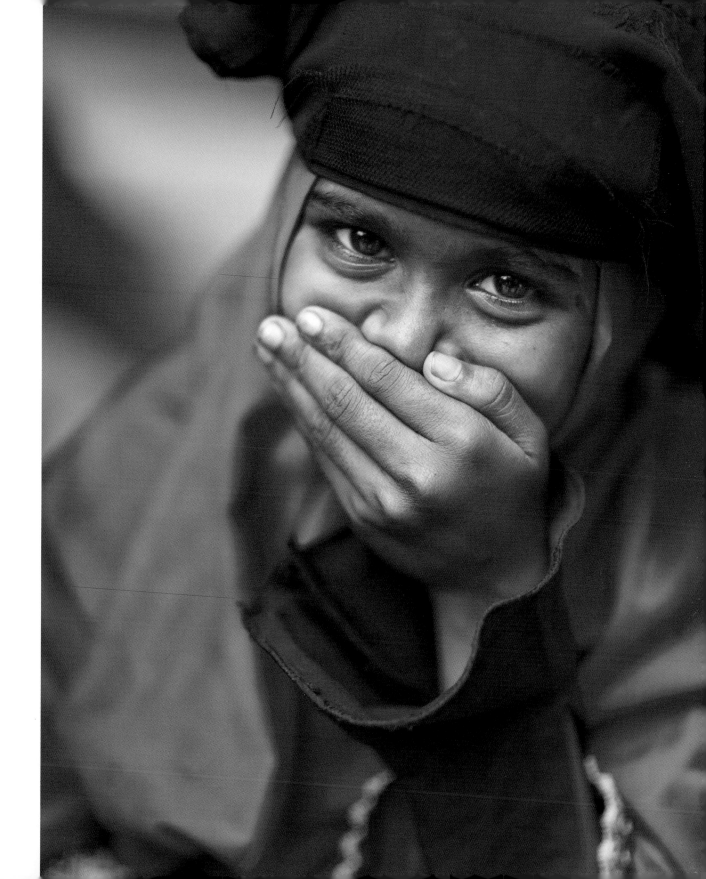

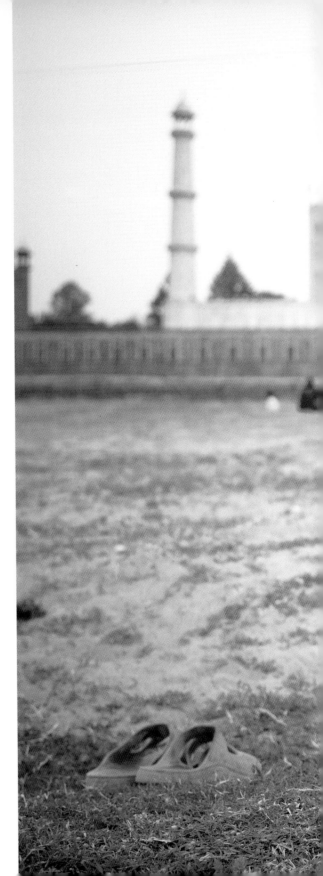

On Giving and Taking

Once you have consent, you'll have a little time to make the image and move on. How much time you have differs from subject to subject, but take what they'll give you and be sensitive to their needs. It's not hard to tell when they're done and want to wrap things up. But don't make it too fast either. Respecting them means taking some time for them, and making your exchange an act of giving as much as an act of taking.

We owe it to our subjects to create the best image we can, and that takes care and time. After all, this is their face and their identity you are interpreting. Rushing in, pushing a camera in their face, and then rushing away is the photographic equivalent of a hit and run, and it's unproductive and unpleasant for all involved. Take your time, and take your cues from the people you're interacting with. But above all, make it an exchange.

I'm not suggesting you pay for images; there are other ways of making this more than a moment in which you get something—an image—and they get nothing. If your subject is giving you a moment of their time, the least you can do is give them

▶ Canon 5D, 30mm, 1/640 @ f/3.2, ISO 500

Agra, India. The front side of the Taj Mahal gets all the glory, but the back side feels much more real. Just on the other side of Yamuna River, this man allowed me to photograph him and then put out a characteristic hand for a little baksheesh. I smiled, thanked him, and moved on. I generally don't pay for photographs, but whether to give something or not is hotly debated among photographers. Nowadays I carry a small pocket-sized printer and give copies of the images I take as a thank-you.

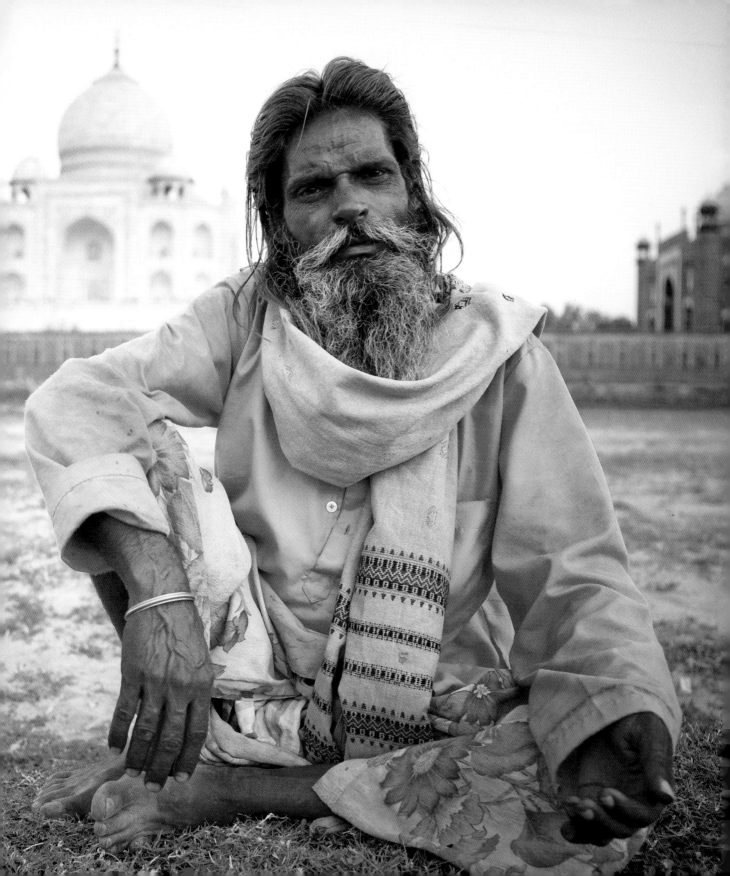

a moment of your own. Take the time to find out their name, or just tell them yours. Say thank you. Shake their hand. Show them their image on the LCD screen. Have a laugh. Don't just shoot and run. In 2008, Polaroid created a small portable USB printer that allows me to print a 2"×3" print right there and then as a gift, and this alone has made my exchanges more mutual.

In the end you'll have better exchanges, and if it must be reduced to pragmatic terms, you'll make better images, too.

Beggars and Choosers

Spend any time on the streets in almost any country and someone will ask you for money.

To the poor who see you walking along with thousands of dollars' worth of equipment strapped to your body, you're a hope for something more, a meal perhaps. Whether or not people are professional beggars, you can't possibly give something to everyone, nor would that approach necessarily be healthy if you could. If you have $100 to give back to the community, consider giving it to a local organization that can distribute it with more wisdom and local understanding than you can.

I sometimes carry a pocketful of pens for children, but beware that giving to one can unleash a storm of requests you can't possibly escape. If you thought it was already hard to photograph a new place, try it surrounded by a crowd of children who have nothing they'd rather do more than follow you around asking for pens, candies, and "one dollar, one dollar."

Paying for photographs is a subject hotly debated by photographers. Journalists don't do it for ethical reasons, but there are other reasons not to make a habit of it, not the least of which is the creation of a precedent. Pay one man for a photograph on the banks of the Ganges, and soon every photographer will be forced to do the same. But there are times when you might ask a willing subject to pose for several minutes, to take time away from their tasks, and then it's only fair to compensate them. Perhaps that means buying from their stall; perhaps

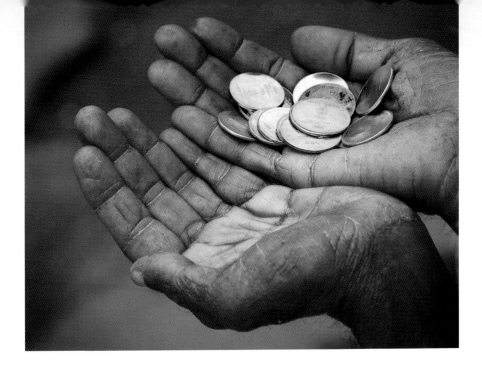

Canon 5D, 148mm,
1/250 @ f/5.6, ISO 200

Old Delhi, India.

it means a dollar or two. You'd pay a model for a commercial shoot, so why not pay someone who's generously given their time to you? This is, as I said, hotly debated, but the principle of fair compensation ought to guide you. I've heard many photographers defend the practice of never paying, and I wonder if their position has more to do with a lack of generosity and the need to save a buck than a more noble principle. Still, it's rare that I pay. I would much sooner give back in other ways.

Indecent Exposures

Almost anywhere you choose to shoot you will inevitably run across the poor, the addicted, the lame, the disfigured. Anyone who's ever wanted to shoot for *National Geographic* might be immediately tempted to take a photograph. There are good reasons for taking photographs of the excluded and the forgotten. And there are good reasons not to, not the least of which is the further trampling of their already ragged dignity.

I have strong feelings about this subject. I spend large chunks of my year in the developing world photographing for groups like World Vision, who work among the poor and excluded, particularly with orphans and vulnerable children. So

"There are good reasons for taking photographs of the excluded and the forgotten. And there are good reasons not to."

photographs of the people I love, when taken to appeal to our inability to turn our eyes from a train wreck or disfigurement, seem to me to be exploitive and unkind. I'm not a journalist, so I shoot for different reasons, none of which include images that exploit another's misfortune.

I've seen beautiful, compelling photographs of people in some of the darkest places life has to offer, and I'm certain the photographers behind these images have spent time with their subjects, have heard their stories, and no doubt, have shed tears over them. Photographs taken by ugly and impersonal means are ugly and impersonal photographs. If you feel compelled to make photographs of people who are suffering poverty, disease, or some other misfortune or indignity, then you owe it to them to make more than a snapshot to show your friends.

Photographing Children

I have a fascination with photographing children. They represent what is best about us, before we grow and become self-conscious and lose our imaginations and sense of play. At our best we retain that childlikeness, but I suspect our love for childhood has something to do with nostalgia over what we've lost.

Nostalgia is powerful, and images that harness that nostalgia are among the most compelling and universal images. The way that children play says something about the place and culture in which we find them, and images of children playing cricket in the alleys of India or soccer with a ball of rags and twine on the dusty streets of Addis Ababa are as rewarding as any other.

It's not easy to photograph children well, and there are technical, relational, and paranoia-related issues that eventually surface for anyone who wants to point the lens toward a child.

Children are easy to capture if you approach it right. If you approach your session, or your brief moment, with a sense of play and prepare to be surprised, you will be rewarded with the best kind of images of children—ones that are spontaneous and playful as they reveal the real spirit of the child. Children can go from laughter to tears in an increment of time so small that science has yet to measure it. If you are prepared for this, you can capture a range of true emotions that you will never get from a suspecting adult. Here are some suggestions for photographing children.

"Nostalgia is powerful, and images that harness that nostalgia are among the most compelling and universal images."

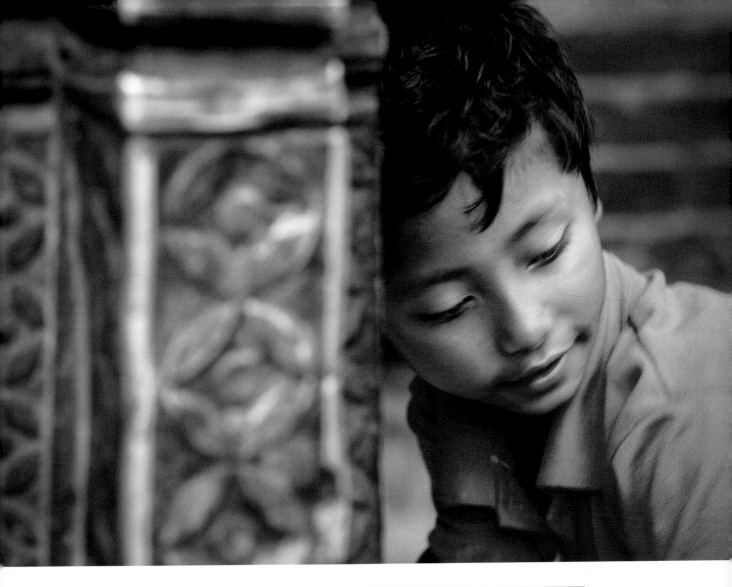

▲ Canon 5D, 135mm, 1/30 @ f/4.5, ISO 500

Bhaktapur, Nepal. This little Nepali girl feigned shyness but stuck around for me to shoot as long as I liked. I nearly deleted this one— there's more blur in it than I wanted—but kept coming back to it. Sometimes all the technique in the world can't trump an emotion or a moment. This one just speaks to me, and as much as I want my images to resonate with others, I photograph first for me, so it stays.

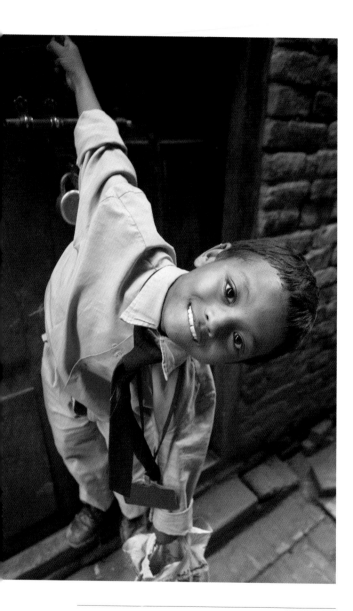

Canon 5D, 24mm, 1/60 @ f/4, ISO 400

Bhaktapur, Nepal. I love using a wide-angle lens with children. It forces me to get in close and kids seem to like that kind of playfulness, which encourages them to be more playful themselves. A wide angle this close emphasizes the eyes and makes their faces playfully disproportionate to the rest of their bodies.

Keep it playful. Let them see the image on the back of the camera. Playing hide-and-seek behind the camera works well. Don't be afraid to make faces, shake your hips, and make funny noises if that's what it takes to endear them to you. Shooting in continuous or burst mode will allow you to capture the pose, as well as the moment they relax and react. It is that post-snap reaction that most often reveals the true character of a child in that moment. Let kids be kids. Think of the photograph as a collaboration between you and the child: you bring the expertise and the camera, and they bring the fun, the unexpected, and the spontaneity.

Don't be afraid to use a wide-angle lens for portraits of kids. Get close and wide and capture their face with something in the background that reveals a part of their world. Or capture a piece of a spinning top or doll in the child's hand. Those details need not be in focus; don't be afraid to shoot wide open at f/1.8 or f/2—or as wide as you can go. The smaller the number, the less that's in focus, which creates a nice soft look that is consistent with the mood and feelings we generally associate with childhood.

Be creative about your angle. Shooting from above while they look up creates an implied relationship of trust or smallness. Shooting from ground level while they are on the ground gives you an insight into how they see the world, or are seen by other children.

If you're using flash, take the time to learn to use it well. Flash can be useful in freezing the movements of energetic children but can be harsh and ruin what would otherwise be a great shot. Children learn to anticipate a flash, and their face shows that

anticipation, removing the spontaneous look. If you must use it, soften it up with a diffuser.

Like other photographs of people, you generally want to keep the eyes in focus. But children are more playful, and there's more room for the images themselves to be playful. The girl with the cookie is my niece, and while I shot hundreds of photographs of her and her sister that day, it's the one shown here that most reveals her character, even with the eyes out of focus. Rules are meant to be broken occasionally, but when the face is the primary subject of the image, aim for the eyes.

Over the years I have photographed many children with whom I have no prior relationship. This makes me a stranger to them, which adds a new dynamic to deal with, and a stranger to their parents, which adds an element of paranoia and possible legalities.

In the developing world, parents are no less protective of their children but they tend to be less paranoid, which gives photographers greater latitude and responsibility. Children can be found running everywhere, and while this allows plenty of opportunities to photograph them, don't be mistaken in thinking they are unattended and fair game. In much of the world, children are the collective

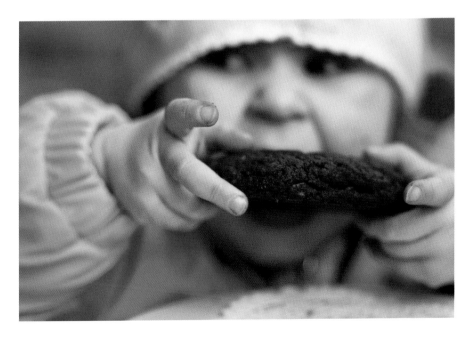

◀ Canon 20D, 85mm,
1/1600 @ f/1.8, ISO 400

Vancouver, Canada.

"Don't be afraid to use a wide-angle lens for portraits of kids."

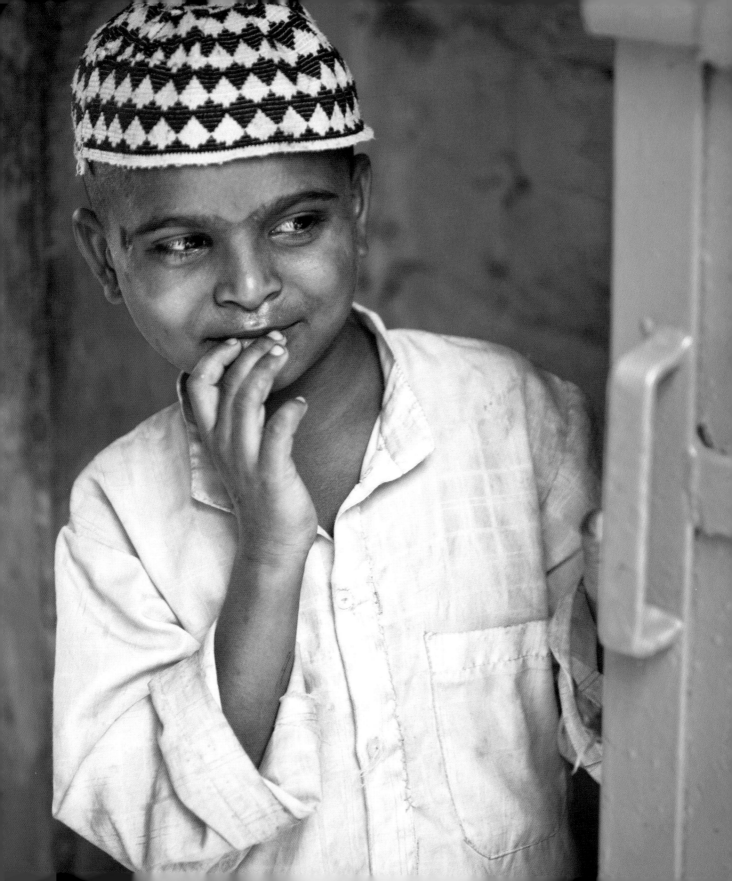

responsibility of the community and you need to treat them as such. Remaining completely above reproach in your behavior toward children allows you to remain welcome in that community; even a perceived violation of that trust is likely to be met with hostility.

Don't lurk or shoot images in a way that can be perceived as predatory. Be open about this. If you look like you're nervous and have something to hide, every responsible adult within sight will be nervous. Engage the adults; show them the pictures. Be very sensitive to the parents' rights to protect their children. Remember that the rights and safety of children is more fundamental than your right to photograph them.

Photographers who appear predatory in any way give parents more reason for their fears and make it even harder for photographers to create meaningful and beautiful images of children without arousing suspicion, fear, and hostility.

That's the unpleasant stuff, but photographing children needn't be avoided or intimidating. Learning a magic trick or being able to make some unexpected faces will endear you to kids, regardless of language. Much of my photography is in countries where English is not spoken primarily. So a magic trick or two breaks the language barrier. Then I snap a picture of them and show them the camera back. Usually this results in a posing frenzy, but if you have the patience to wait it out (you can delete them later) you will eventually be rewarded with some candid images.

When I travel in the west I carry business cards, and when it is appropriate, I make sure the parents get a couple of cards. I let them know who I am and tell them I appreciated interacting with their child and what a great kid he or she is. I invite them to email me with their address, and I ask them permission to send them some photographs as a thank-you. The more open you are with people, the more they will trust you.

Photographing children can be deeply rewarding. Be patient, be gentle, be prepared for anything, and shoot with your heart as well as your camera.

> "The more open you are with people, the more they will trust you."

◄ Canon 5D, 70mm, 1/125 @ f/2.8, ISO 200

Old Delhi, India. Children can be delightfully unself-conscious, as with this child and his open curiosity. As we age we tend to hide these things, but they are at the heart of our humanity, so often our best chance at capturing them is with children.

One of the most misunderstood aspects of photographing people is the issue of model releases. This is a legal issue, and I'm not in the least qualified to comment on it in depth. What is often misunderstood is that there is a vast difference between permission to shoot, which legally you do not need in many places, and permission to publish. A model release is written permission to publish an image. It is required by most clients as well as stock agencies for purposes that do not qualify as editorial, but you do not need it to simply create a photograph. Legally, you do not need permission to photograph in most places,* but acquiring at least the implied permission to photograph is a courtesy and a kindness. A quick search online will give you plenty of sample model releases, and more conflicting information than you ever wanted regarding if and when a release is needed. Generally speaking, if all you want to do is photograph, releases are unnecessary.

*Every country has different laws about this. For example, photographing in Ethiopia will not afford you the same rights and protections as photographing in the United States or Canada. Do your homework and be sure that it is legally or socially permissible to photograph what you intend to point your lens at. What won't get you arrested might still get you stoned.

> "They tend to buck at the western trends creeping into most cultures, and that alone makes them interesting to photograph."

Photographing the Elderly

The elderly are often as much fun to photograph as children are. Guardians of their ways and culture, the elderly are often the last living windows into the way things once were and can provide unique opportunities that you might not find among the younger population. They tend to buck at the western trends creeping into most cultures, and that alone makes them interesting to photograph. Traditional clothes, a willingness to spend some time with you, and the years of character and story that they wear in the lines on their faces make the elderly ideal subjects when you're looking to create images that capture the spirit of a place.

▶ Canon 5D, 85mm, 1/1600 @ f/1.2, ISO 100

Kathmandu, Nepal. Sometimes you just take a photograph because it makes you laugh.

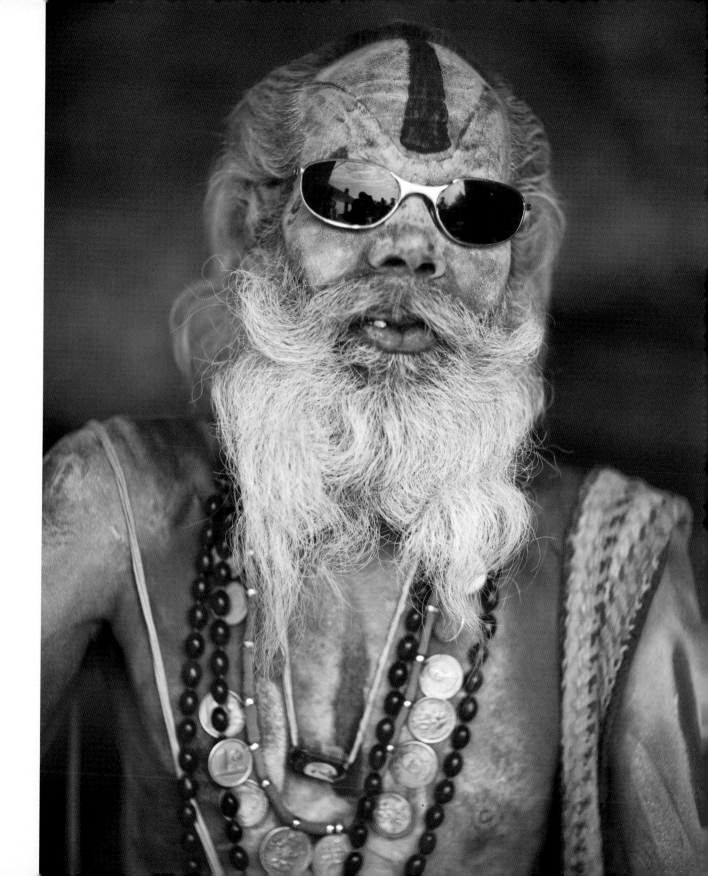

WITHOUT THE FRAME

KASHMIR, INDIA. We'd camped beside the Lidder River above Aru in Kashmir. We were there to meet the Gujjar shepherds and were striking camp after two days of visiting their homes, sharing endless cups of salt-tea, and photographing their families. When this character approached me, I wondered if he'd let me take his photograph, so when he grabbed my arm and insisted he was over 100 years old and I should take his photograph while I could, I knew we were going to have a good time. We walked over to a small goat shelter and I asked him to sit just under the lip where the light was softer and the background wasn't burned out by the noon sun. He was stoic and rather unexpressive, so I started making some faces (it's true: my subjects have dignity, but I have none!) and when he cracked this smile I knew I had the image I wanted—something that still reflects back to me the character that this man had. Laughter is universal, and when it's genuine it's evidence that a protective wall has come down and you're witnessing an authentic facet of someone's personality.

▶ Canon 5D, 62mm, 1/500 @ f/2.8, ISO 400

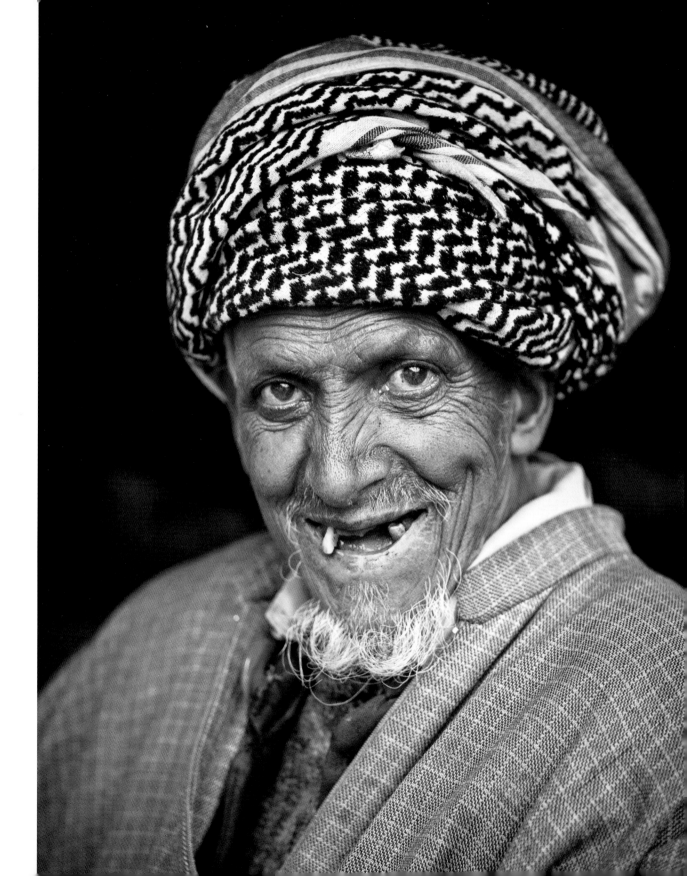

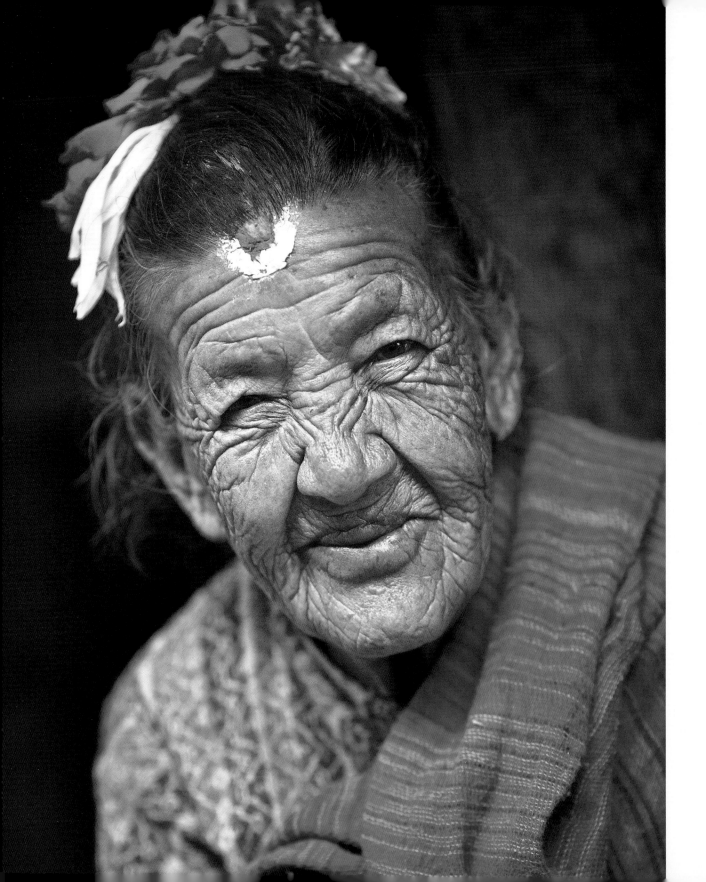

The approach to photographing older subjects is not much different than others; remember to treat them with special respect, kindness, and humility, and you'll often find yourself spending more time than you expected. While the young are often more familiar with technology, the elderly may have never seen their image on the back of a digital camera and may be more inclined to ask for a hard copy.

This image (opposite) was shot in the village of Sankhu, a short motorcycle drive out of Kathmandu to the east. This traditionally dressed Newari woman has one of the most interesting faces I have ever seen. Sitting back in the door of her home, she happily let me photograph her. Had she moved forward a little more she'd have been in more directional light, and the harsher shadows would have taken the soft kindness from her face and replaced it with even harsher lines. I was not looking to portray her as the sum of her wrinkles, but to catch the feeling of mischief I saw in her—and I could only do that with softer light and by paying particular attention to the already small catchlight in her eye, without which her eyes would be lifeless. Seniors often have deep eyes, and the wrinkles and darker discoloration makes a good catchlight even more vital. I kept the depth of field low to keep the bright colors and textures of her clothes—and her larger, curiously shaped ears—from distracting. Obscured by softer focus, these elements become a surprise, something to be discovered as the eye moves through the image—layers within the image that complement rather than compete.

> "Seniors often have deep eyes, and the wrinkles and darker discoloration makes a good catchlight even more vital."

Candids vs. Portraits

Where intimate portraits require the collaboration of the subject and necessitate an interaction, candids of individuals and groups of people on the street allow you to slip in with greater ease and less fear. It's a great place to ease into photographing strangers in strange places.

Street scenes are the easiest to shoot—the busy chaos of a street means people will be less likely to notice you off to the side shooting their activities. Even when you are noticed, people feel less targeted when they are part of a group. Because you are shooting with a wider lens, it's likely you won't have it pointed directly at them, which can be enough to reduce any perceived threat or invasion of privacy.

◀ Canon 5D, 135mm, 1/640 @ f/2.5, ISO 200

Sankhu, Nepal.

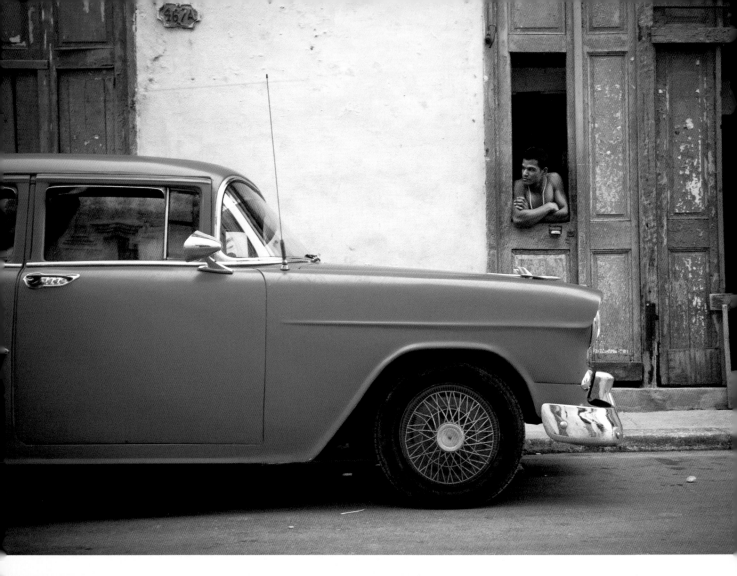

▲ Canon 5D, 40mm, 1/30 @ f/5, ISO 400

Havana, Cuba.

◀ Canon 5D, 85mm, 1/250 @ f/2.5, ISO 400

Cairo, Egypt.

Why Photograph Candid Street Scenes?

Aside from the relative psychological ease of shooting streets, there are plenty of good reasons to shoot the scenes playing out before you.

In much of the world, life and all its activity is played out before us on the streets. Cooking, eating, playing, working, worshipping, falling in love—all happen in a swirl of local color, and photographing this is often as close as you can come to capturing the genuine spirit of a place.

When a subject is aware of the camera, it changes the dynamics. The resulting photograph is less a record of a person at a place and time, and more a record of a person in a place reacting to a camera. The difference is not a subtle one, and it's here where candid street photography shines. It's on the streets, squares, and markets where people are at their most natural and unposed—unaware, even, that you are photographing.

Shooting in public places like this, while generally less intimidating, takes no less care and skill than shooting the portraits many photographers are more reluctant to try. In fact, in some ways it is more difficult. Photography is as much about deciding what to exclude from the frame as it is about choosing what to include. In the scenes unfolding before you on the streets, particularly in places like Kathmandu—where the activity is relentless and the streets are packed—it's difficult to isolate your subjects, await the decisive scene, and still be sure to compose, focus, and nail your exposure. There's much to think about, and add to that the task of creating a compelling image that expresses how you think or feel.

Aside from your camera and wider lens, the most important thing you can bring to a morning shooting on streets or in public places is a keen awareness of what is going on. It's helpful to see the scenes unfolding before you in both the wider and tighter contexts. Is there a perspective from which you can shoot this whole buzzing scene? Can you get above street level or position yourself at a corner where it all converges and gives you a strong oblique perspective? Is there a tighter crop of the scene that better communicates how you feel about this market than a wider shot?

"Cooking, eating, playing, working, worshipping, falling in love—all happen in a swirl of local color."

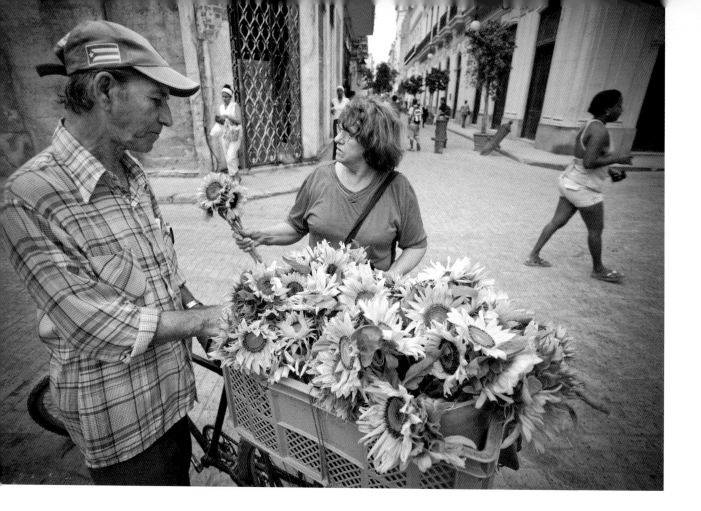

▲ Canon 5D, 17mm,
1/80 @ f/4, ISO 400

Havana, Cuba. A sunflower
vendor plies his trade.
I went back and forth
on whether to duotone
this image as I have. In
the end, the colors just
didn't work together as
well as I'd have liked and
distracted from the other
dynamics in the image.

Point and Shoot

Being discreet with large SLR bodies and lenses, a backpack, and skin or clothes
that contrast with the local culture is next to impossible. I've given up. But
many photographers still prefer to use a smaller camera and call less attention to
themselves.

Here's one of those contexts where a point-and-shoot camera can rival the SLR.
It's easy to carry, less noticeable, and often makes subjects see you less as a
professional photographer and more as just another curious tourist who they've
learned to ignore. Choosing a camera with a short lag time and a swiveling LCD
screen can make photographing on the streets a little easier.

Remember that, in a visual sense, a photograph with too much going on can say nothing at all. Simply recording a chaotic scene does not mean you've created a photograph that expresses that chaos. Your perspective might need to be much lower, at the level of wheels and hooves. Your shutter speed might need to be slower to capture some of the motion. A photograph of a man on a moped might be better shot by panning and capturing his speed rather than frozen still. However you do it, you need a sense of what you're trying to communicate—a sense of your vision—before you choose the tools to make the image.

Human interactions in public places can give you an infinite palette of emotional colors with which to create your photographs. Watch for people talking to each other, negotiating a sale, or engaged in activities that are specific to a local place. In Kathmandu, this might be people jumping on and off local transportation, selling and buying local goods, or walking clockwise around a stupa. The more uniquely local these activities and interactions are, the more specifically these images will reflect the spirit of this place.

▼ Canon 5D, 70mm, 1/2500 @ f/4, ISO 400

Douz, Tunisia. Moments later he made the same gesture to me.

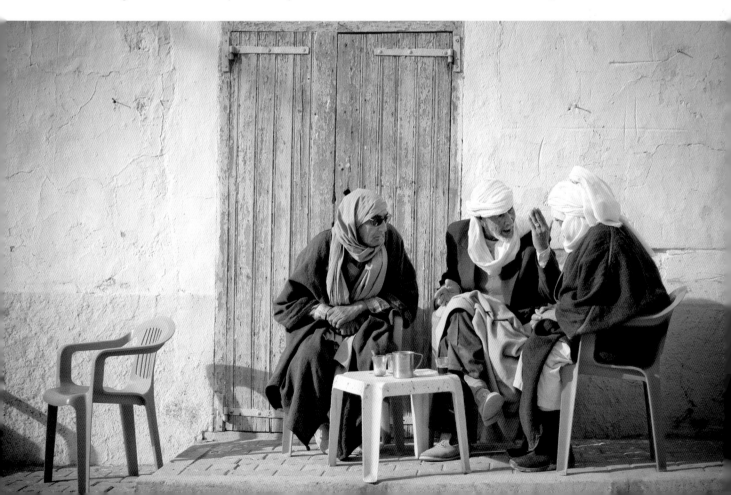

WITHOUT THE FRAME

CAIRO, EGYPT. Wandering through Cairo's Khan el-Khalili I bumped into four men sitting in the shade, drinking tea and chatting away. One of them noticed me with my cameras, wagged his finger at me and said, "Ten dollars!" I smiled, waved him off, and turned to one of his friends who smiled and posed. So I shot a few frames, then printed him off a copy on my portable printer. He smiled, shook my hand, and said thank you while the others all looked on. The first man, now intrigued, got my attention, used the same finger to point to his chest, and said, "Photo, photo!" I smiled, wagged my finger, and said, "Ten dollars!" He looked at me sternly, then a grin spread across his face. He laughed, and I spent the next 15 minutes taking photographs, with full permission, while we drank tea and made small talk.

▶ Canon 5D, 110mm, 1/200 @ f/2.8, ISO 400

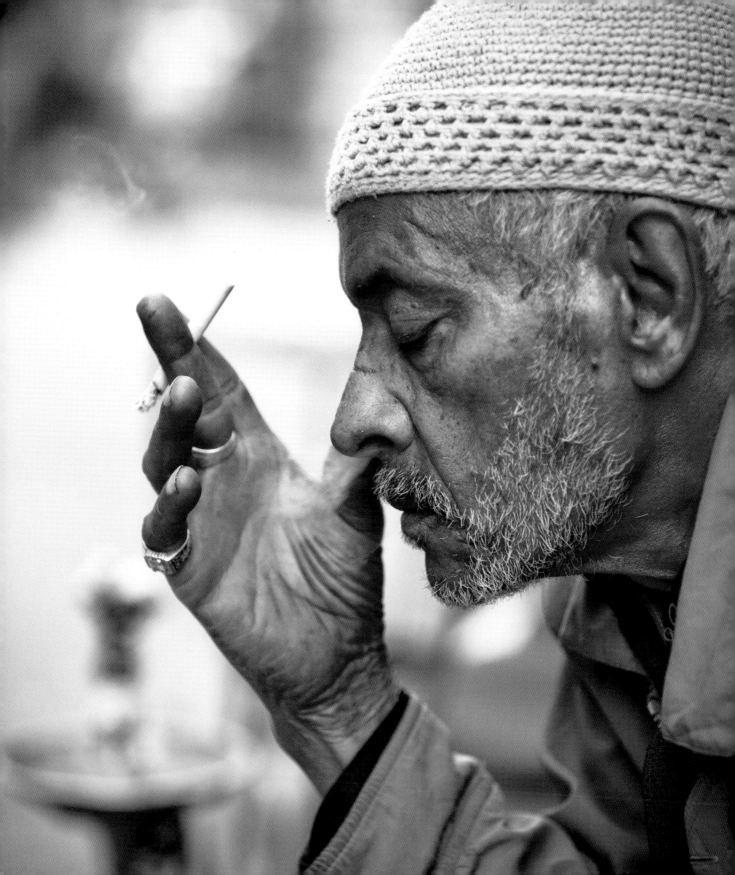

> "The more uniquely local these activities and interactions are, the more specifically these images will reflect the spirit of this place."

Sit in a corner or at a café for an hour. You'll see it all, from joy to sorrow, and everything in between. Tighter candids in these places can be easier when shot with a longer lens, but a telephoto lens can also draw more attention. I still use a telephoto lens, but when I do it's for the look that lens gives me, not for its ability to take a sneaky grab shot.

I feel very predatory when lurking with a longer lens, and I've all but abandoned this technique for one that feels more honest and human but is much harder. I've substituted a longer lens for something shorter and adopted a little more confidence. If you move in a little, settle in for a while, and take your time, you'll eventually blend into the scene and people will ignore you, allowing you to shoot more freely. You'll also feel less afraid of being caught. The sneaky grab shot rarely works as well as we hope, and if you're caught it may well rob you of the chance to take a better image later.

When you want to take the next step and create more intimate portraits, there's just no way but to walk up and ask.

Be Aware

Shooting the streets and markets requires a great deal of creative attention. It's no surprise that losing cell phones or wallets is common if you put them in an outside pocket.

Be vigilant. Pickpockets aside, the local traffic is a more certain concern. Rickshaws, buses, cars, and motorcycles on busy streets may not see you if you suddenly back into traffic while trying to get just the right shot. They might not even care. In places like Kathmandu it is easy to get run over, but this advice is no less relevant in New York City.

Pay attention; you'll find it much harder to shoot with a broken arm or from your hospital bed.

Abstracting People

An intimate portrait of a child in Bangkok is a visual representation, and interpretation, of a very specific person. It is *this particular child*. And these images can be very powerful, as they speak to the individuality of human beings. But there also times when you may want to present the people in your photographs as abstract figures rather than individuals, making them more symbolic than specific. Or you may want to make them more of a human detail, a secondary subject within the image that's needed for context or emotion but not because they are specific people. You might even need to present people in your images in such a way that protects their anonymity.

Blurring via the intentional use of a slower shutter speed can be effective in preserving the human element while also allowing it to give way to another element in the image. The human figure, particularly the face, is so compelling to us that our eye is drawn to it almost unavoidably. This can so diminish the impact of other elements in the frame that they become secondary, if not invisible. Blurring that human element reduces this pull on our attention and emotion, and the primary element is allowed to function again as the viewer's eye is directed where it was meant to go.

Motion blur can also create an effect of movement or busyness, the anonymity of a crowd, and other impressions that, while leaning on the need for a human element, need it to not be specific, only implied.

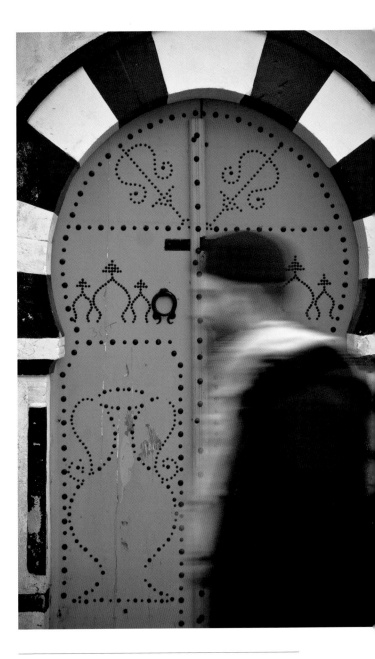

▲ Canon 5D, 70mm, 1/20 @ f/8, ISO 400

Kairouan, Tunisia.

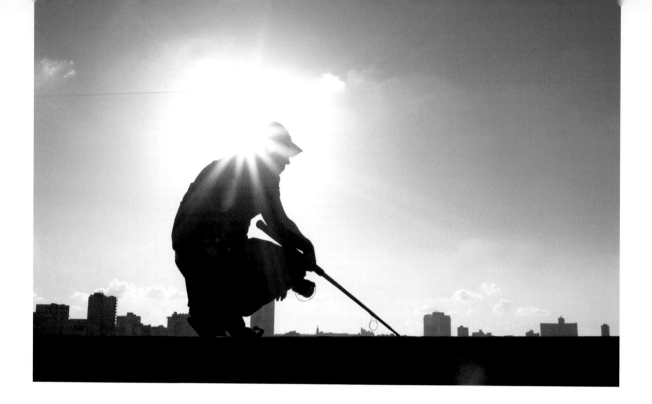

▲ Canon 5D, 33mm,
1/200 @ f/22, ISO 200

Havana, Cuba. Fishing
on the Malecón.

The use of a silhouette is another means by which the human element can be introduced or preserved in a photograph without the specific identity of that person distracting or being revealed. The viewer sees the silhouette, recognizes it as human, and infers enough information from the posture and gesture, but the eye doesn't return often because the brain has already processed that there is no further information there. If that person were well lit, the eye of the viewer would return time and again to scan the face, the clothing, and the details for more information.

Finally, the human can be abstracted simply by choosing an angle that conceals the face. A silhouette or blur effect might well be undesirable for the same reason it is useful in others. You might want the details and textures of a person's clothing to reveal information about the context in which that person lives. Shooting them from behind—or even from the front, but catching their head turned or lowered—can give you all the information your image needs while withholding from it the power of the human face and the specific identity of the person in your image. It's unlikely you'll want a whole portfolio of these abstracted images, but when used in service of the vision and purpose you have for specific images, it can be a powerful tool.

Lighting Challenges on Location

Sadly, we can't always shoot at magic hour, but the need for the right light never changes. The challenges of natural light and the fact that the sun just keeps on moving across the sky means that there is always a need to be mindful of natural light and the ways in which we can modify and supplement it. While this is not a chapter on using multiple off-camera gelled strobes to mimic the look of sunset, here are a few problems I often encounter with natural light and the simpler principles that come into play to resolve them.

Problem: Harsh overhead light creating harsh shadows on your subject's face and washing out their color.

Solutions:

- Move your subject into the shade. Under a tree, into a doorway, or to the other side of the street. This one's so simple it gets overlooked, or people figure it's easier just to set up a bunch of strobes. Just move them.

- Use your reflector to bounce some fill light into the shadows. Hold it under their face and bounce that harsh light right back at them. It's not a great solution, but it can work. It can also make them squint even more, especially if you're using the silver or gold reflector and not the white. Be nice and use the white.

- Use your diffuser and have someone hold it above their head, creating a really soft, large source of light. This one would be my choice over the previous solution, but it presents another dilemma: the background behind them is likely very hot since it's being hit by the same ugly light you're now shielding your subject from. Shooting toward the shade or a darker background ought to even out your exposure and reduce the distracting hot spots.

- Use diffused, off-camera flash to fill in the shadows. Done right, this can be a great solution, but it means setting up your strobes, diffuser, and… well, it's just plain too much work for me in the circumstances I usually find myself in. If it suits your working style and gives you the results you like, go for it.

Problem: Shooting into sunset or any other background that's much brighter than your model. If you expose for the background, your model is too dark; if you expose for the model, your background blows out.

Solutions:

- This is a great place for your reflector. Bouncing light back into your subject allows you to make up for the difference in exposure and capture one without losing the other.

- If the difference is too great to make up for, it's time to get out your flash. Diffuse it and get it off the camera if you can. If not, try bouncing it off a wall or someone's white shirt.

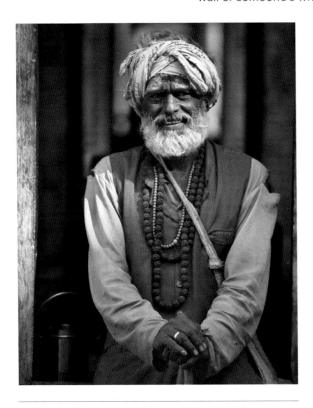

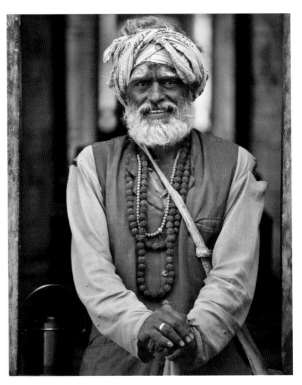

▲ Canon 5D, 200mm, 1/1600 @ f/2.8, ISO 800

▲ Canon 5D, 200mm, 1/1000 @ f/2.8, ISO 800

Kathmandu, Nepal. Undiffused, the light falling on this man's face is pretty unflattering. We evened it out with a large Photoflex diffusion panel to his left, just out of frame. The result is lower contrast, smoother tones, and—importantly—a little more exposure so we can see his eyes.

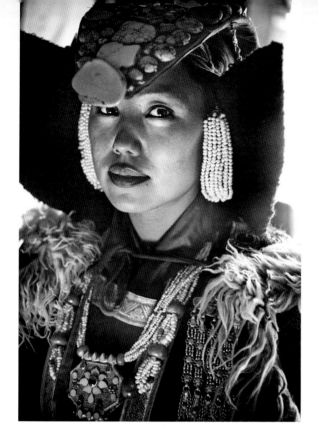

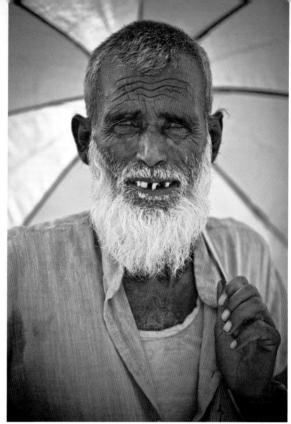

⚠ Canon 5D, 110mm, 1/40 @ f/2.8, ISO 400

⚠ Canon 5D, 140mm, 1/800 @ f/2.8, ISO 100

Leh, Ladakh, India. I photographed this woman on a model shoot we did with dancers at the Leh Palace on a Lumen Dei Tour. I'm a sucker for backlight, so we positioned her about six feet inside the door and then bounced light back into her face with a large white light disc held very close and low—you can see the catchlight from its bounce in her eyes.

Biratnagar, Nepal. This was a really bright day and this man, standing on the banks of a flooded river in Nepal, was disappearing into the background. I just gestured to him to put his umbrella back over his shoulder, which solved not only my lighting problem but cut the background clutter and gave me some nice color.

Problem: Subject/model disappearing into background.

Solutions:

- Position them against a lighter background. If that's not possible, see if moving them forward, backward, or even side to side gives them a hit of light on their hair, rimming them with light and giving some contrast to set them apart from the background.

- If this doesn't work, consider putting a remote flash up and behind them. If you angle it right, the flash will provide a hair light without flaring your lens.

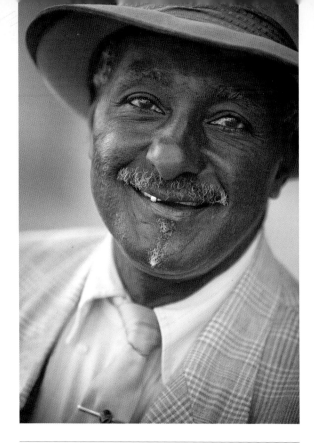

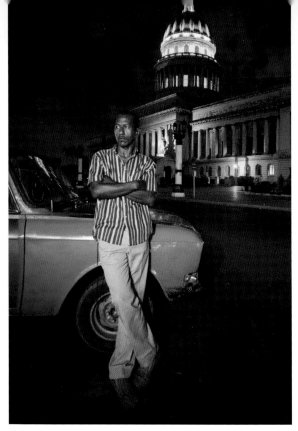

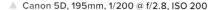
Canon 5D, 195mm, 1/200 @ f/2.8, ISO 200

Havana, Cuba. This man's a professional model for
tourists in Old Havana. He carries an unfortunately
phallic cigar that he insists on posing with, so the biggest
challenge was getting that out of the frame. After that,
putting him under an overhang with the brighter light
of Plaza Vieja reflected in his eyes was simple.

Canon 5D, 19mm, 8 seconds @ f/11, ISO 200,
Canon 580EX flash fired manually

Havana, Cuba. Sometimes there just isn't enough light.
This image was shot in a sequence of frames with a
tripod, long exposures, and a manually fired strobe. I
was trying to get light trails from the passing cars, but
this one—without the trails—was the one I liked most.

Problem: Subject has no catchlight in their eyes.

Solutions:

- No catchlight means no life in the eyes. Caused by a lack of brighter light
 reflected in the eyes, a white reflector catching the sun can provide this.
 So can a small flash when used with a light touch.

- Of course, the easiest solution is to move the model into a situation where
 they are looking out at a brighter light than the one they are in.

Problem: There just isn't enough light.

Solutions:

- Bounce it in. A large reflector can provide an incredible amount of natural, balanced light into a dark hallway or room.

- A flash that is bounced off some walls provides more light, too, and can be much easier to control, especially if the natural light suddenly disappears behind a bank of clouds.

There are very few locations I go without a large 5-in-1 reflector, at least one strobe, and PocketWizard radio remotes. While my preference, by far, is to use the reflector or diffuser, there are times when nothing but a strobe will do what I need, particularly when I want to add light and not merely modify it. I think of my 5-in-1 as a modifying tool and my flash as an adding tool.

Whatever tools you use, once you have enough light in the correct places, pursue the quality of light. Do what you can to make the light say what you want it to say. Be aware of how sharp it is, or how soft. Watch where shadows fall and how deep they are. And do whatever you can to give your subjects a great catchlight.

> "Once you have enough light in the correct places, pursue the quality of light."

Closer to the Source

The closer your model is to the source of light, the softer that light will appear. Distant light sources are smaller, and they create harder light. So when using a diffusion panel, experiment with getting really close to your model and see how much softer the light is, how much more it wraps around their face.

You can do the same with a white reflector. Get it nice and close. Doing this with a silver reflector will burn out their retinas, so play nice.

This principle is why we bounce our flash off a wall or a reflector—it creates a larger light source and thus a softer light. Firing your flash through a large diffusion panel does the same thing. Didn't bring one? Put the subject closer to a wall that's got some light bouncing off it. Soft light is everywhere; you just have to use it.

Four More

Placing the human figure into the frame is more than a decision about composition. Where the placement of buildings and inanimate objects is entirely compositional, the human figure communicates volumes on its own, even before it is placed into the context of the frame. For this reason, it demands special attention as its own compositional element. Even in silhouette, without the aid of the expressive nature of the face, the human figure is so familiar to us that its positions and gestures speak loudly. Used to reinforce the communication of your image, the human figure can strongly add to your images. But used without consideration, it can work against the impact or information you intend your photograph to express.

Here are four suggestions as you work with the human form within your images:

- Get enough of it in the shot...but no more. If you do not need the legs and feet of your subject to tell the story you want to tell, exclude them. But be careful what you crop out and what you leave in. Cropping people at the joints or leaving small bits out of the frame can feel sloppy and unintentional.

- Ensure that the body language is congruent with your intended mood or message. We've already discussed the power of the human face, particularly the eyes, to communicate emotion, but it doesn't follow that the rest of us has no role to play in communication. Our posture and gesture, even in silhouette, can be very powerful.

- For a moment, try looking at your subject not as a person but as lines, shapes, and tones. Do those lines and tones that are created in your viewfinder lead in the right direction? Are they balanced within the frame? Would the lines work better if your model turned to the left or right, giving you access to more oblique lines of a body seen in perspective rather than straight on? Would tilting your camera and giving it a "dutch" angle give you a more powerful diagonal line through the image than you might have had leaving the camera level?

- Don't forget the details. While your subject is there, take a quick visual inventory. The face and emotions get all the attention, but a person's hands or clothes tell stories all their own, or support the story being told by the face.

"Placing the human figure into the frame is more than a decision about composition."

▶ Canon 5D, 200mm, 1/400 @ f/2.8, ISO 400

Beijing, China. A guard at the Forbidden City. Simple and symmetrical.

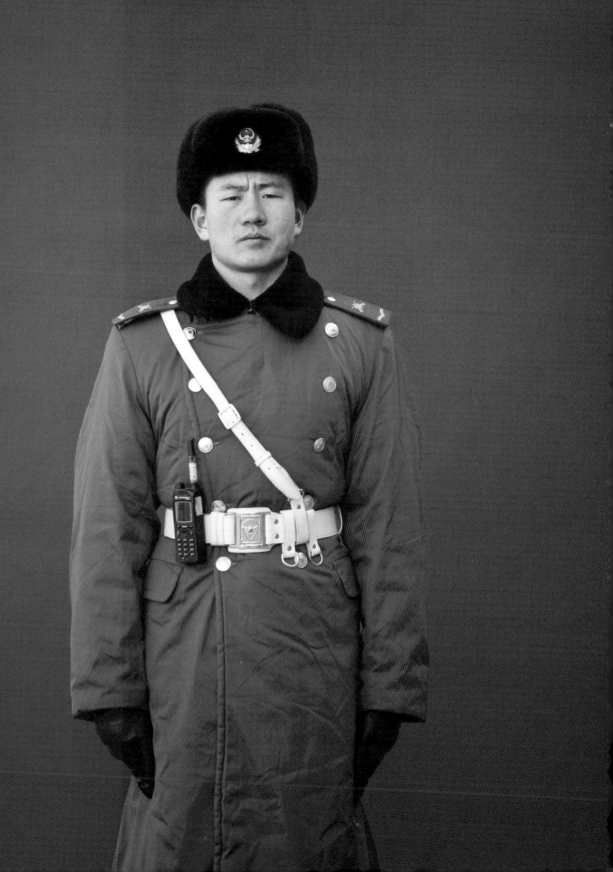

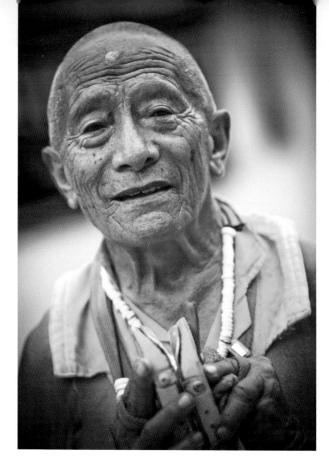

▶ Canon 5D, 135mm, 1/1250 @ f/2.5, ISO 200

Kathmandu, Nepal. The man behind these hands is a Buddhist devotee. I see him each time I visit Kathmandu. He circles the Boudha stupa, kneeling, then lying prostrate, sliding his gnarled hands forward on these little sleds. He rises, takes a step, and does it again. He's one of the kindest men I've ever met, and if you're ever there, be sure to greet him. He'll smile and bless you for the effort.

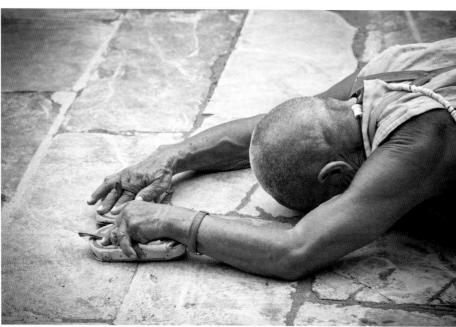

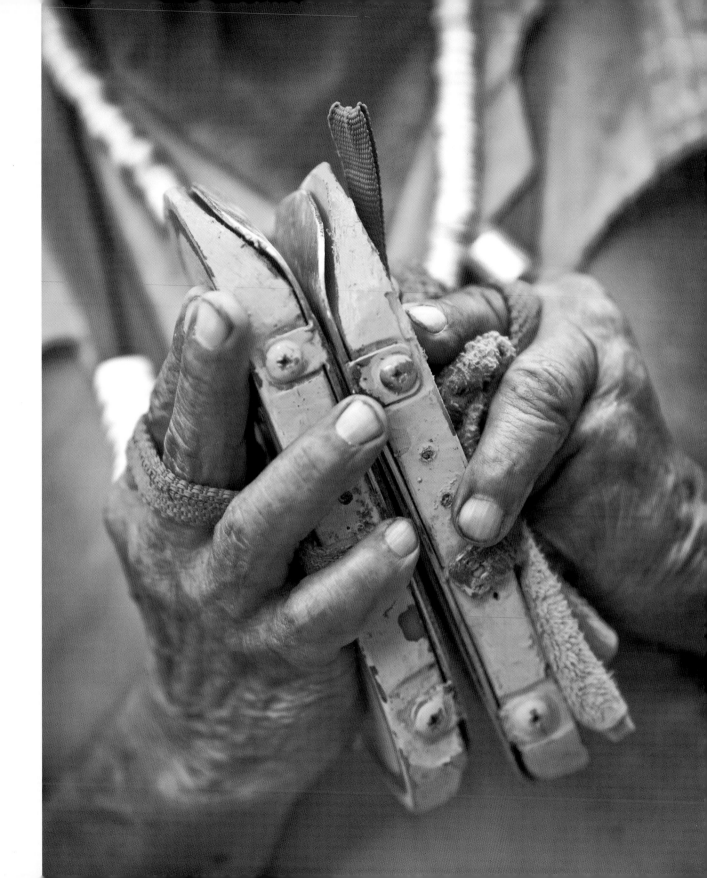

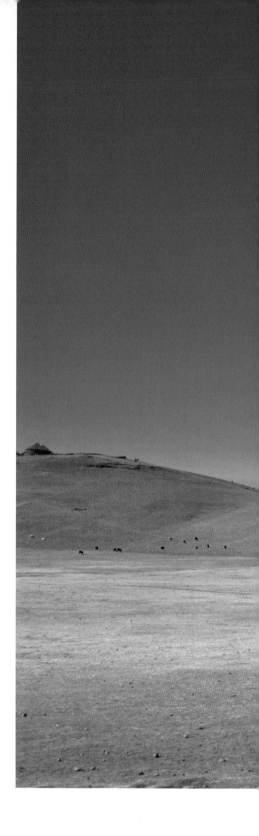

Photographing Places

PHOTOGRAPHING THE SO-CALLED SPIRIT of a place is, at

the best of times, a bit of a tall order. For one thing, there is

probably not one single spirit that defines any given place,

so trying to capture it is presumptuous at best. For another,

places—like people—change with time and season. I am not

the same person I was last year, and my mood changes daily.

The same goes for places. The New York you experience in

▶ Canon 20D, 17mm, 1/800 @ f/9, ISO 400

Ethiopia, on the way to Lalibela. All wisdom to the contrary, I shot
this while leaning out the window of a Land Cruiser at 40 mph. Not
a technique I recommend. Next time I will get the driver to stop.

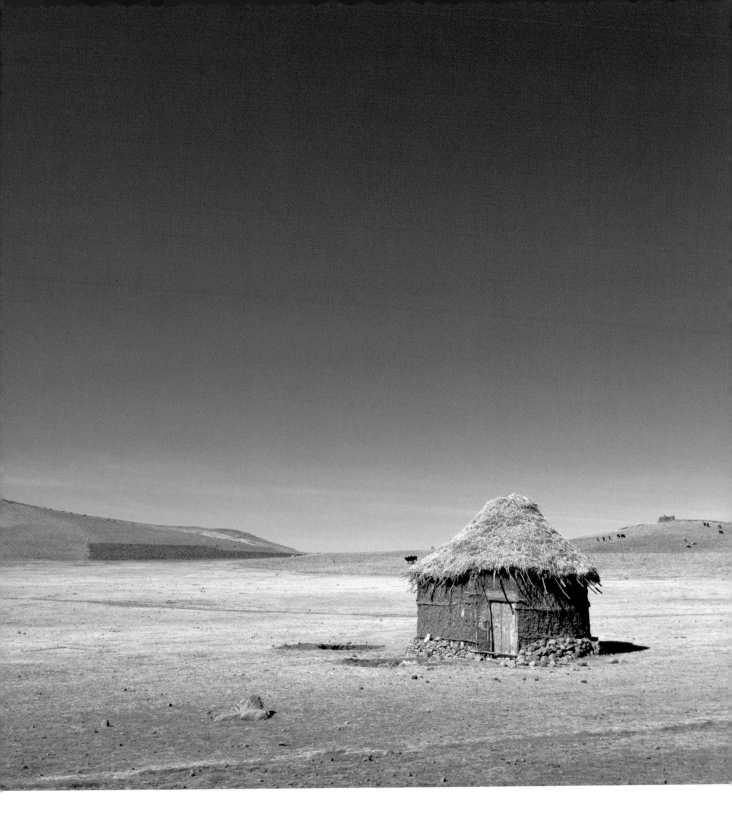

Giza, Egypt. This was one of those places where I decided to combine my scouting and my shooting. We arrived early—and with a plan. Not being really drawn to the pyramids and not having a client to shoot for, I treated the morning there as my only chance to shoot the place, but remained open to coming back if it surprised me. So I was constantly thinking about how I could shoot it differently at a different time, from a different place. Although I didn't scout the area before shooting, I researched it well and knew exactly where the sun would rise and where I wanted to be.

December will be different from the New York you experience in August. Also, just as people are often different, depending on who they are with at the time, so too will places seem different from person to person. Cutting through these challenges and taking photographs that not only remind you of a place—but that also reveal that place to others—is the task of the photographer who sets out to capture the spirit of a place.

How you create a photograph that is both representational *and* interpretational depends on how deeply you experience a place and how familiar you are with your visual language tools. A representational photograph says, "This is what Vienna looked like." An interpretational photograph goes one better and says, "This is what Vienna *was like*. This is how I felt about it." It's the difference between your wife's passport photograph and the portraits you took when you got engaged. Both may have been created with similar technology, but what stands in that great gulf between them are the passion you have for your wife, the knowledge you have of her personality, and your willingness to use your craft, time, and energy to express that. One says, "She looks like this." The other says, "This is who she is to me. It's how I feel about her. See how amazing she is?"

It's as easy to fall in love with a place as it is with a person, and though I'm not saying it's the same, it makes for a helpful way of looking at things. The process is different, but the goal is the same: the creation of images that reveal the personality of a place as you've experienced it, and in such a way that your viewers will look at those photographs and react with an emotional response rather than thinking, "Wow, you must have a really great camera." One can always hope.

Research

I'm a big fan of planned spontaneity. Planning ahead of time allows me greater spontaneity while I am shooting, and it relieves some of the stress inherent in wandering a place looking for something to shoot. Before leaving on my around-the-world trip, I made a shot list for each city, culled from watching Lonely Planet videos, reading guidebooks, and asking other traveling photographers for ideas. Early in the planning, I look for generalities, not specifics. I look to identify my preconceptions, uncover things I hadn't thought of, and begin to let the ideas incubate. The goal is not so much a shot list as a thought list. This applies to shooting at home as well as to traveling—in fact, sometimes more so, as we tend to take our hometown for granted.

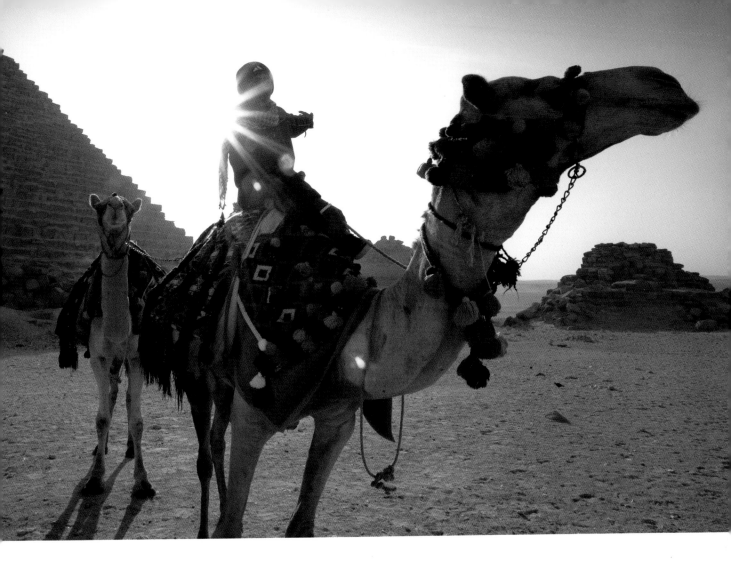

Here's my very first thought list for Cairo: Egypt, pharaoh, pyramids, Sphinx, camels, sand, Arab culture, palms, metropolitan, City of the Dead, souks and bazaars, camel market, bright colors against muted sand, Nile River, fishing, fish markets, falucas. It's not a long list, but it's a start. In fact, I ended up with only a few images of these things specifically, but it gave me a starting place. These things are the first step in identifying local icons and the visual cues that allow you to shoot images that, depending on your vision, either exploit these icons or avoid them. Go in the direction appropriate to your vision and experience of the place, but start with an awareness of the possibilities.

From here it's a matter of refining your list. If you have longed to see the pyramids since that project you did on Egypt in third grade geography class, you

have your work cut out for you. How do you take a photograph of a place so over-photographed and over-represented by mediocre cliché shots? It begins with research. Where are the best angles, perhaps the ones no one has shot before (if such a thing exists)? Take some time on Google and look for images of the pyramids. See what's been shot; see what hasn't if that's possible. Now find out how early you can get there, if you can climb them, and how long they'll let you sit there. If you've planned a gorgeous shot of the pyramids at sunset and there is a laser light show at the same time, it'll help to know that, too. Think of every angle and then, when you've done your homework, go and hold your plans lightly because there's nothing like encountering a place to have your expectations totally changed. You may go there and hate the place. If the photographs are for a client, that's tough because you still need to shoot it as if you love it. But if you aren't shooting for a client, you can either go elsewhere, pretend you have a client and force yourself to shoot the place as though you love it, or zero in on why you don't like it and shoot that. But hold the plans loosely because, until you get there, you're just guessing.

These same principles apply when you shoot closer to home. Do what you can to identify your presuppositions about the place, start from a clean slate, and do your homework. You may find you don't know home like you thought you did and uncover angles and subjects you'd never considered. But it all starts with knowing as much as you possibly can before you get there.

Scouting

Once you get there, and you're armed with as much local information as possible, it's time to scout. Scouting is the act of going to a location and discovering it's nothing like you thought it was, that you've planned yourself into a corner, your local contacts were clearly sniffing the local glue, and in no uncertain terms, you're screwed if for one minute you ever thought you could shoot anything decent.

And then you take a breath, wander around a little more, think about the direction of the sun in the evening, discover that things are quiet now because it's siesta and in three hours the place will be hopping. Or you cut your losses and move on, finding a location better than you imagined, and aren't you glad you did this now rather than on the evening of your last day in town when no time remained to recover and shoot elsewhere?

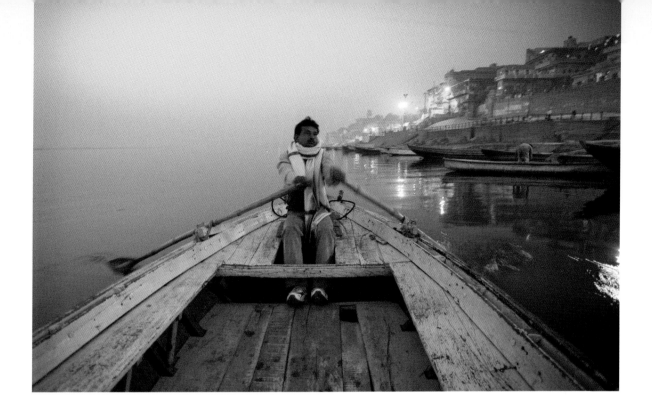

▲ Canon 5D, 17mm,
1/8 @ f/4, ISO 800

Varanasi, India.

Scouting is no substitute for wandering aimlessly, which is also important, but it's a crucial part of getting the shots you want, or the ones the client wants. It's doing your due diligence. I know a number of photographers, myself included, who scout with minimal gear. They go, they wander, and they pack a point-and-shoot camera with a good zoom lens. Unencumbered by the technology, it's often easier to "see" the place, to wander, to consider possibilities and back-grounds and "what ifs."

The key is information. The more you know, the better. But it's actual scouting that will give you the more experiential hook on which you might better hang your photographs when you return in the morning. In Varanasi, India, a couple of years ago, I did my scouting for about a day. I wandered up and down the steps that line the Ganges and asked myself two questions: What can I shoot in which locations? And, more importantly, what is this place all about?

It was a frustrating day, full of doubts and disappointments. Locals didn't seem to want to be photographed, I was hounded by boat touts, and the water was at an all-time low. But it allowed me to identify my expectations, clear the cob-webs, and see what was really there. I came to see that this place was about the relationship between the people and the place, specifically the people and the river. It was their place of worship and trade, and it was the place they went to

> "Taking some time to separate the research phase from the creative phase often allows the creative phase to function a little more unhindered."

die. They went there to bathe, to find forgiveness, to get on a boat, to do their laundry. So I spent a week there, kept entirely to the banks of the river, and photographed the interaction of people and place. Scouting will give this to you, and taking some time to separate the research phase from the creative phase often allows the creative phase to function a little more unhindered.

Do It Again

One of the most helpful parts of my process is an AAR, or After-Action Review. It consists of spending time at the end of the day, usually while looking at the day's selects, and asking myself what went well, what did not go well, and what I shot today that I could shoot better tomorrow. For all the scouting in the world, there's nothing like shooting something to realize you could have done it differently. Sometimes the angle needs to be changed, sometimes the time needs to be changed to accommodate the light, and sometimes the moment you hoped for just never came. Don't let the knowledge you gained on today's shoot go to waste if you can redeem it tomorrow for the images you *really* wanted.

Not-So-Great Expectations

It's no secret that as humans we hear what we want to hear and see what we want to see. If our expectations determine, to some degree, what we see, then to that same degree our expectations determine what we will and will not shoot. In the case of photographing new places, especially where well-known destinations are involved, we have a lifetime of postcards and classic travel photographs that inform our thoughts and feelings of a place. In the case of photographing at home or in places we know well, these expectations often stand in the way of seeing a place more fully.

To the degree that we keep to that vision, we will never see, feel, or experience a place for ourselves. When shooting the Taj Mahal on my first trip to India, it took all day to first shoot the classic images and get them out of the way before I could slow down and begin to see the place for what it was, or what it was in those moments to me. A compelling photograph is one that says what you feel about a place, and to feel something beyond the cliché you need to take some

time and slow down. Stop looking and begin seeing. This has been compared elsewhere to the difference between shooting a picture of a model and shooting a portrait. The image of the model, usually a product shot of some kind, is an image *of* a person. A portrait is an image *about* a person. And so it is with photographs of all people, places, or cultures.

Expectations rear their heads in other ways as well. What you expect to see, experience, and shoot often determines your selection of gear. If you wind up on location expecting to shoot tight portraits and discover, as I did in India, that you feel differently than you originally thought about a place—that you see it differently and do not have the tools you need—then you are limited in your ability to express yourself and create the images that are in your mind. I realize creativity always happens under constraints of various kinds, including limited gear, but photographers who allow their expectations to inform their choice of gear without being conscious that they are doing so risk exposing themselves to more constraints than necessary. It's hard enough to get truly compelling images; there's no need to make it harder.

I very nearly did not bring my 17–40mm lens with me on my first journey to India. I expected to do more portraiture and planned for that. At the last minute I threw it in the bag. The week I spent in Varanasi produced some of my favorite images, and they were shot entirely with that lens.

Be aware of your expectations, and plan to have them be exceeded or go in a different direction entirely. The same story could be told of my tripod. It's not heavy; it's a Gitzo basalt tripod that's small and light, but I nearly didn't bring it, and its lack on that trip would have meant coming home with much different images. Bring more than enough batteries and memory, too. I shoot to 8GB Compact Flash (CF) cards and I always carry more than I think I will need for a day of shooting. You never know, and that's what makes expectations such a hazard—at the end of the day they're just guesses, and guesses are notoriously unreliable. It's always that one time you just "go for a short walk," planning to be back in an hour, but you stumble on something wonderful and stay out all day. If you have an extra battery, a handful of CF cards, and a granola bar, you'll be spared a long sprint back to the guesthouse to get them. Assumptions always seem so airtight at the time, so well conceived. That's what makes them such a pain in the ass. They suck us in with their logic, and that logic doesn't stand a chance against the unexpected and spontaneous.

"Stop looking and begin seeing."

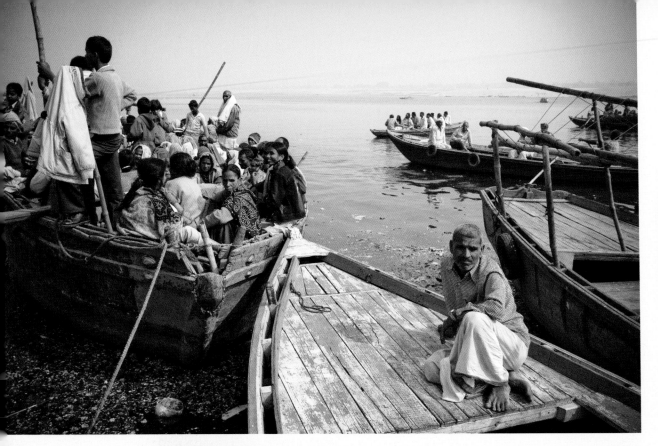

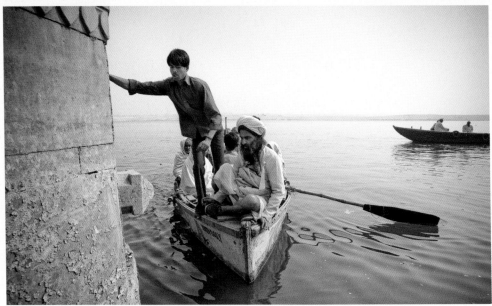

▲ Canon 5D, 21mm, 1/320 @ f/10, ISO 200

◀ Canon 5D, 33mm, 1/320 @ f/10, ISO 200

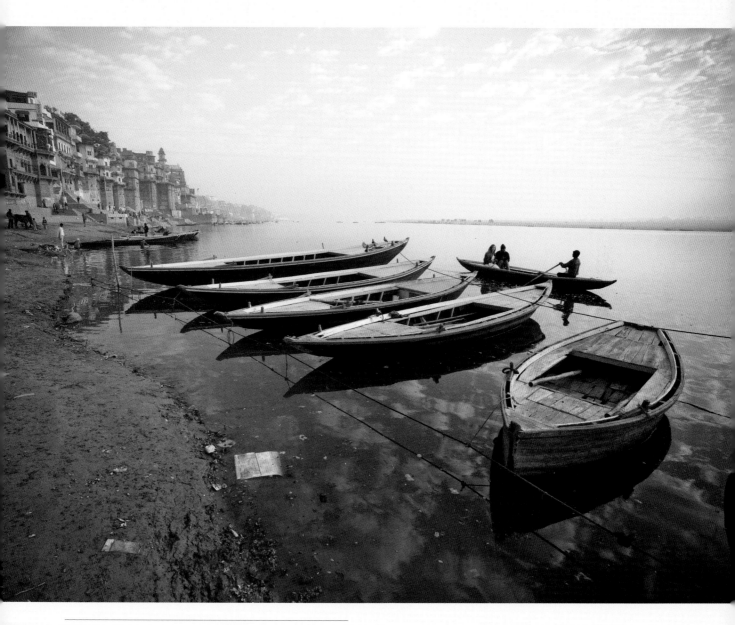

▲ Canon 5D, 17mm, 1/320 @ f/13, ISO 640

Varanasi, India.

Be Prepared

If our assumptions can be so persuasive, perhaps it's easier to just create a new assumption—one that trumps all others—than it is to fight the old assumptions. If you can't beat 'em, join 'em, right? When I shoot, my master assumption is this: nothing will go completely as planned. Not because my planning stinks, but because life has a habit of getting in the way. So I plan as carefully as possible, based on the best research I can gather, but I plan into the margins, as it were. I create a buffer. Yes, I know I am going out specifically to shoot portraits of a colorful local man, and I know I'm going to use my 85mm f/1.2 lens. I have a vision of the shot, and I know how I'm going to express that vision.

But then I get there, and as we're shooting, my vision changes. I see something I didn't see before, and if only I had my 200mm lens I could really pull that background detail in. If only I had my 17–40mm I could really open up the

Canon 5D, 24mm, 1/1000 @ f/9, ISO 400

Beijing, China. Unsure whether our layover would permit time in Beijing en route to Mongolia, we secured visas and carried on more gear than usual, just in case. As it turned out, we had a couple hours to photograph the Forbidden City. Being prepared and planning for serendipity always pays off.

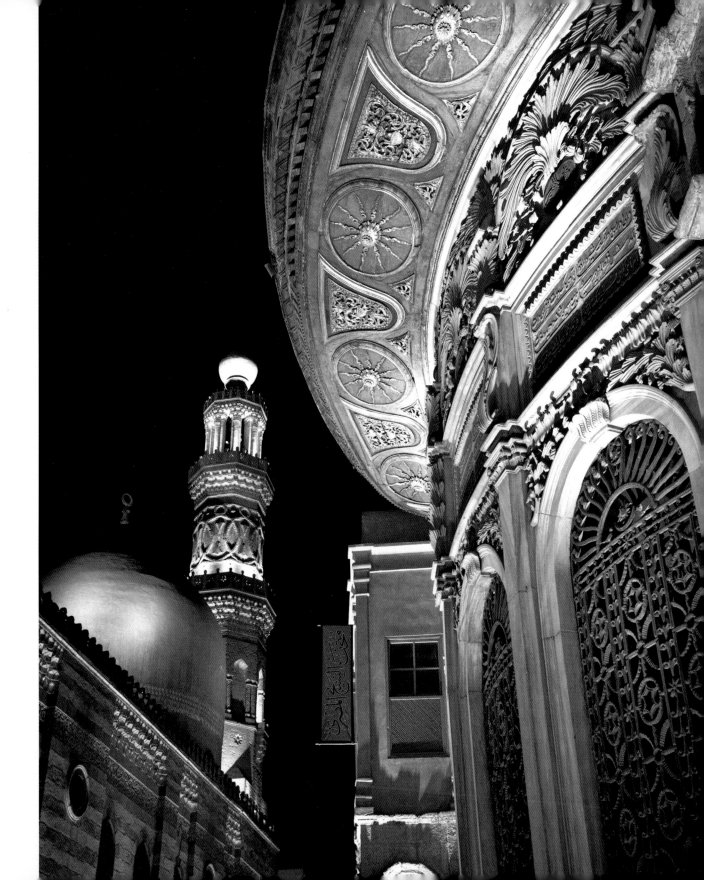

> "My clients don't pay me to travel light—they pay me to come home with the shots."

background and give myself some environmental portraits that hadn't even been part of my vision. On the way home, we pass an idyllic fishing village and the men are pulling in the boats. My memory card is full. My battery is dry. My tripod is back in the guesthouse. I would have brought them if I'd known, but I wasn't expecting…. And that's always the way it goes, isn't it? I wasn't expecting that. I hadn't planned on it. I was sure I'd charged them.

Traveling ultra-light has its advantages, but being prepared is not among them. You might be okay with this if you're shooting for yourself, particularly if packing too heavily prevents you from shooting other opportunities. But when you shoot for a client or for a project that means a lot to you, it's usually better to be a little overprepared. My clients don't pay me to travel light—they pay me to come home with the shots. If traveling light—either by cab to a local assignment or by plane to an international one—helps you get the shot, do it. If it prevents you from getting the shot, don't. I don't travel light. In fact, when I do travel light and I arrive at the airport patting myself on the back for such economy of packing, my colleagues arrive and mock me for packing the kitchen sink.

For me, being prepared means anticipating changes in weather, broken gear, changes of plan, and the unexpected event. It means carrying an extra camera body, an extra lens, and a roll of duct tape. It means dragging my tripod through 15 airports knowing I may never use it. It means going for a walk with extra batteries, extra cards, the lens I think I might not use, and a bag or vest full of sunblock, granola bars, bottled water, and my Moleskine notebook. It means arriving on a commercial shoot with more gear than I think I'll need.

You just have to plan for—or make room for—serendipity. This isn't geeked-out logistics I'm talking about; it's about having the tools to practice your craft when you've traveled a long, long way to do so, you have clients relying on you, or Murphy's Law kicks into high gear. There is such a thing as too much, as being overprepared. How do you know? When that last piece of gear makes it harder, not easier, for you to do your job. It's a fine balance, and I guarantee you'll miss a shot either way: too prepared, and the time will come when you miss the shot because the gear weighed you down in some way; not prepared enough, and you'll miss the shot for the lack of a battery or flash. Them's the breaks. You win some, you lose some.

Fill Yer Pockets

Whether I am at home or on location around the world, I tend to have my pockets full. I used to wear a photographer's vest—and still love their functionality—but in hot climates they just tire me out, so I've started wearing my gear on a belt with a Think Tank Photo system. Inevitably, these are the things that I don't leave home—or the hotel—without.

Home

- Hoodman Screen Loupe
- Bandana for cleaning/drying gear
- A granola bar or two
- A bottle of water
- Leatherman multi-tool
- Two spare batteries
- Two spare 8GB cards
- A few spare bucks for coffee
- Gaffer tape
- Flashlight

International

All of the above, plus:

- My passports
- Local currency
- Compass
- Lip balm, sunscreen
- iPod Touch with recent work on it
- Cell phone with local SIM card
- Address and phone number of hotel

All of this fits in one of my belt bags, and it always comes with me. If there's any chance at all that I'll use a strobe, I'll pack one of those, too, plus spare batteries and some gels.

WITHOUT THE FRAME

KATHMANDU, NEPAL. I shot this the day after I saw it. I went to dinner without my cameras. Glad to be free of all my gear, I ate, sent some emails, then walked home and—wouldn't you know it?—missed some unforgettable opportunities. Everywhere people gathered around butter candles or fires, their faces illuminated by the flames, small pockets of warm light in darkness I wouldn't normally think about shooting in. I walked the long road back to the guesthouse kicking myself. The next night, I brought my camera and my fastest lens, Canon's 85mm f/1.2 L, which allowed me to shoot at ISO 800 and still keep the shutter at a manageable 1/100. The scenes I saw the second night were easily more beautiful than the first, so while leaving my camera behind was regrettable, not seizing the chance to return would have been much more so. The images I got on this evening are some of my most cherished, in part for their warmth and intimacy, and in part for the reminder of lessons learned—carry your camera, and don't bemoan missed opportunities. Just chase new ones.

▶ Canon 5D, 85mm, 1/100 @ f/1.2, ISO 800

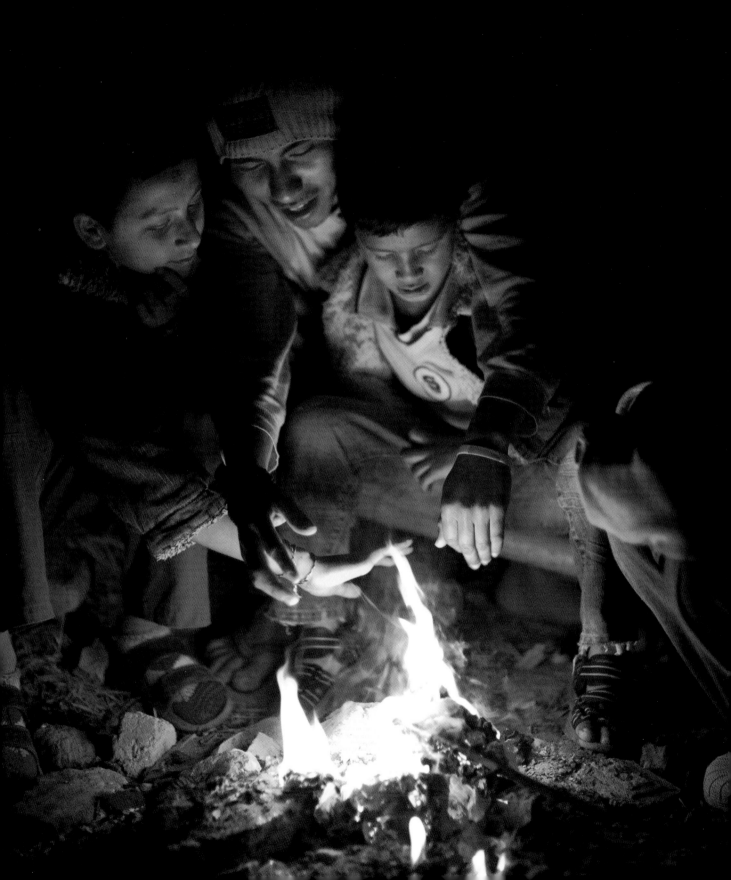

Beyond the Postcard:
The Value of Wandering

I was looking for the so-called Blue Mosque in Cairo. It took us three hours to find it, and when we did it was rundown, lifeless, and occupied by an asthmatic and self-appointed guide who I thought was going to die on me as he led me up the stairs to see the view. As cliché as it is to say that the journey matters more than the destination, it's truer than not most of the time. While it took me three hours to get to a destination in which I didn't shoot a single frame, the journey there through the alleys, side streets, and souks provided me with many shots. Getting lost has given me more of my better images than I care to admit.

When seeing and capturing the spirit of a place, nothing can compete with wandering on foot and getting good and lost. Not momentarily lost, but completely and unfindably lost. Getting this kind of lost opens the door to serendipity and chance like nothing else, and has always, for me, resulted in some of my favorite images. I suspect this is, in part, because you generally abandon your expectations the moment you have no idea where you are. When you round the next corner and have no idea if it will open to a bustling market, a family courtyard, or a narrow alley that is the de facto red-light district of a town, it opens in you an increased receptivity without all the usual effort and Zen thinking. You just can't help but be open to what comes 'round the bend.

Visiting a new city is a little like dating: your first impressions are calculated, you see what you want to see, and to a degree, she shows you what you want to see. Wandering aimlessly in a new place is a little like moving in with that new person. Suddenly you are seeing the things that were so easily hidden before. It's not that she intended to hide these things from you; you just never asked. All your exchanges were so geared toward seeing what you wanted to see. But wandering lost in the city you see it all—the hidden truths, the dark corners, the unpolished jewels. You get beyond the surface of a place and begin to see its layers and deeper personality. The metaphor isn't a good one, but it's the one that most commonly occurs to me, reinforcing for me that photographing a place is much like photographing a person—it's an effort in revealing on the outside what is present on the inside.

As you wander, keep a mental list of the things you see, the things that you begin to identify uniquely with this place. Think of this as visual inventory. It might

> "When seeing and capturing the spirit of a place, nothing can compete with wandering on foot and getting good and lost."

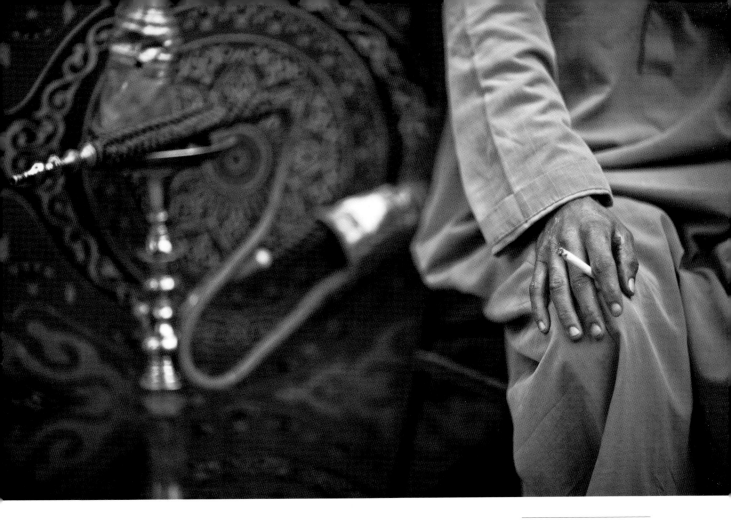

▲ Canon 5D, 85mm,
1/800 @ f/1.2, ISO 200

Cairo, Egypt.

be blue taxis or green fire hydrants; it might be the language on the signs or the numerous old bicycles. Whatever these things are, make a note. Write it down if you have to. Or take a photograph. The reason you're doing this is to form an inventory of things you want to shoot. The blue taxi on this corner might not be a particularly strong photograph, but you've identified it as something you do want to shoot—so keep your eye open for the right blue taxi on the right street corner. That taxi might only be a great background, and that green hydrant might not work on its own, but when you turn the corner and see the hydrant in the foreground and the taxi in the background your mind will go back to that list. If a list doesn't work for you, that's fine, too. Just do what it takes to be receptive and conscious of the things that turn your eye. Wandering gives you a chance to clear your head and think about the place you are in, the photographs you've taken, and the ones you've yet to capture. I carry a small notebook and pen and make sloppy notes and checklists of all these things. Remember, it's not what

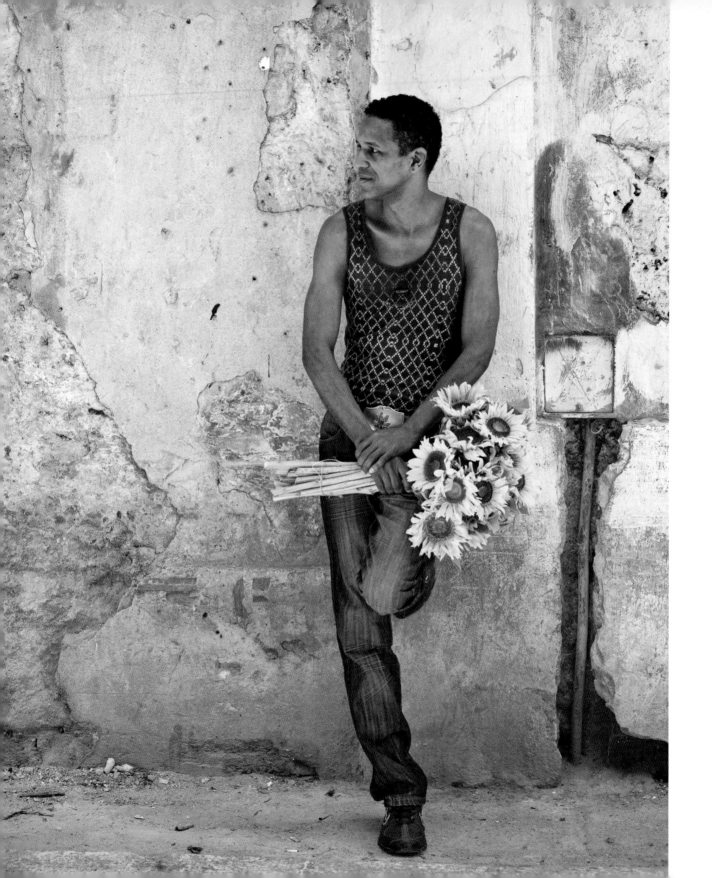

others think about a city, or how they experience a place—it's how *you* experience it, see it, photograph it. Shoot the things that catch *your* eye.

Wandering in this way has its challenges. Getting lost, for one. Wasted time, for another. There are parts of Vancouver that you could wander for days and never see anything that captures your imagination. Most places are like this. It's not that those areas aren't worth photographing at all—it's just that they don't catch *your* eye. People are like this, too—some folks are just more interesting to look at and photograph than others. There is no shame in moving on, as long as you aren't shooting for a client. Local advice can help you avoid these areas—the more carefully you find out what kind of things are in which direction, the more carefully you can aim your aimless wandering.

It's not just boring neighborhoods you want to avoid—this is subjective—but dangerous ones. This is less subjective. It doesn't seem to matter where you shoot—locally or globally—there are always places you want to steer clear of, places without a visual hook for you, and places you ought to avoid. Your Lonely Planet book can be helpful in this regard, as can the guy at the desk in the guesthouse—he probably avoids these areas, too. Playing it safe is important, and a little paranoia can go a long way toward avoiding a mugging. But too much paranoia or fear can cripple you creatively, so shoot where you are comfortable. And when you get so lost that you don't have a hope in the world of finding your way back, grab a cab or a local, pull out the business card of your hotel (you did put one in your pocket, right?), get some directions, and start the long walk home on a new path through new neighborhoods and see what there is to be seen.

There is a long history of this kind of wandering photography. Legends like Henri Cartier-Bresson practiced it. They were called *flâneurs*, or wanderers. It's been long accepted that this kind of exploration without expectation yields exciting photographs and experiences. It takes us beyond the postcards, beyond the best-foot-forward impression that a city, like a person, tries to make on new acquaintances. The postcard shots are the easy ones, the low-hanging fruit. They're easily found by the crowds of other photographers gathered nearby, and they yield the same photographs that those crowds of photographers have already taken. Take the time to get beyond the cobblestones the tourists have worn down, and get under the skin of the place. You'll be rewarded for it.

◀ Canon 5D, 73mm,
1/250 @ f/4.5, ISO 200

Havana, Cuba. I have no idea where I shot this. Old Havana somewhere. I didn't even know I was looking for this image until it found me.

Try this exercise.

Start with the postcard shot. The Eiffel Tower, for example. Then walk in ever-widening circles around it. (If you do this with the Eiffel Tower, you'll fall into the Seine, but you could instead choose a zigzag pattern.) Turn left at one corner, right at the next café, then left, then right.

Just walk. Keep your eyes open. Be receptive. Don't allow yourself to deviate until you come upon something totally unexpected. The purpose of this exercise is to force you away from your assumptions, plans, and expectations and into situations where the place you are in can unexpectedly open to you.

Slow Down

If photographing a place is a little like photographing a person, each visit to a place is an encounter, and the extent to which that encounter touches you, you will see that place in a new way. It is very hard to photograph a place in a hurry while skipping across the surface of it. It can be done, and it can be done in a way that produces beautiful images, but not usually in a way that produces deeper, more revealing photographs. Often we're reduced to shooting the classic stuff, the postcards and the clichés, when we photograph quickly.

"Try going deeper rather than broader."

Of course, it's all relative. I've tried to get under the surface of whole cities in the span of a week. Ludicrous. I wish I had more time. But no one will ever see the images of a Havana I haven't encountered, only the images of the Havana I did encounter. My photographs are not using their thousand words to say, "Here is a definitive view of Havana," but to say, "Here is the Havana that I experienced." To the degree that you experience a place, you can photograph it, and you can do that in a day, a week, or a month.

So unless you have an assignment for a client who dictates otherwise, try going deeper rather than broader. I chose the cities on my 2009 around-the-world trip with real intention, and I spent almost all of my time in a select few

locations. Old Havana, Old Cairo, the Tibetan side of Kathmandu. There could be books and books of photographs from the places I did not see while in Vietnam. But no one will see them because I wasn't in those other places, so I never took those images. Unless a client is creating my shot list, I am free to shoot the images I choose. So, for the most part, I choose to go deeper, and that effort pays off with images not possible on the first pass—the subtle details, the opportunities that you find only after walking past the same place every morning or speaking to the same street vendor each evening. Will I regret not shooting everything that Vietnam—even Hanoi—has to offer? I doubt it. But I will regret not taking my time, slowing down, truly meeting the place, and then creating images that reflect that. Wandering aimlessly is about what you choose to see, while slowing down is about how much time you allow yourself to see it, to soak it in, to listen to the place. The longer you take, the better you hear it. We don't always have that luxury, but when we do our photographs reflect it.

It's not easy to see the details when you're rushing past them, and it's impossible to shoot them when you're in a vehicle. The few times I've succeeded it's been sheer dumb luck. To truly experience a place, you need to walk it, smell it, taste it. You need to engage it on a level not possible at a running pace or in a car with the windows up and the AC on. Get out. Slow down. Hang out with the locals. Hear their stories, play with their children, watch them as they worship, work, eat, play. Participate where you can. This is true of any place—at home or abroad. You need to walk with camera in hand, take your time, and be willing to get diverted, distracted, and just plain lost.

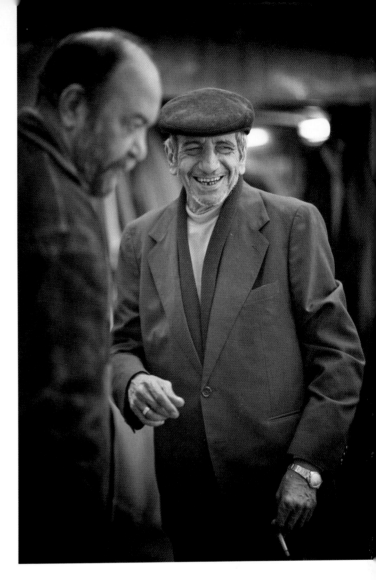

▲ Canon 5D, 85mm, 1/200 @ f/1.2, ISO 400

Cairo, Egypt. This is Munir with one of his friends. We met Munir at a teahouse in a souk in the back alleys of Islamic Cairo. He invited us in to talk, to have tea and a sheesha. In 30 minutes I casually made portraits and candids in a way I never could have if I had tried to do it quickly. This story repeats over and over again. Slow down, take time, allow yourself to be wildly diverted from your plan. People are the soul of a place; don't forget to meet them and enjoy their company as you explore a place.

The Feel of Place: Sensual Exploration

One of my favorite places in the world is Old Delhi, particularly Chandni Chowk. Walking it is sensory chaos. It's loud; the din of horns and bells and voices is inescapable. The air is thick with smells—diesel fumes, motor oil, incense, goats (both alive and recently butchered). It's a place you experience with every sense, each new smell or sound turning your head and pushing your curiosity. It's overwhelming and exhausting. But when walking it with camera in hand, it's a place you can't help but feel strongly about. I come out of Chandni Chowk with more images on a single outing than I gather in a week in other places. I think the more levels on which a place engages and captivates you, the more compelled you are—and the more able you are—to photograph it.

▼ Canon 5D, 46mm,
1/500 @ f/2.8, ISO 800

Old Delhi, India.

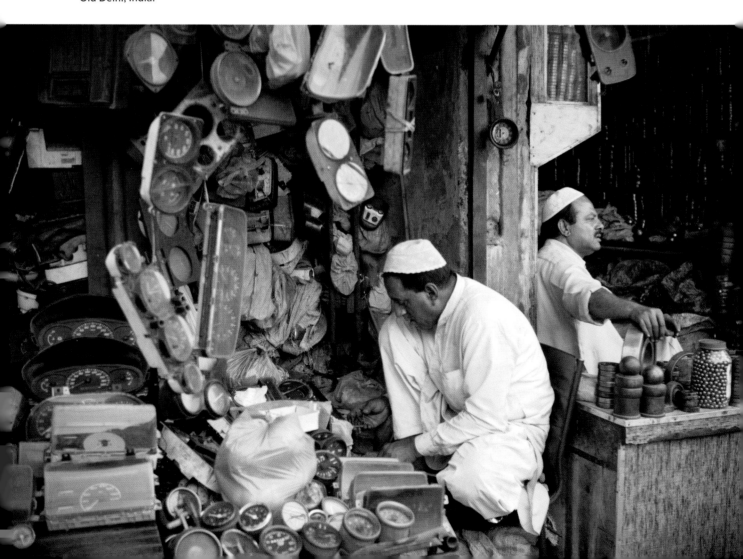

Walking a location does more than slow your pace. It forces you to explore a place with every sense engaged. Photography is a visual art, but that doesn't render the other senses unimportant in the process. Your other senses contribute to your experience of a place, and that contributes to your vision. The more you engage a place, the more deeply you explore it—aware of the smells, sounds, flavors, textures—the more able you are to answer these questions: What is this place to me? What is its character? And how can I best capture that within the impossibly restrictive limits of the frame? It's a question of raw materials—the more you have to work with, the better.

By all means, wander aimlessly, but do not do so with such energy given to your gaze that you forget to listen, to take in the smells and the feel of the humid air. The eye is a remarkable organ, but it is not the only means of perception, and while your eventual image will have only visual clues to lean on, the making of that image is richer for the participation of your other senses.

"The more levels on which a place engages and captivates you, the more compelled you are—and the more able you are—to photograph it."

Be Present: Physical and Emotional Receptivity

"F/8 and be there." That's the motto you hear. The best bit of this advice, the one that applies to every photographer, regardless of the discipline, is the last part: *be there*. Be in the right places, at the right times, and in the right frame of mind. Even if you have no idea that you're in the right place at the right time, being in the right frame of mind can sometimes make it so.

Be in the Right Place…

Being in the right place is often a matter of odds—there's just no way to know ahead of time that the place you are in is the "right" one. You can only know that in hindsight, when you have the photographs in the can and have that sense of excitement that comes when you know you got the shot. Still, you can increase your odds. How? Research and scouting. Start with your Lonely Planet or Rough Guide. Those will give you the broad strokes, while the locals, the guy at the hotel, or the backpackers who have been there for a month and have no plans to leave can help you with the details. The thing to remember is that unless these founts of local knowledge are photographers themselves, they're unlikely to look at things the same way you do. So there is no substitute for scouting.

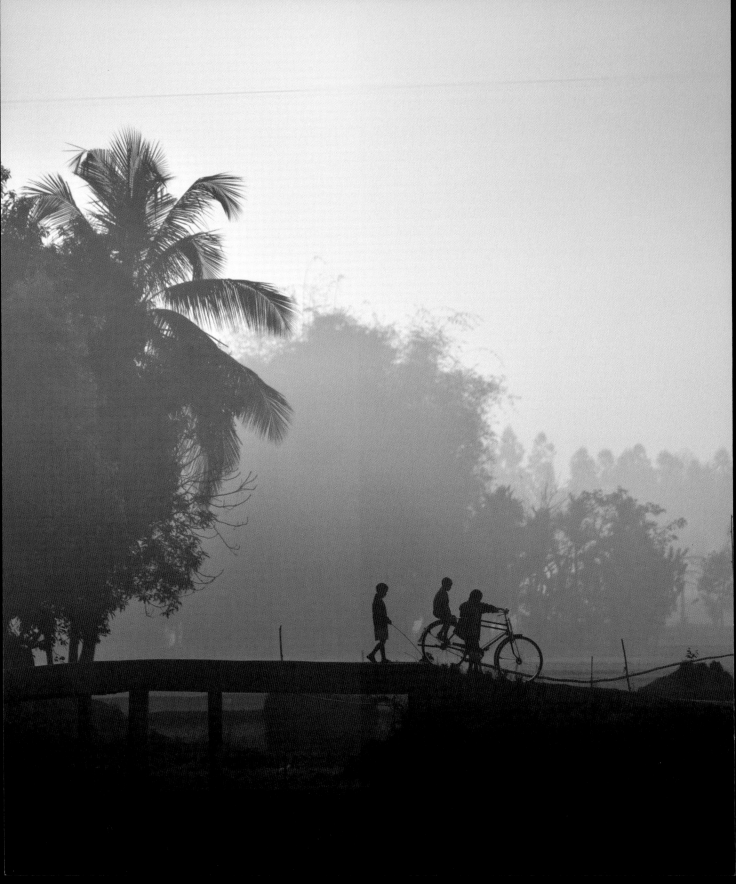

...At the Right Time...

You can't shoot if you aren't there, and in much of the world the action happens in back alleys, markets, and out-of-the-way places at hours most travelers would prefer to be asleep. Getting up with the sun and getting out there will make your images stronger, both in terms of what you capture and the light in which you capture it.

When I travel I often shoot between 5 and 10 a.m.; spend the midday hours researching, eating, resting, and downloading files; and spend the hours between 4 and 10 p.m. shooting again—depending on the time of year. Beautiful images require beautiful light, and the easiest way to get that is to catch it when it's low and soft. It's not the only way, but it's the easiest. Shooting this way also gives me the broadest amount of time possible to capture the spirit of a place, and gives me the broadest range of activities to capture. Shops opening, shops doing business, shops closing. Morning tea, lunch, evening meals. Rituals that begin a day, rituals that end a day. Light coming from one direction, light coming from the other. Were I confined to simply shooting in the middle of the day, I'd be limited in what I could photograph. The added bonus is this: you shoot when the tourists are sleeping or packing up to get back on their tour buses. I love photographing people, but if I wanted images of westerners in white shorts,

◀ Canon 5D MkII, 200mm, 1/1600 @ f/2.8, ISO 100

Sherpur District, Bangladesh. The sun had just risen, and kids were on their way to school. This moment comes only once a day, and it only lasts for seconds.

▼ Canon 5D, 52mm, 1/160 @ f/8, ISO 400

Dal Lake, Srinagar, India.

> "Living in the moment is more than just a principle upheld by the enlightened; it's solid photographic wisdom."

tube socks, and Tilley hats I'd have stayed home in Vancouver and waited for them to come to me.

Even in your own town, the mood of any given street corner can change over the course of the day, and each of those moods offers something unique to be photographed. How long has it been since you've walked your city as it was waking up or going to sleep? Have you considered getting out there and photographing the hustle and chaos when rush hour is at its peak?

Get Your Bearings

Carrying a compass so that you know where sunset and sunrise will be is a great idea. It helps when you get lost, too. Knowing which direction the sun will be moving in a couple of hours allows you to predict what the light will look like and where the shadows will fall. The light might not be perfect now, but it could be in an hour.

Checking the internet ahead of time for the sunrise and sunset times allows you to be where you need to be when the sun goes down—either in that perfect spot for magic hour or heading back to your guesthouse before darkness falls and that remote spot with lots of character becomes a scary spot with too many characters.

…In the Right Frame of Mind

If you're anything like me, you get to your location and your brain kicks into overdrive. Your eyes start scanning the place, hunting for something to shoot. My brain begins to chatter, to compare this place to the last place. It begins to tell me I'll never find anything here and might as well give up, saddle up to the nearest coffeehouse, and sit for a while. Or I begin to look for that one thing I came for, I get tunnel-visioned, looking for what is not there and missing what is there. It's so easy to be somewhere and not be present.

Living in the moment is more than just a principle upheld by the enlightened; it's solid photographic wisdom. When our minds are chattering and we're thinking

▶ Canon 5D, 68mm, 1/1000 @ f/2.8, ISO 100

Tunis, Tunisia.

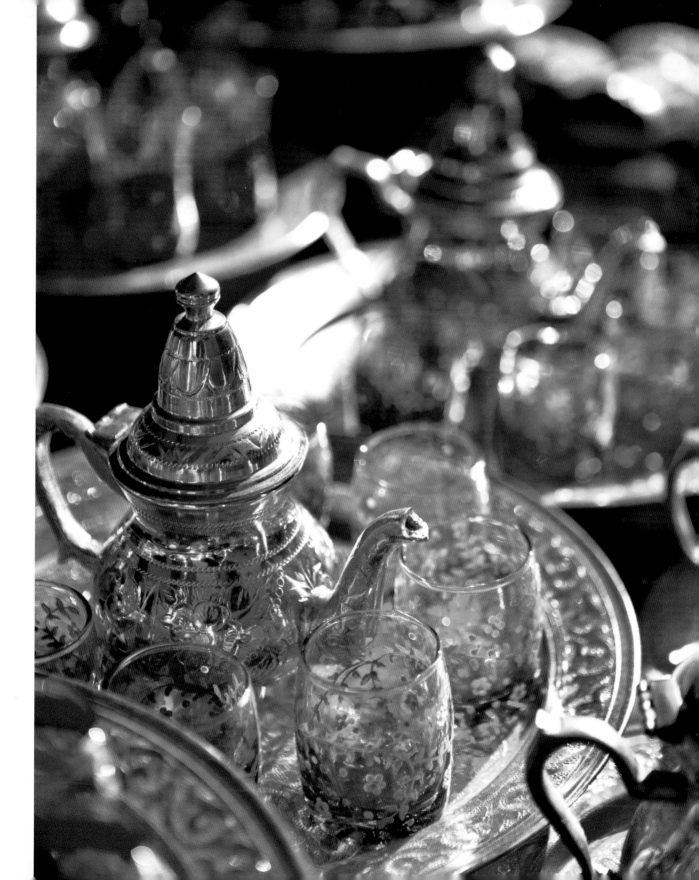

about a million other things—how hard this is, how tired we are, how elusive our subject is, and how terrified we are of the next dodgy meal eaten on the street—we aren't in the moment. We lose—and this is the key—our *receptivity*. We stop being attentive, even when we are trying so hard. Too hard, in fact. It's as though we're stuck on transmit instead of receive, and the creative process needs very much for us to be receptive. I think of it sometimes as though a voice is whispering, "Hey, look over here. See that?" And I'm saying, "Shut up! Can't you see I'm looking for something to photograph?" The sooner I slow down, take a breath, and stop looking for what I expect and hope to see, and just let the place show me what it will, the sooner I get creating. It's as though it's a collaborative process between the place I am visiting and my creative self. If I don't listen to my partner, the process stalls.

How open are you to seeing the place you are photographing in a new way? To letting the place itself show you around and into its hidden spots? How receptive are you to being, not a photographer first, but a *participant*? Not a looker but a see-er? A looker may never see what is there, so while the means to seeing might be the process of *looking*, it is *seeing* that is the desired end, in the same way that one seeks something not for the seeking but for the finding. Sometimes you just have to stop seeking so hard and let the thing you're looking for come out of hiding on its own.

It's a little like those horrible 3D magic-eye posters so in vogue during the '90s. The harder you looked, the less likely it was that the hidden image would appear. But if you unfocused the eyes and stopped seeking the image, it would emerge. Once you finally saw it, it was hard to believe you could have missed it. Your eye was free to explore the 3D image, but getting there in the first place was the hard part. I'm not saying not to look—just that sometimes the looking takes us out of the moment and gets in the way of the seeing.

Shooting Iconic Places

An icon is like a symbol, an image of something particular that represents something larger. The Eiffel Tower is an icon of Paris, the Taj Mahal is an icon of India, the Pyramids are icons of Egypt. The challenge of iconic places is shooting them with fresh eyes, and ideally with a fresh opinion. Arrive at any airport or train station in the world and look at the first rack of postcards you see—the

local icons are probably at the top, and they have been shot over and over again. It is easier to create a new icon or shoot an iconic image of something else than it is to shoot against the grain and photograph an established icon in a new way. But that doesn't mean it can't be done.

The guiding questions in shooting an icon in a new way are these:

- How has it been shot before and why?
- What emotion do these images generally appeal to?
- What do *you* feel and think about this place?
- Can you capture your encounter with this place in a new way?

The first question is easy to answer. Look at the postcards. Search Google Images or a stock photography library. You'll see more shots of these places than you ever wanted to. You'll also be able to divide them into a few groups and later, when you are there on location, you'll be able to see what wasn't captured simply by doing a little exploring.

The second question is less easy to answer. Some of these shots will appeal to no emotion at all. Some will appeal to romance or grandeur. Some will be more iconoclastic. What you're looking for are the ruts that these images fall into, so you can avoid them.

The third question is where the creative process begins—at your encounter with the place. Where your opinions, thoughts, reactions, and vision meet that place at that moment in time.

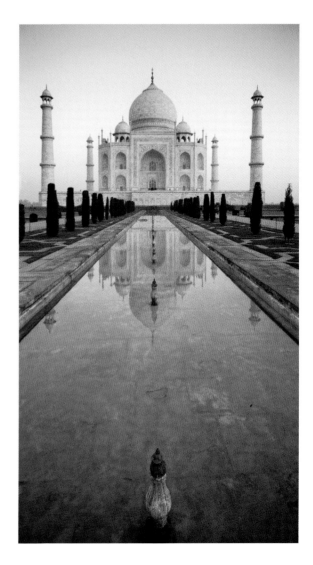

▲ Canon 5D, 25mm, 1/25 @ f/22, ISO 800

Agra, India. The iconic, but overshot, image of the Taj Mahal. The best I could do with this shot was to treat it with a split tone in Adobe Lightroom and hope someone might call and ask for a boring shot of the Taj with a nice split tone. Hasn't happened yet.

The fourth question is where the third one is played out and expressed. It's important to remember that there are few places in the world that have not been photographed. We all try to avoid the cliché shot, but the cliché comes not in *what* you shoot but in *how* you shoot it. It's also pretty subjective. Don't worry about not creating a cliché; instead, put your energy into creating an image that brings something new to the table, shows a different angle, or evokes a different emotion.

"The cliché comes not in *what* you shoot but in *how* you shoot it."

The first time I photographed the Taj Mahal, we had rushed from the train station to see the morning light hit the Taj at sunrise. We hurried through security, angrily placed our forbidden items in a storage locker (no food, no tripods, no electronics other than cameras) and rushed through the grounds to join the crowds already there and waiting for the first rays of light to kiss the white-marbled dome. It was not the best way to begin a morning at the serene monument to love that the Taj Mahal is always touted as. Don't get me wrong, I love the Taj Mahal—it's an undeniably beautiful building, as far as buildings go. But my passion is not buildings—it's people and cultures—and when the building is no longer what it once was and is now only a tourist attraction and a reminder of its former glory, my eyes gloss over.

I shot the usual image of the Taj Mahal in the reflecting pool, then wandered around, conscious of my disappointment. I'd been expecting it to be the mythical place of my imagination. Honestly, I think I expected to see Rudyard Kipling, not dead but very much alive and writing *The Jungle Book* under the shadow of a nearby tree. I probably expected elephants. I expected…something else. Instead it was a tourist attraction, a dusty version of what it once was. So when I took my shoes off and wandered into the mosque, those are the thoughts I was thinking. And when a worker walked by with a broom, sweeping the floor with the Taj Mahal perfectly framed by the arch of the mosque while he was in silhouette sweeping out the dust, I had my shot of the Taj Mahal. It perfectly expressed my feelings about it being a dusty monument now just kept clean for the tourists.

Not everyone will see the Taj Mahal as I did. Some will see it as the love story it is told to be—about Emperor Shah Jahan mourning the death of his favorite wife, Mumtaz Mahal. Some will see it as a Muslim monument built by the Mughals with the hands of Hindu laborers. Others will see the tragic end when Shah Jahan was imprisoned by his son for misspending the nation's wealth,

▶ Canon 5D, 17mm, 1/250 @ f/13, ISO 500

Agra, India.

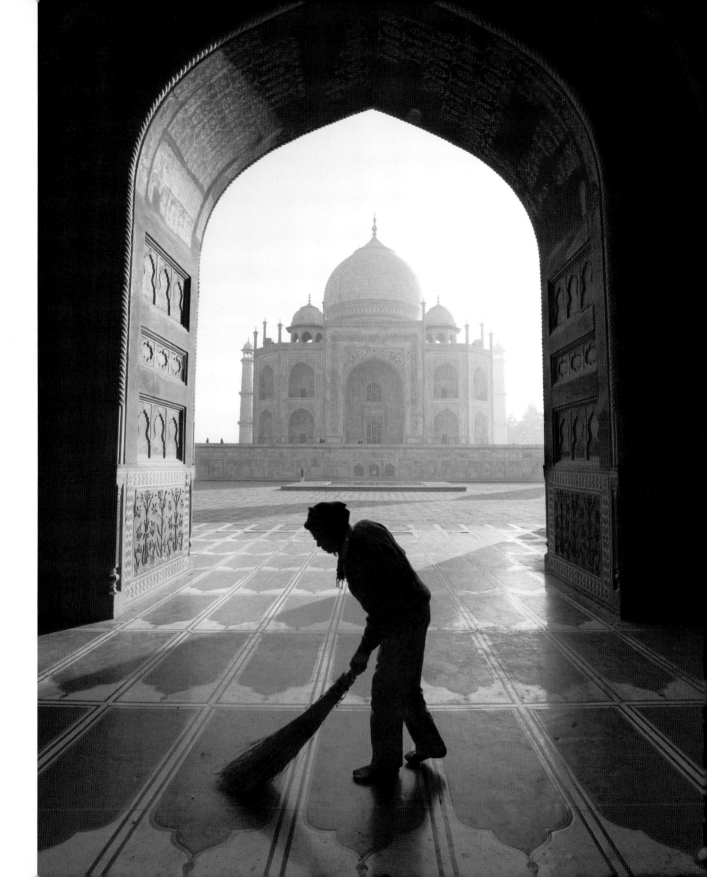

and spent the rest of his days staring at the Taj Mahal, still mourning, from his imprisonment at the Agra fort. And still others, unaware of the history, will see it in different ways. For them it might be about symmetry and balance. It might be about the shapes. However you see it, it is those personal perspectives that give a photographer a foothold when shooting a place already photographed so many times.

Iconic Images in Mundane Places

Creating an iconic image is not easy, but I'm pretty sure most of them have not been taken at iconic places. That would be like making a symbol of a symbol, and I'm not sure we have much need for those. Instead, iconic images seem to be taken in places we most resonate with, places where daily life occurs—the struggle to earn a living, to find love, to conquer our fears or our demons. Sometimes, as in the case of images captured in New York City during the events of 9/11, the images resonate with the emotional power of the event or place they are capturing. Sometimes they just happen in the mundane quarters of life— unremarkable except that they mirror something profoundly and universally human. Creating an iconic image of this order is a tall task and is, I suspect, accomplished a little accidentally; it's probably only in hindsight that these images are recognized as iconic.

An easier task is to begin making images that, while not iconic in their own right, contain iconic elements. You're looking to create images that are symbolic of the place you are photographing—they represent the whole. You want to create an image that is so representative of the place that people who know and love the place you've captured will exclaim, "That *is* Hanoi! That's exactly how Hanoi is!" Given the number of people who know and love a place like Hanoi, and the different experiences they've all had there, it should be clear just how hard it is to find one moment in one place that resonates commonly with most of them.

It begins with finding those quintessential and unique experiences and activities of a place. A yellow cab in New York, a rickshaw in Calcutta, a coffee in a smoky café in Paris. Now combine this with a specific location that is unique to the place you are photographing. I'm not suggesting you find the easiest cliché possible—Times Square or the Eiffel Tower, for example—but a place that *feels* like New York or Paris. A place that speaks volumes without wrestling your viewers to the ground and making them say uncle. Be subtle. If you must put the

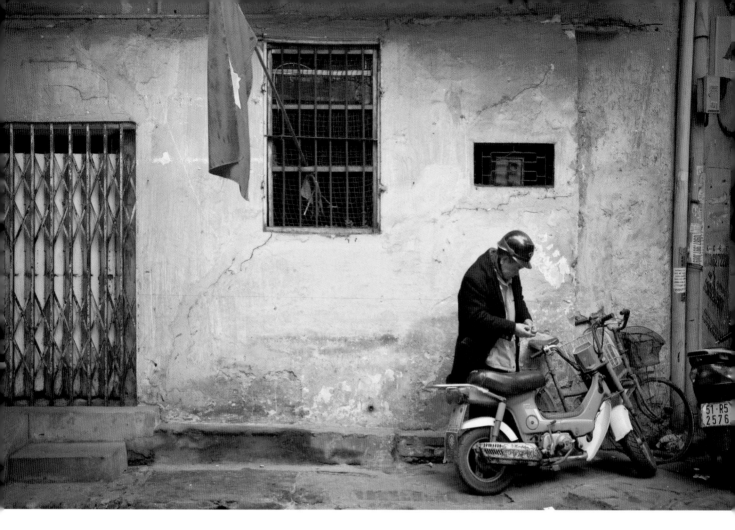

▲ Canon 5D, 40mm, 1/60 @ f/4, ISO 400

Hanoi, Vietnam. This shot is Old Hanoi for me. The old wall, the ubiquitous red Vietnamese flag, and the quintessential Vietnamese man with helmet and motorcycle. A powerful image that will change the world? Hardly, but it contains for me iconic elements that best represent my time in Hanoi.

Statue of Liberty in your shot, find a way to make it a hidden detail, a small counterpoint to the other details. It says, "Yeah, this is New York," not, *"Hey! This is New York! Did you notice?! New York!"* There's a place for those images in your portfolio, but not many of them. We get bored by these shots quickly and go off through the pages of your portfolio in search of something a little more experiential, a little more personal—something that resonates with real life and the struggles and daily details therein.

The key is to capture the most universal elements and feelings of a place in one frame, and this requires a light touch but a very intentional one. The hardest part of this is avoiding the cliché, keeping it simple, and—most importantly—tapping into the most characteristic elements of a place. Add a strong emotion or a particularly decisive moment and you're on your way to creating an image with strong iconic elements.

Another way of looking at this is through the paradigm of images *of* versus images *about*. I discussed this in relation to storytelling, but it holds true with regard to images of places as much as it does for images of people. In fact, I think it only reinforces my proposition that shooting people and shooting places requires a similar approach in thinking. Making a photograph *about* Havana is tougher than making a photograph that is merely *of* Havana, and it's the mark of a good photograph of a place as much as it is the mark of a good portrait.

▼ Canon 5D, 20mm, 1/4 @ f/4, ISO 800

Old Havana, Cuba.

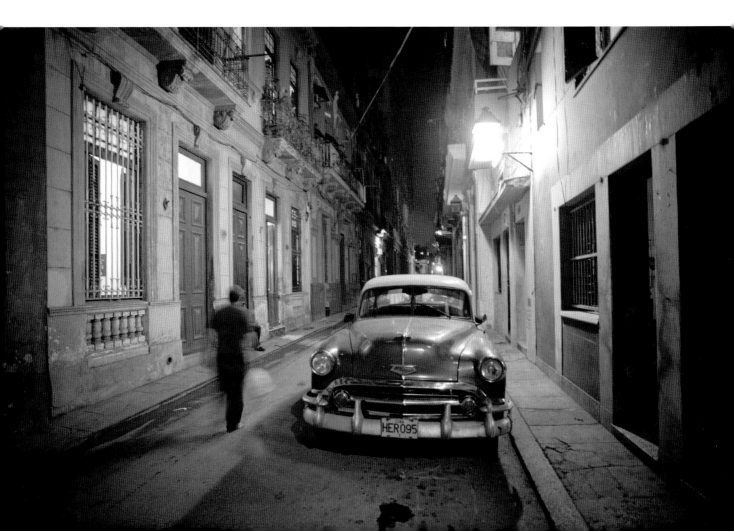

How do you capture *about* in addition to capturing *of*? *About* tells us what a place is like, and that's an act of interpretation on your part. It's an act of selection and exclusion, to include those elements that most strongly reflect your experience of a place and to leave out those details that aren't relevant to you. Ask yourself questions that can be answered with visual clues. What color is this place? Red. What one item do most of the locals own? A guitar. What do the men wear? Cowboy hats. What does it smell like? Tequila and dust. Whiff of stray dogs. Is it hot or cold? Force yourself to think about the essential nature of the place *as you experience it*, so your resulting photographs say as clearly as possible, "This is a photograph about Guatemala City *through the lens of me*."

> "The key is to capture the most universal elements and feelings of a place in one frame, and this requires a light touch but a very intentional one."

Making the Shot

If, as many photographers before me have suggested, we *make* a photograph rather than *take* a photograph, then the process is in our hands to make it what we will. If we choose to make the photograph quickly and move on, then that's as much a choice and a process as it is when we take our time, wait it out, and move our (or our subject's) position. The great freedom that has come after being a photographer for so long is that I've become more patient and more intentional about making photographs. I am no longer ashamed of it or self-conscious about it. I am a photographer, and I am proud of the work I do and the way in which I do it. I'm passionate about it, and that passion pushes me to go beyond the shoot-and-run or the one-minute effort. I no longer take a photograph. I wait for it, seek it, create it.

Wait for It

Timing is important. To arrive at a place I want to photograph and expect the stars to align, the weather to cooperate, and the locals to be in exactly the right place—all for me and my photograph—would be the height of absurdity. Kind of arrogant, too. And it never happens. But to show up, snap a shot, and leave disappointed because "it's just not working for me" implies that some exact scenario *should* happen. So here's the insider scoop: it never does. Or rarely. And to base our photographic expectations and practice solely on those few times it does happen is, well, just plain nutty. So here's another photographic technique they never talk about and that you can't buy at your local camera store: patience.

Canon 5D, 78mm, 1/320 @ f/8, ISO 800

Kairouan, Tunisia. The interaction of shapes and colors on this wall drew my eye immediately, but it's the image on the right that I really wanted, and that took a little more intentional effort to create.

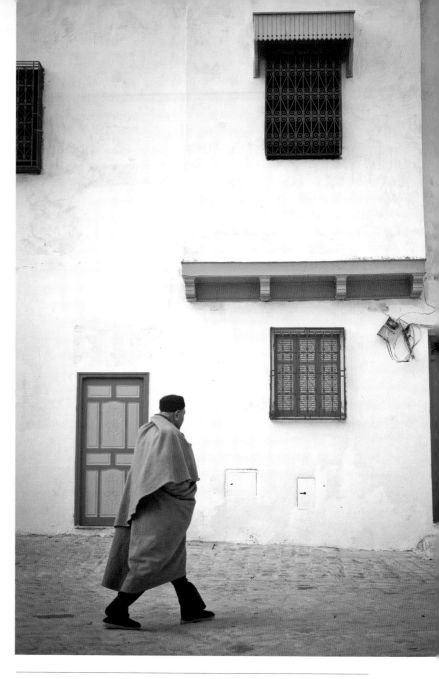

Canon 5D, 55mm, 1/200 @ f/8, ISO 800

Kairouan, Tunisia. I saw this wall and made a few frames, but I wanted something more—a human element. Better yet, one with a red hat. In Tunisia, you don't have to wait long. I set my camera on its tripod, framed the shot, set a depth of field that gave me a fighting chance, and waited. The perfect moment is one of our treasures, and patience is the best way to find it.

The next time you are in a place you love and want to photograph, but sadly the immediate circumstances don't much contribute to capturing your unique vision of the place, wait it out. Sit down and wait. Landscape photographers, among whom I am not numbered, are a patient bunch. Neurotically so. They will wait for hours, even days, to get the shot they imagine. They've scouted, they know what the light can look like at what time of day, and they know the weather. All they have to do is wait for it to come together. Kind of makes me wonder why I find it so hard to wait an hour for the elements to come together when I photograph a market or temple. The best photographs contain a number of elements that had to come together at that 1/60th of a second to make the image. It's rare that you *won't* have to wait for it.

Seek It

Of course, sometimes the stars just don't align. Or they do, but they aren't where you are. If the shot's not where you are, and it won't come to you, go looking for the shot. If you have something in mind and your current location isn't doing it for you, find a place that is. Move your location; walk around until you find it. Get in a plane, get on a boat or a bus. Find the stairs and get on the rooftop. Wade through the river and get to the other side. If you're looking for something specific, ask someone. Anywhere in the world the cabbies know the lay of the land better than nearly anyone. Jump in a taxi. If there are language issues, ask your hotel or guesthouse to recommend a driver who is trustworthy, knows the city, and speaks English. You won't likely be the first person to ask.

Mine It

Once you've found your shot, mine it for all it's worth. Take some time and dig for the gold in the shot. You've waited, you've looked for it, you might even have created the circumstances; don't blow it now by taking one frame and calling it a wrap. Put on your wide-angle and push in close. Put on your telephoto and shoot it tight. Shoot it deep, shoot it shallow. Shoot it horizontally, shoot it vertically. Work the shot for all it's got—you may never be back in this place and in these circumstances again.

Once you've got shot it, take a breath and review your images. Think it through. What framing are you going to wish you had when you got back to the hotel

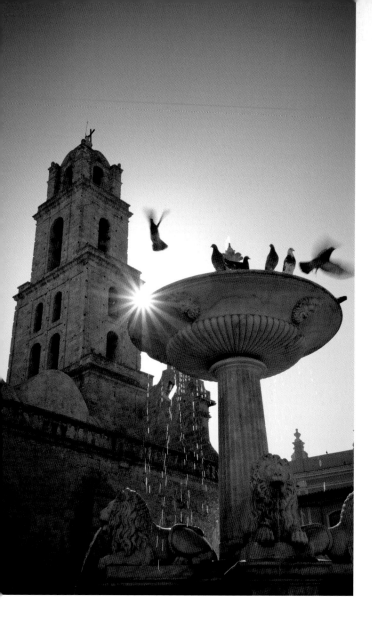

▲ Canon 5D, 40mm, 1/80 @ f/22, ISO 100

Old Havana, Cuba. I shot 100 frames of this fountain. Wider, tighter, vertical, horizontal. All looking for the perfect collision of light, timing, and settings. I shot this on my first day in Havana, a day I had allocated to scouting, so I nearly stopped after a couple frames with the intention to come back later during the week and shoot it more thoroughly. My instincts told me to get it done while the moment was there. That was the last day I saw water in the fountain. If you've got it, shoot it.

or your home? Should you have shot from a lower perspective to get that shrubbery out of the frame? Should you have shot from the right a little more to include more of the castle in the background? Did you shoot at f/1.8 when you should have shot at f/11? Will you wish you'd shot some less-posed photographs of your model, or with a wider range of emotions? I'm not saying that you shoot indiscriminately or with your finger mashed on the shutter button at five frames per second, but that you shoot so discriminately that you carefully consider each angle that might tell your story, and don't pack it up until you've nailed it.

Adding the Human Element

I used to spend a great deal of time waiting for people to get out of my frame before making a photograph. I've now gone the polar opposite and wait, beg, and plead for people to walk into my frame. The images I shoot without a person in them are few and far between now, and the more I shoot the more stubborn I'm getting about this. I think it's because I spend so much more time with people—making their portraits, laughing with them—that I feel increasingly as though a place is hollow or incomplete without them. I think I am most interested in the moments where people and places intersect such that each contributes to the story told by the other, resulting in richer stories and images that, if not better, are at least a more personal reflection of the photographer and person that I am.

Waiting for or intentionally placing people in the frame does more than add another element to balance a composition or add some life—all good reasons on their own. It can introduce contrast,

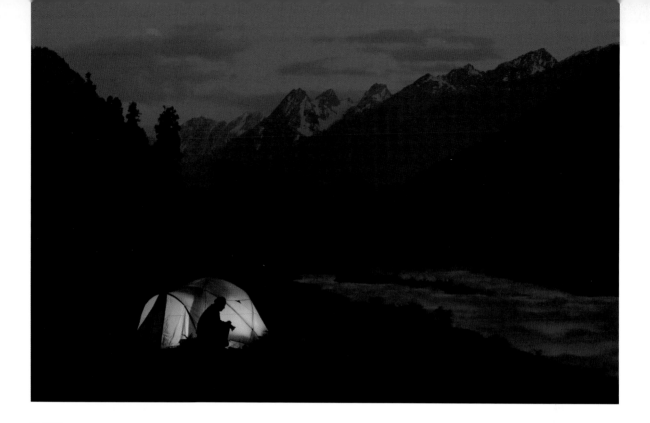

▲ Canon 5D, 59mm, 30 seconds @ f/13, ISO 200

Lidderwat, Kashmir, India. We lit the tent from the inside with a large
kerosene lamp. It seemed like a good idea at the time. That's photographer
Matt Brandon sitting outside the tent to provide silhouette.

as in the case of a man walking against a row of buildings, that's an organic-
versus-inorganic or inhabitant-versus-habitation type of contrast. But even more
than this, it places your viewer within the frame by giving her a human figure to
identify with. A photograph of a row of buildings with no human element in it
may feel empty and lifeless. But if you place a figure walking through the scene,
we feel as though we could be there in that person's shoes. It adds a point of
contact, even empathy.

It also implies something more about the scene than the scene alone can pro-
vide. Without the presence of the woman in the black and white image of the
Louvre, the photograph would only be an image of the Louvre's interior. With
the woman standing in the frame, looking up at the statue, it becomes an image
about a tourist in the Louvre, or about a small figure dwarfed by the massive

architecture, or even about an imagined conversation, across time, between a modern woman and an ancient woman. It's stronger still because you can't see the woman's face and, abstracted this way, she becomes a symbol of all women, not just a particular one you could identify.

Including people in your images of a place also allows you to provide visual clues about where that place is. To someone who's never been there, a street in Hanoi might be hard to distinguish from a street anywhere else in the world. But put a woman in traditional clothing and a straw hat on a bicycle riding through the scene and you'll have immediately narrowed it down to Asia, if not specifically to Vietnam. It need not be a clear shot of a person, nor even their face, but if you catch them in mid-stride walking down the street in Paris, baguette in hand, you'll have said something more about the place, and about this person, than if you simply shot a random person. Choosing someone who in some way speaks to characteristics of a place will allow you not only to introduce the human—or universal—element, but also the local—or particular—element. It adds yet another layer to your image, imbues it with the spirit of a place more fully than you might otherwise. If you've found a great location for a photograph, it's worth taking the time to wait for the perfect person to walk by.

Adding Scale

Size is relative. Without a point of reference, a giant sequoia pine tree in your photograph is any size we assume it to be. Place a hiker walking past its base and suddenly the size of the tree jumps out at us and takes the job of guessing out of our hands. By placing a known point of reference in the frame next to something of unknown size, you are saying, "It was *this* big!"

The human figure is probably the strongest point of reference because it not only says, "The tree was *this* big," but also, "The tree was this big in relation to *me*." It personalizes it and removes the need to interpret. Instead of having to do the math—"Let's see, if the tree was that big next to an elephant, it would be..."—we immediately have a sense of its scale as though we were standing in front of that tree ourselves—it becomes experiential. It also relieves your audience of the burden of trying to figure out just how big the elephant might be.

◀ Canon Digital Rebel, 18mm, 1/60 @ f/5, ISO 800

Paris, France. The Louvre.

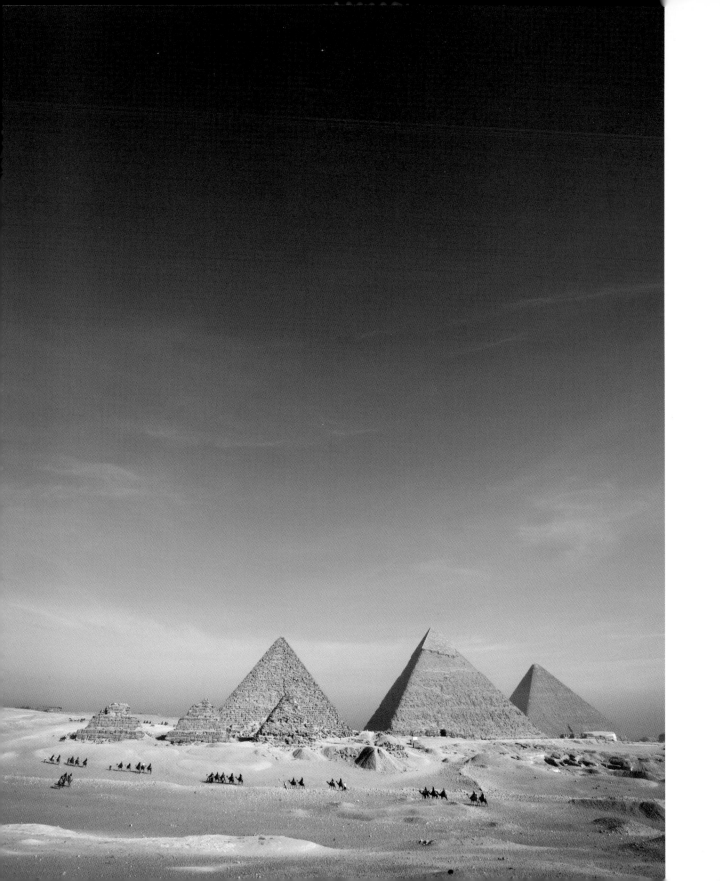

Human figures aren't the only thing you can use to establish or imply scale. A passing dog or cat can do it. A car, a boat, a chair—placing anything of a known size next to something of an unknown size gives a sense of scale and makes the story you are telling more complete.

Introducing scale in this way also contributes an added layer to your image via the notion of conceptual contrasts discussed earlier. It can add a small-versus-big contrast that can create or imply a sense of conflict or plot within the image. Any way we can further engage our viewers and make the story deeper, more textured, or more meaningful for them makes the image stronger.

Landscapes

For someone who loves great landscapes as much as I do, I don't shoot a lot of them. When I do, it's accidental that I find myself in these places to begin with. It's probably my temperament; my impatience makes me ill-suited to sitting for days and waiting for the light. It doesn't help that I hate carrying a tripod. But once in a while I look at the work of other photographers and the interplay of light, weather, and land, and I realize again how a truly excellent landscape can give a sense of the scope, beauty, and feel of a place that environmental portraits and tighter detail shots just can't.

Whether you're in the middle of Montana or Venice, a landscape—rural or urban—can be a powerful establishing shot, creating mood as much as it informs. Consider the following:

1. **Use a tripod.** Keeping your camera still and level, while having enough time for careful composure, makes a sturdy tripod worth its weight. Have you seen the sticks some landscape shooters use? There has to be some reason those guys'll drag a tripod like that all over the globe.

2. **Take advantage of your depth of field.** Landscapes benefit from the depth of focus that a tighter aperture can provide. A deeper plane of focus more closely imitates how the human eye would react in that scene, able to scan from foreground to background and really feel as if they were there. Don't be afraid to stop it down, but make sure your sensor is clean; sensor dust appears more prominently when the lens is stopped down, particularly in skies and areas of even, lighter tonality.

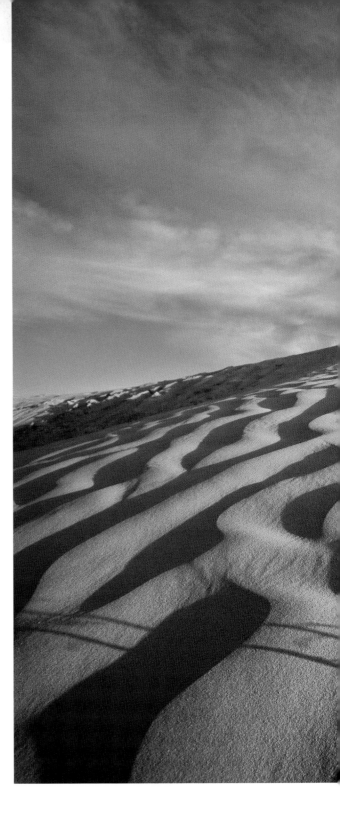

3. **Be sure you have a subject.** As with other photographs, it's important that your landscapes are about something. What is the photo about? Is it about color? Focus on that. About a coming storm? Tell the story simply and powerfully.

4. **Be sure you have a foreground.** Put something interesting into the foreground. Lead us into the scene from front to back. This isn't a hard and fast rule—many excellent landscapes don't do this, but it's an excellent tool for many of them. Try this on the next sunset you feel compelled to shoot.

5. **Check your horizon.** Placing your horizon somewhere other than in the middle of the scene makes your image much stronger compositionally. Consider what it is you are pointing at with this image. Is it a great sky? Try putting the horizon along the bottom third of the image. Is it a great foreground—a field of poppies, for example? Start your composing process with the horizon along the top third of the frame. Begin there, but move around until the image has the balance and impact you want. And then check that it's level. If you do much landscape photography, you might think about getting a focusing screen with grid lines or a spirit bubble to mount on the hotshoe.

▶ Canon 5D, 17mm, 1/200 @ f/14, ISO 400

Sahara Desert, near Douz, Tunisia. These stalks were only about four inches high, so I was on my belly to get this one. The scroll wheel on my old 5D still grinds a little from the fine Sahara sand.

▲ Canon 5D, 200mm,
1/1000 @ f/8, ISO 400

Cairo, Egypt. Morning,
looking across Islamic
Cairo. Racked out to
200mm, my 70–200mm
f/2.8 lens provides the
compression to make this
shot work. The gradual
fading of hues from
foreground to distant
background comes from
atmospheric haze and
is one of the best things
about the unrelenting
smog of Cairo.

6. **Make use of compression.** Try pulling in the background and maximiz-ing the compression effect of a longer lens. Using a telephoto lens to stack mountains or pull a background into closer apparent relationship with the foreground can give you strong, graphic images. Try shooting a series of frames with your longer lens and then stitching them into a panorama later.

7. **Pay attention to the light.** Landscapes need great light that is appropri-ate to the mood you are trying to convey. This might take some patience. Wait it out, wait for magic hour, sunset, twilight. Find the dramatic light and harness it!

8. **Watch the skies.** One of the favored tools of the landscape photographer is the graduated neutral density filter. Available in various gradations, the graduated ND filter allows you to expose for the landscape while maintaining the drama of the skies. A polarizer can be helpful in popping the skies. Add the unpredictability of the weather itself, and skies can strongly carry the mood and emotion of a landscape. Remember that the skies and clouds appear in infinite variations and are as much a compositional element as the land itself, so treat it with as much care and intention.

9. **Use leading lines.** Using compositional tools like leading lines can be another means by which the viewer is pulled into the scene and invited to explore the space within the frame. Lines leading from front to back invite the viewer deeper into the image, while horizontal lines or diagonals lead the viewer to explore the space from side to side as well.

10. **Think in contrasts and transitions.** In a landscape, this might be where forest meets meadow, where nature meets city, or where land meets sky or water. These transitions and contrasts provide greater interest and deeper thematic appeal. They provide a sense of story.

11. **Play with the backlight.** Backlight, particularly around magic hour, can really make your landscapes sing. It can add mood and emphasize foreground elements that have been rimmed with light.

▲ Canon 5D, 70mm, 1/320 @ f/8, ISO 100

Ladakh, India.

12. **Play with motion.** If you've set up with a tripod, consider playing with longer exposures, allowing time and motion to get some play in the frame. Allowing the wind on the grass or water, for example, to blur with a slow shutter can give greater mood and subtlety to an otherwise unremarkable landscape.

13. **Don't forget about emotion.** Even in landscapes, free from human elements, emotion and mood can have a role to play. What is the mood of the place? Is it brooding or moody? Is it luminous? Is it a lonely or peaceful place? Enchanting? Now make an image that says so.

14. **Look for patterns, and for patterns broken.** Natural and man-made environments can provide repeating elements that form patterns. These patterns are particularly interesting to the eye, but even more interesting are those scenes when a pattern or series of repeating elements is broken. Look for a lone fire-red sugar maple in a grove of spruce trees, a bird flying out of formation, or a colorful heritage home in a row of glass and chrome highrises.

Creating Depth with Layers

They say a good story has a beginning, a middle, and an end. So it is with many strong photographs, but the visual equivalent is a foreground, midground, and background. Not every image will make use of all three working together, but ones that do will usually be stronger for it. Placing an intentional foreground, midground, and background in your image, especially as you photograph places, creates visual depth. It pulls the viewer into the image and invites the eye to walk around a little, to explore the space. It adds the illusion and feel of the third dimension and creates an image that beckons viewers to spend some time. It adds complexity and texture. If you want your images to give the viewer a greater sense of being there, creating depth is important.

▶ Canon 5D, 26mm, 1/160 @ f/8, ISO 100

Thiksey Monastery, Ladakh, India. Not even 7 a.m. and we were at Thiksey to shoot the call to morning devotion, or puja. The wider angle allows me a strong foreground element while keeping the monks and the mountains prominent in the frame. A tighter lens would have prevented me from including strong fore-, mid-, and backgrounds.

The challenge of giving your image this triad of elements is in giving it the *strongest* foreground, midground, and background, choosing and placing them so that they work together. If all three have equal visual mass—if they all draw the eye equally—the result is an image that confuses the eye, a story in which the characters compete and no one knows who the protagonist really is. Done right, this can make for a powerful story. But where a film has two hours to make this tension clear, a photograph does not. You can make this easier on your viewer and draw the eye more purposefully if you make use of some of the tools discussed in Chapter 4 on storytelling, particularly the knowledge of what the eye is drawn to—light before dark, sharp before blurred, and so forth. You might choose to create an image that is sharply focused from foreground to background but to lead the eye from large elements to smaller elements or with paths of lighter rocks through the surface of a dark lake, getting smaller as they

"If you want your images to give the viewer a greater sense of being there, creating depth is important."

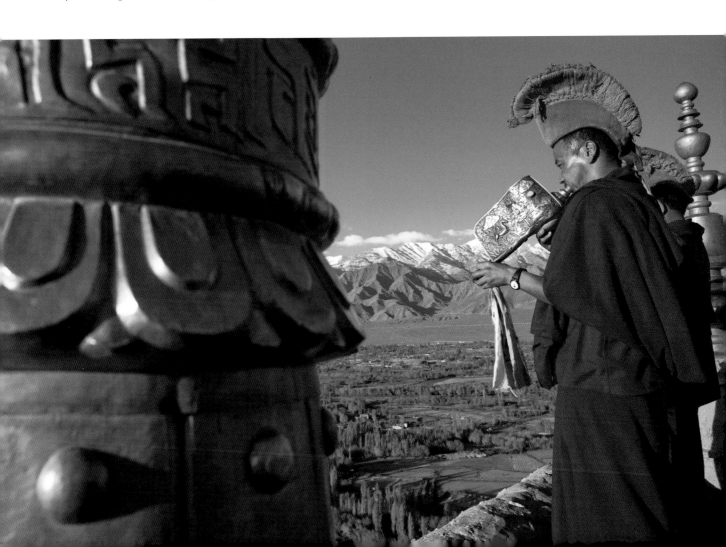

Canon 5D, 90mm, 1/1600 @ f/6.3, ISO 200

Havana, Cuba.

recede, and leading the viewer through the image from front to back, toward a setting sun or distant canoe, and back again. An S-curve, rather than a straight line, will delay that journey and encourage the eye to take its time, to explore more of the frame.

Wide-angle lenses are particularly suitable for this kind of image, as they allow room for the foreground, midground, and background to breathe. A longer lens will compress these elements and can pull them too close to each other for them to function as true fore-, mid-, and backgrounds. You're going for a feeling of depth here, and longer lenses, for all the things they are good at, are not as well suited to this. To make the most of the behavior of the wide lens, be sure to push it in nice and close to your foreground, and play with your point of view— a little higher, a little lower, more to the left or right. Even subtle movements can have a dramatic effect on an image seen through a wider lens and can turn boring lines into strong oblique ones that give your image more interest and a stronger pull.

Shoot the Big Stuff

Architectural differences from one place to another are pretty hard to miss. They're immediate visual clues that tell a viewer where your story is set. As backgrounds, great buildings are pretty hard to beat (and impossible to avoid in most urban settings), but relegating them only to background elements is a shame when they often so strongly reflect local values, local craftsmanship, historical influences, and economic conditions. As backgrounds, they provide great hints, but there's no reason they shouldn't be the central focus of your image once in a while.

▲ Canon 5D, 17mm,
1/250 @ f/22, ISO 400

Bangkok, Thailand.

Architects are concerned with many of the same things photographers are concerned with—lines, balance, shapes, color. As such, they build these forms into their creations. While architectural photography is a discipline all its own, creating images of buildings free from the confines of that discipline is an excellent way to communicate the feel of a place.

One of the key challenges in shooting buildings is their height. We stand on the ground looking up at the building and the lines of the building follow the laws of perspective and begin to converge. The wider your lens, the more pronounced this convergence. Architectural photographers deal with this phenomenon with perspective-correction lenses to compensate for the convergence and force the lines back to parallel, but unless you've got a P/C (also known as a Tilt/Shift) lens, you're left to either correct this in post-production or go with it and allow

the converging lines to create a sense of looming presence. Some of my favorite images are those that run with the "problem" rather than fighting it. Converging lines and sun flare suit my own vision just fine because they place me into the scene and give me a stronger sense of being there.

Like creating a portrait of an individual, the story might be better told in pieces, so don't hesitate to shoot parts of the building, concentrating on the lines, shapes, colors, their interaction with each other, or even the negative shapes created as they react with the blue sky. Often the sky is not merely just the space where the building isn't, but in fact becomes an important element, a shape of blue or cloud that interacts importantly with the shapes of the building and contributes to your composition—seeing it as a graphic element strengthens the composition and balance of your images.

One of my favorite techniques is the edge-cut sun. Shooting a building during hours of strong daylight can rob the building of the color and texture it has at other times of day, and while it would be nice if we could always count on being there when the light is nice, sometimes you have to play the cards you're dealt. When the sun is higher, I move to the backlit side of the building and look for the shadow cast on the ground. Move your camera to the edge of that shadow, look up, and you'll see the sun just peeking out from behind the building. Play

Canon 5D, 140mm, 1/2000 @ f/3.5, ISO 200

Havana, Cuba.

with your exposure a little and you'll find a balance between blowing out the sky and getting details in your shadows. If you're lucky, the ground on which the building is built will be lighter—white marble, light cement—and will add a little fill light for you. Stopping your aperture down to f/16, f/22, or deeper gives your sun a natural starburst effect.

Key to a Great Edge-Cut Sun

1. Look for the shadow's edge and get your camera to that spot. If there's a unique detail, like the cross of a church or the mouth of a gargoyle, placing the sun at that point draws the eye, so look for the shadow of that feature and go there.

2. Stop your aperture down to f/16 or deeper if you want a starburst effect; open it up if you don't.

3. A clean, filter-free lens will lessen the flaring, but shooting straight toward the sun is bound to give you some flaring, no matter how big your lens hood.

4. Keep an eye on your histogram. You will have blown-out highlights—after all, you're shooting into the sun, the ultimate specular highlight. Keep an eye on your shadows and make sure they aren't clipped. What you're aiming for is good shadows and midtones.

5. If you're comfortable with programs like Adobe Lightroom, use the Brightness or Fill slider to bring a little life, color, and detail back to the darker areas.

▲ Canon 5D, 22mm, 1/3200 @ f/4, ISO 400

Vancouver, Canada. A couple hundred years of architectural history in one frame.

▲ Canon 5D, 40mm,
1/30 @ f/6.3, ISO 800

Shoot the Details

It's so easy to get distracted and wooed by the big stuff. You can see the pyramids at Giza from miles away. You can see the Eiffel Tower from almost anywhere in Paris. It's massive. Buildings and statues, even the local people themselves are the obvious choices for photographing a place. But the spirit of a place resides as much—if not more—in the details as it does in the big stuff. The calligraphy stalls outside the Temple of Literature are as much a part of the Hanoi I experienced as all the French colonial architecture. By all means, shoot a wide shot of the monastery in Kathmandu. But you'll create a more intimate photograph of the place by shooting the butter lamps or the hand of the Buddha holding an offering.

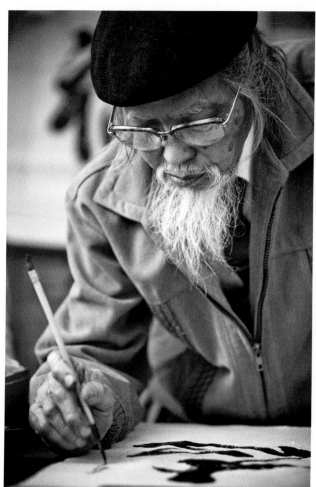

▲ Canon 5D, 75mm, 1/125 @ f/2.8, ISO 800

▲ Canon 5D, 180mm, 1/160 @ f/2.8, ISO 400

Hanoi, Vietnam.

Don't forget to include the people in this. If you're shooting a small Nepali knick-knack or a prayer wheel, why not place it in the hands of a Nepali? If you're buying from a local craftsman, ask if you can shoot some images of him making the items, or even just a close-up of your brass singing bowl in his worn and calloused hands. If that's not quite what you had in mind, why not take it back to the guesthouse, wait for the right light, and shoot it against a wall that's painted a color that's characteristic of the place?

What things will always be associated with a particular place? If you're in Ethiopia, it might be coffee (oh, the coffee in Ethiopia!). Taking the time to shoot the coffee you've been served, backlit and steaming in that tiny glass cup, might give you an image that is not only saleable on stock sites or a great detail shot for a magazine, but a strong memory of all the incredible coffee you were strung out on while there. (And by "you" I mean "me.") If you're lucky enough to spend time in a coffee roasting house, get shots of the beans in an Ethiopian's hands. Get a portrait while you're there. In fact, why not do a photo essay on the coffee from bean to brew?

◄ Canon 5D, 50mm, 1/800 @ f/1.8, ISO 640

Old Delhi, India. Not far from the Jamma Masjid, the large mosque in Old Delhi, this arch containing Arabic writing provides small visual clues to the larger place in which it's found.

Tips for Shooting the Smallest Details

Using a macro lens or a lens with macro settings allows you to get as close as you need to. If you don't have a good macro lens, consider getting an extension tube. Extension tubes—not to be confused with extenders or multipliers—are non-optical tubes placed between the lens and the body, creating greater magnification and closer focusing distance.

I carry the smallest of the Canon extension tubes. I'd never use anything more in my travels, but just this small accessory allows me to shoot coins, stamps, intricate craftsmanship, and so forth without carrying an extra lens for the purpose.

Remember that for items where the texture is important, side lighting will make it pop and direct light will flatten it out.

Photographing Culture

"HOW DO CULTURES DIFFER FROM ONE ANOTHER? Above all in their customs. Tell me how you dress, how you act, what are your habits, which gods you honor—and I will tell you who you are. Man not only creates culture, he inhabits it, he carries it around with him—man is culture."

—Ryszard Kapuscinski, *Travels with Herodotus*

▶ Canon 5D, 17mm, 1/1600 @ f/4, ISO 200

Leh, Ladakh, India.

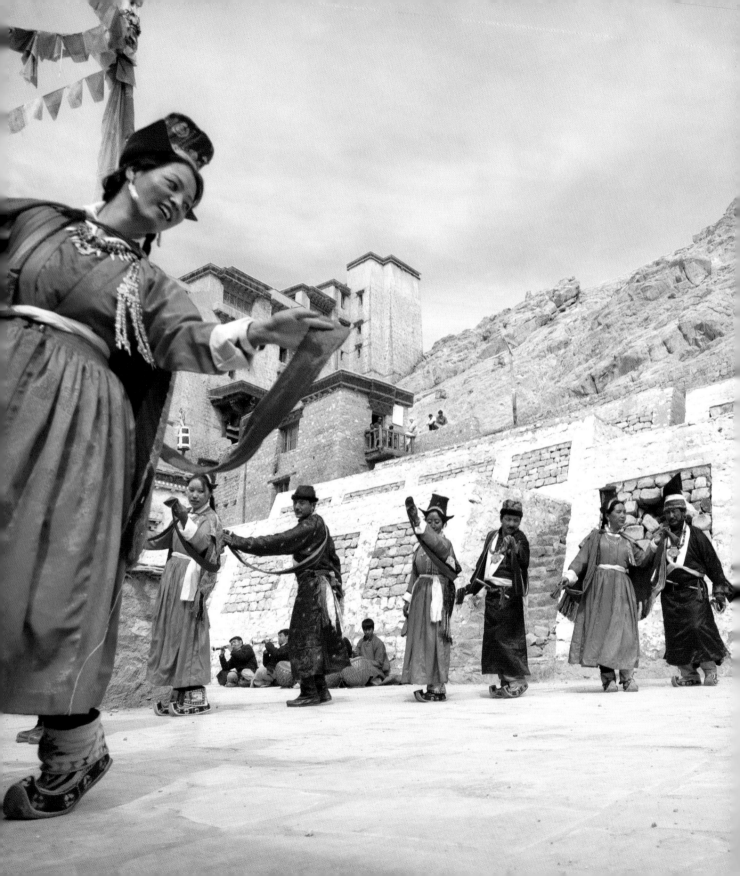

I never had a chance. I was born to military parents and started traveling months after I was born. I spent my early years in Germany, seeing Europe on weekends while burning my legs on the hot black seats in the back of our yellow Volvo. As I grew, *National Geographic* captured my interest and never let go. Later still, when I could read, and words alone had the power to conjure pictures in my head, I read about Thor Heyerdahl, Sir Edmund Hillary, and early explorers. Even my surname, duChemin, means "of the road." I was born, it seems, to travel. I am drawn to new places for their exotic nature, to meet new people and discover the differences between us that make the commonalities even more amazing. I wander new cities and countries driven by my curiosity, wanting to see how others meet the challenge of being human—earning a living, finding meaning and purpose—and how they express those things. And I want to capture it, show the diversity for the beautiful thing it is. I know I am not alone in this.

As this world becomes increasingly smaller, for good or bad we no longer have to travel to see and participate in other cultures; they come to us. Whole neighborhoods throughout the western world are now Chinatowns, Little Indias, and more. With their immigration, newcomers to the countries in which we live bring their culture with them.

"Culture is the outward expression of the inner life of a particular demographic."

Culture is the outward expression of the inner life of a particular demographic. It's ancient and new and a mix of both. And most wonderful of all for those of us drawn to images, it is visual. It's outward, so it can be seen. It manifests in the clothes we wear, the food we cook, and the way we eat that food. It's seen in how we pray and express affection, how we celebrate birth and death and the transitions in between. In broad strokes, cultural expression says, "This is who we are," not prescriptively but descriptively. So photographs of these expressions can be particularly revealing, even intimate.

There is no place without culture, though familiarity with our own tends to blind us to it in the same way that it seems everyone else speaks with an accent and we do not. It is on the streets and in the homes, in shops and restaurants, in public places and private lives. It's everywhere. It is exhibited in our religious lives, our art, food, architecture, and the days and ways we celebrate holidays.

Because it is an expression of those things we hold most dear, it's also something that often requires sensitivity to photograph. Doing so requires open minds and hearts as much as open eyes.

Cultural Sensitivity

When you interact within a culture, and you do so with intentionality, humility, and respect, you not only find those qualities reciprocated, but you emerge with better images and you leave the place having made your photography an act of giving, not just taking. The thing that draws us to photograph expressions of culture—its otherness—is the very thing that makes it challenging. It's unfamiliar and contains its own codes that need deciphering if we're to understand and photograph it.

Research and Ask Questions

The first step is research. A broader, deeper understanding of the culture you are photographing leads to better images that more fully reflect the uniqueness of that culture. If you know that a certain piece of clothing is unique to, or characteristic of, a certain place, then images created with a subject in those clothes will more uniquely capture that place's spirit. I'm not recommending you resort

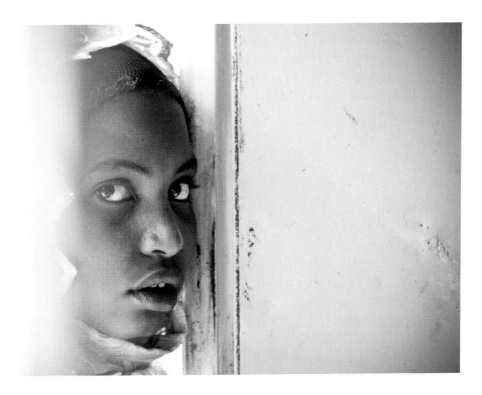

◀ Canon 20D, 200mm, 1/800 @ f/2.8, ISO 800

Outside Harar, Ethiopia. I shot this in a coffee shop full of Afar warriors drinking coffee with casually handled Kalashnikovs on their laps. She looked in, I took the photograph and nearly got us all arrested. Running afoul of cultural taboos, like photographing a woman in a Muslim neighborhood, is met with varying responses. Now I know.

to asking your subjects to dress up, but that you should keep your eyes open for unique opportunities—the more you know, the more readily you will be able to identify them.

Spending a few hours before your trip doing a little reading can pay off richly. Arriving with a little more insight into what people value and how they express those values is a great start. The Lonely Planet guides are an excellent place to start; they provide historical background that can help you understand why things are the way they are. Spending time online researching your destination will also give you enough information to get you started. But nothing is a substitute for talking to people and asking questions. Find someone you can communicate with and ask what cultural cues you need to be attentive to, gender roles you need to be aware of, or taboos associated with faith or ritual. Is there a correct way to eat?

<div style="float:left; width:30%;">

"Don't let the fear of giving offense paralyze you into doing nothing at all."

</div>

Values and Taboos

While you are researching a place, look into the values of the people who live there. Rarely are cultures completely homogenous, but they often share a core value system, especially those cultures based on a common faith. In Cairo, for example, our interactions were almost entirely with Muslims. Knowing how to exchange greetings with Muslims, how to dress without giving offense, how to eat, and how to accept their hospitality are all things that show you respect them enough to learn about and honor them. More often than not, this respect is returned and opens the way for a relationship of trust—even a brief one. It's in those kinds of relationships that compelling, and revealing, images are created.

Respect: Different Isn't Wrong

I realize I'm a bit of a one-sermon kind of guy. Ultimately I believe this all comes down to caring enough to take time to show respect to the people you want to photograph. This means avoiding shoot-and-run tactics. It means slowing down, drinking a cup of chai, asking questions, fumbling through awkwardness and the imposing language barrier. On my first trip to Kashmir, we spent time with the Gujjars in their family huts, talking and sipping salt tea, exchanging greetings, and laughing. Only after we did this would we ask if we could take some time to photograph them. And by then we'd laid some foundations, and they

liked and respected us. In most cases, we had experiences we'd never have had otherwise, with images that we'll cherish for a lifetime.

In many parts of the world, you don't eat with your left hand. It's just not done. The right hand is for eating, the left is for hygiene activities, if you know what I mean. Some folks just do things differently, and not only does that not mean it's wrong, they probably have as good a reason for the way they do things as we do at home—wherever that is.

Don't let the fear of giving offense paralyze you into doing nothing at all. Making a blunder is a good way to learn, and most people are forgiving when you interact with humility and respond to a rebuke with sincere apologies. But knowing ahead of time how to generally express your respect in a particular culture can help avoid that. The rest you fill in along the way by being observant, watching, and following their lead.

▼ Canon 5D, 17mm,
1/13 @ f/4, ISO 800

**Boudha, Kathmandu,
Nepal. Monastery door.**

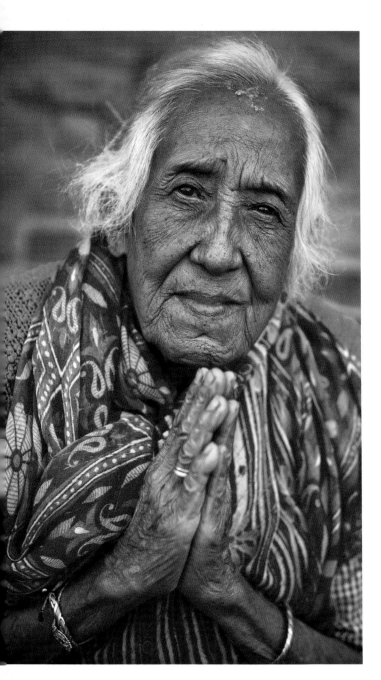

We Are All Different, We Are All the Same

The more I see of this fascinating planet, the more I want to see. Despite the growing number of places I have photographed, my list is getting longer, not shorter. One of the things that drives me most is the way a new place reinforces this incredible paradox: we are all different, we are all the same. No matter where we go, people are so strikingly different. Race by race, we differ in appearance; region by region, we differ in dress and custom; faith by faith, we differ in belief. Some places are more outwardly passionate than others, some more stoic. But underneath it all is an incredible commonality. We share the same basic longings, we fear the same things, we laugh the same way. It is this contrast of same versus different that catches my spirit, my heart, and my eye in place after place.

Being aware of similarities and differences as we photograph people, places, or cultures opens us to seeing and photographing things from two different angles—and it can change what we shoot and how we shoot it. Photographing differences in a culture other than your own can result in images that are innately interesting. Photographing the similarities—particularly in the presence of those same differences—can make the images more personal; it gives us a means of relating, seeing the place and

▲ Canon 5D, 85mm, 1/500 @ f/2.5, ISO 200

Pashupatinath, Kathmandu, Nepal.

▶ Canon 5D, 85mm, 1/500 @ f/2.8, ISO 100

Pashupatinath, Kathmandu, Nepal. I'm a sucker for the written word, so I usually see something of myself in people I catch reading. I also love the natural fill light that paper bounces back into faces, as though books themselves are a source of illumination.

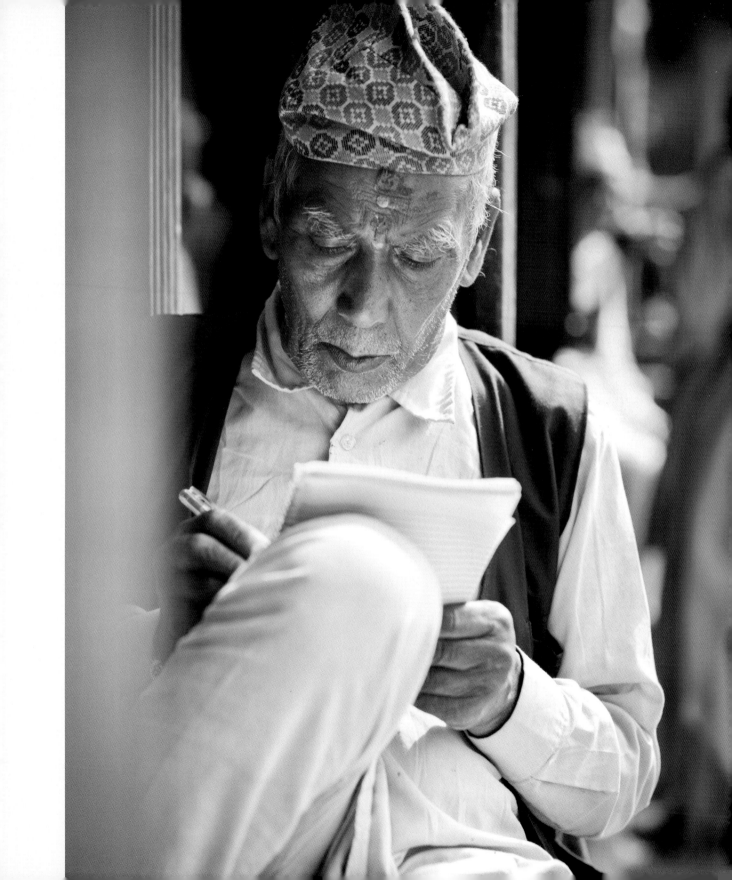

"We are different
because of place
and culture
only; we share
a common
humanity that
binds us together."

people as connected to us, no matter how different. It can break down the walls formed by our usual us-versus-them mentality. When that wall comes down, it opens the way to understanding, compassion, and respect.

An example. Not many of us can relate to an image of a Tibetan woman standing stoically by her yak near her home. That woman is just a curiosity, a concept. But show that woman with her head thrown back in laughter, or beside her son who is distracted playing a Nintendo Gameboy, and you've given your viewers a handle to grab on to—an emotion to relate to, a situation we understand all too well. It's clear the woman lives a different kind of life, but she's not so unlike us. This is the photographic equivalent of pulling back the distracting outer layer of otherness to reveal something beneath, something we share, understand, connect to. Anything we can do to bring this dynamic to a photograph makes it stronger. I'm not suggesting we attempt to minimize the differences or cover them with an emotional device. Quite the opposite—placing the same/different juxtaposition (a conceptual contrast) into our images reinforces just how different we are. But we are different because of place and culture only; we share a common humanity that binds us together.

Simply asking yourself the following questions can help as you frame your images:

- What are the visible differences in this culture, and how can I create photographs that clearly show those differences?

- What are the visible ways in which this culture, this place, or these people are similar to my own?

- How can I combine the differences and similarities within one frame to highlight the contrast between them?

Shooting History and Heroes

▶ Canon 5D, 110mm,
1/500 @ f/5, ISO 200

Old Havana, Cuba. I like to think Che glanced at these women as they walked by. Hey, you can't be all revolution, all the time.

Images of Che Guevara and Fidel Castro are everywhere in Havana. They line the walls, adorn t-shirts, and appear as statues. They appear as ubiquitously and iconically as the Virgin Mary does in other Latin American cultures, or as Ho Chi Minh does in Vietnam. The revolution and the heroes who fought it are not just an historical curiosity of the past but a mindset. It has a personality of its own here, and you brush against it in every café and marketplace. You begin

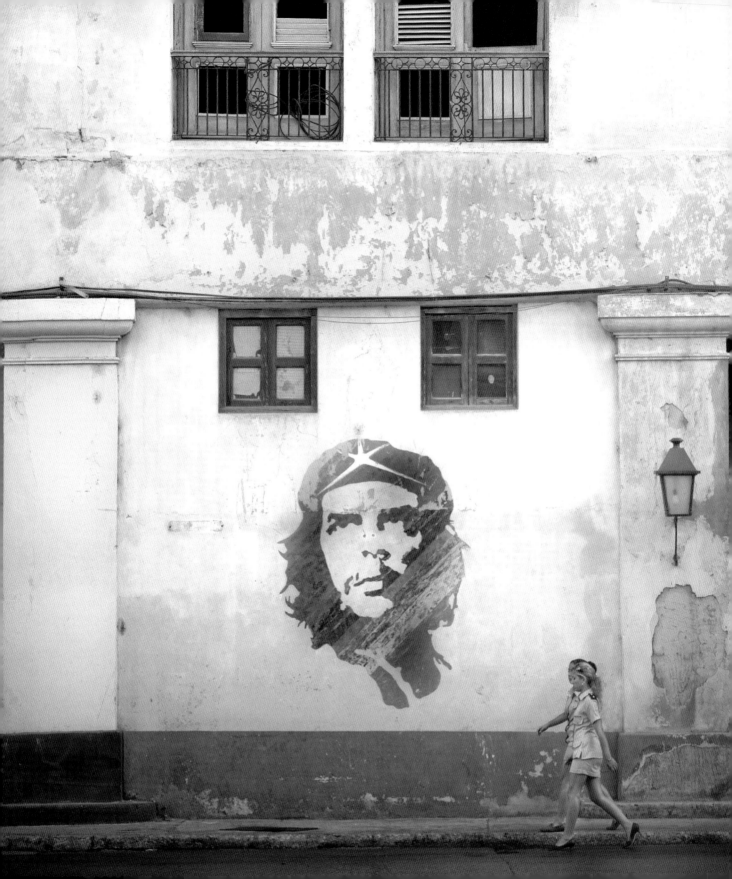

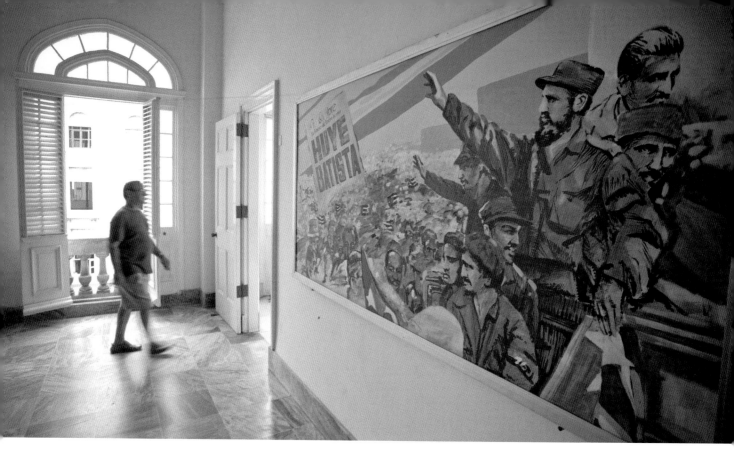

▲ Canon 5D, 17mm, 1/20 @ f/4, ISO 200

Old Havana, Cuba. The Museum of the Revolution. That's Castro waving to the man walking by. While I was there, Fidel was on his rumored last days. Speculations were going around that he'd already died. Whatever the truth of it, his waving seemed appropriate.

to think you could awaken in the morning to find the ghost of Che standing over your bed and not be surprised at all to see him calling you to arms.

What a culture is in the present is a result of what legacy the past has left upon it. In Cuba that legacy is a revolution that, in terms of history, is relatively recent. In Egypt that legacy is thousands of years old, but no less a part of the flavor there. In China the present is always presided over by Chairman Mao. Most places have one foot in the past, and this anchor is often visual—like secular icons that remind a nation where it has been, where it is going, and, in some cases, who is watching you at all times.

Photographing a culture in the here and now often means photographing the intersection of the present with the past. Making the most of visual clues to anchor the image in a certain place, even in subtle ways, can help you tell your stories of culture more simply. As with other things, a little research goes far. Knowing a little more about the local history, the heroes and villains, can give you clues about how to photograph them. In Old Delhi a couple years ago my friend Matt Brandon shot an image of a homeless man slumbering away under a wall of posters that featured the face of Jawaharlal Nehru. Nehru was India's first Prime Minister, a liberal, and a man who strongly advocated for economic reform. Seeing a homeless man sleeping at his feet is a telling commentary, much like seeing a slave at the foot of the Lincoln Memorial in Washington, D.C., might be.

Here are some questions I find helpful as I consider the intersection of present culture and its revered past:

- Who are the heroes and villains of this culture?

- Why are they so revered or vilified?

- What does this tell you about this culture?

- How does this play out visually?

Furthermore, are there clues—apart from the obvious statues and posters—that you can pick up on and insert into your visual storytelling? In China it might be the classic Chairman Mao hat, in Cuba it could be the Che Guevara beret or the Fidel Castro army cap and cigar.

What heroes a culture elevates, and who they vilify, are significant clues to what values are at the center of that culture. Even if you choose never to photograph the recurring images of Che Guevara, they should tell you something about the Cuban culture that will be helpful in how you choose to photograph the place and her people. How could the central heroes, history, and values those represent not somehow make it into your images? Those same characteristics that make Cubans so devoted to Che are what make them so proud, independent, and strong. They are, as a people, defiant. They've lived under a U.S. trade embargo that has hamstrung their economy for half a century and counting, and their revolutionary spirit is what got them there, and it's what carries them through it. To not capture this is to miss the spirit of Cuba.

"Photographing a culture in the here and now often means photographing the intersection of the present with the past."

Shooting Food

Food is an important part of local culture. What a culture eats and how they eat it is as much a part of the unique personality of a place as any other cultural element, possibly more. What we eat locally reflects what we grow, what kind of land we have to farm, and what kind of climate in which we live. Photographed well, food can elicit a more complete response from us because it appeals to our senses. It can be very sensual, and even though we can only see the food in the photograph, a lifetime of eating has given us the tools to unconsciously infer the smell and the taste from only an image.

We have strong emotional ties to food, as well—it's fundamental to our survival and chief among our pleasures. Food is at the foundation of our pyramid of needs, and most of us feel pretty strongly about it. So photographs of food can connect on an emotional and sensual level. They may not be deep emotions, but they're usually strong ones.

They say if you can shoot food well you can shoot anything. Taking photographs of food is an important reflection of the culture you are exploring, but it's not easy. Here are a few suggestions for shooting food on location with a minimum of tools.

When shooting food, the three most important things are the quality and direction of the light, the interplay of colors, and the texture. Once you have attended to those three considerations, placing the food in front of a background that supplies context, mood, or a sense of story can give you all the elements for a strong food shot.

Light and texture are both very important in food photography, and they work together. Using hard front light or flat fluorescent light kills the texture and color; you might as well just go ahead and eat the food, because the resulting photographs are going to make it look pretty unappealing. Using diffused side or backlight and filling in the shadows allows the texture and color to take center stage. Choosing a seat close to the window at restaurants or eating from stalls on the shaded side of the street will give you access to the best light. Wine, beer, and spirits are particularly well lit from behind and seem to glow from within.

▶ Canon 5D MkII, 70mm,
1/60 @ f/5, ISO 125

Sherpur, Bangladesh. This man was making fresh roti, a local flatbread, and selling them as fast as he could fling them.

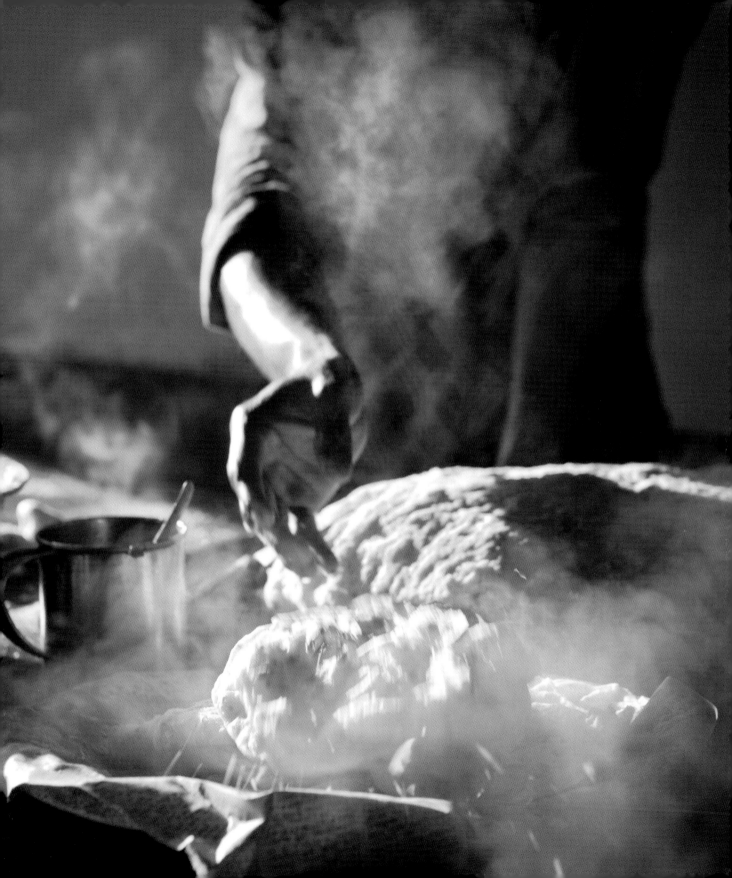

Food that has a quality of wetness to it can be given a glisten from back or sidelight, through the introduction of specular highlights. Front light can't do this. Bouncing light back onto the sidelit or backlit food with a small portable reflector—or even a white menu card—will fill in the shadows and make the colors pop a little.

Trying not to think of your subject as "food" but as graphic elements that need care in composition as much as any other photograph might make this easier for you. Don't let your emotional attachment, or your hunger, blind you to the need

▼ Canon 5D, 40mm, 1/200 @ f/4, ISO 200

Old Havana, Cuba. Caramel flan at The Hanoi Restaurant.

▲ Canon 5D, 85mm, 1/60 @ f/2, ISO 200

Bangkok, Thailand.

to create a great photograph of good food, not merely a mediocre shot of good food. Just because it looks tasty doesn't mean the photograph will compose itself. Watch how lines and colors work together. Remember, your goal is to create an image that says more than "this is what I ate," but shows your viewers what it tasted like, and ideally in the context of photographing culture, would say something about the culture or place itself.

Finally, add relevant local elements to your background. Perhaps it's the atmosphere of the restaurant. Maybe it's the artisan bread served in a unique basket or the chopsticks supplied with your meal. Perhaps it's just the label on a well-placed wine bottle or the language on a menu. They're all details that give context to the photograph and place the food into its cultural context.

Of course, the table is not the only context for food; some of the most enjoyable shooting experiences I've had have been early mornings in vegetable, meat, or spice markets. I can still feel the tickle in the back of my throat from wandering the chili markets in Ethiopia—long walks that left me with great images of local produce as well as the local characters who grow or supply it. Even locally in Vancouver, Granville Island, local farmers' markets are a rich source of colors and characters. Finding out when the market days are, and getting there early, is always rewarding.

> "Just because it looks tasty doesn't mean the photograph will compose itself."

Takeaway

Much of the food I've eaten along the course of my journeys has been fantastic—if not a little scary—but photogenic it is not. Most of the food photography we're exposed to is styled and plated by a professional. In fact, much of it isn't real food at all. But if you're looking to capture that bowl of Vietnamese pho, why not buy some local props—bowls, chopsticks, plates, a bottle of local wine—and shoot the food when you get home. If you've got an interest in food photography, head to the local Chinatown and buy some props, then order some takeaway. Or take an ethnic cooking class and start shooting. You can capture the mood and feel of great food without being there, and shooting at home gives you control over light and mood in a way you won't have elsewhere.

Shooting Festivals and Celebrations

Worldwide, the calendar is filled with festivals and celebrations that are concentrated glimpses into the cultures that celebrate them. Marked as much by intimate rituals as they are by large public gatherings, festivals can be extraordinary events to photograph. Filled with color, music, and often the clothing and customs most traditional to or representative of a culture, the annual festival calendar of any place, at home or abroad, is worth your attention.

In many major North American cities you can shoot a steady stream of festivities from around the globe without ever leaving home, from Chinese New Year to the Hindu festival of light, Diwali, or more traditional western Christmas celebrations. Take it on the road and you'll find celebrations around the globe.

We arrived in Vietnam only hours from Tet, the lunar New Year. Fireworks and concerts made these celebrations familiar, but other elements of Tet, like the ubiquitous kumquat trees, heavy with fruit, in every home and business, made it different, as did the burning of paper money offerings. In Sapa, high in the hills near the Chinese border, the Hmong people played games and celebrated together in a way that is visually very different. Across the border in China, the lunar New Year is celebrated with dragon dances and a riot of color. Back in Hanoi, the celebration lasts all week with auspicious activities meant to bring good luck. Outside the Temple of Literature, calligraphers ply their trade writing symbols for prosperity, happiness, and other blessings for the coming year, while inside the families burn incense, say a prayer, and leave an offering. Who could not love this?

The first step in shooting festivals is research. Knowing what happens, and when and why it happens, is the key to photographing it and knowing where to be and when. But more important is knowing the meaning of these rituals. This kind of information can lead you to create more meaningful images, and can help you make decisions about the events you most want to photograph. The same information can also prevent you from making mistakes. This research can be as simple as getting online and doing a search for key events and customs related to a festival, or as deep as spending time with your cultural informant and really picking their brains.

"More important is knowing the meaning of these rituals."

Researching the festival should give you a list of key visual cues to consider shooting, and from there you've got a good start on a shot list. If you're shooting for documentary purposes, this shot list might be more linear or event related; if you're shooting for a personal project, you might have the freedom to pursue only the things that interest you. But it begins with research. As with location scouting, searching the internet for images of festivals gives you advance knowledge of what things look like and what others have shot, and it might give you a mental shot list or even suggest other directions than the ground that other photographers have already covered.

▼ Canon 5D, 173mm, 1/1250 @ f/2.8, ISO 200

Old Hanoi, Vietnam.

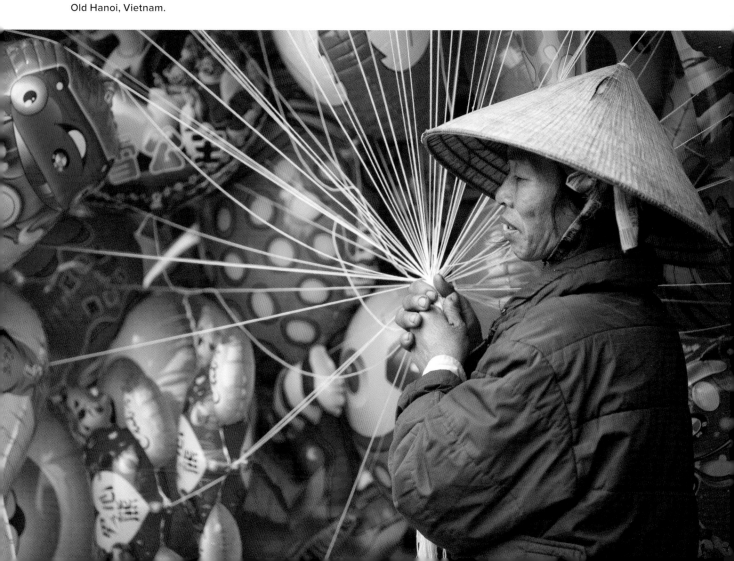

Canon 5D, 160mm, 1/1000 @ f/2.8, ISO 400

Old Havana, Cuba. I caught this moment during a street festival in Havana. Loud, colorful, and full of characters, it was hard not to get swept up in it.

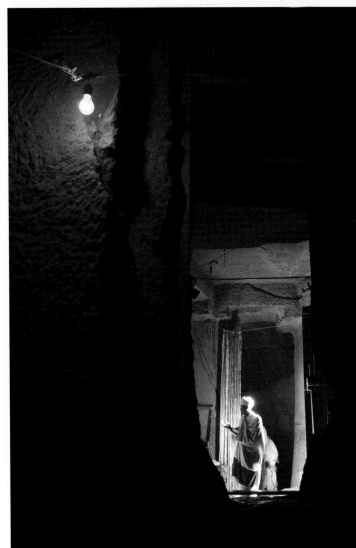

Canon 20D, 17mm, 1/40 @ f/4, ISO 800

Lalibela, Ethiopia. Aside from the memories, two things make this work for me. One is the frame-within-a-frame composition; the second is the conceptual contrast of man's light versus natural light, even divine light.

The big challenge of festivals is often the sheer size of them, in terms of both the number of people and the number of activities. Both mean it takes more time and planning to shoot them. Logistically, shooting an international celebration might mean a shortage of flights and hotel rooms, as well as inflated prices. Locally, it means you just need to plan for more time to get there and less room to work in the crowds. Festivals can also mean the suspension of normal life. While big crowds mean one kind of photographic opportunity, they also mean it's harder to photograph so-called real life. Throngs of people packing a temple mean there's little chance of getting that feeling of solitary seeking or worship you might be more drawn to. The city of Hanoi empties out for Tet as folks return to families in the villages. My research had prepared me for this, but I had no idea just how quiet it would be, leaving me unable to shoot much of what I had hoped I'd be able to photograph. Having a backup plan—in my case, taking the night train to Sapa to photograph things there while Hanoi was at its quietest—is a great idea; things never go entirely as planned, and the more flexible you are, the more able you'll be to make the most of your time.

On the other hand, I arrived in Lalibela, Ethiopia, for Orthodox Christmas in 2006 and was met by one of the most extraordinary places and times I've ever experienced. Surrounded by white-robed pilgrims who'd walked days to this ancient city to worship at the rock-hewn churches, I felt I'd truly traveled back in time. The photographs I took there, so wrapped up in the wonder of it, remain to this day some of my favorites and carry with them, I hope, some of the magic. It was not, as I had expected, a celebration of noise and color but one simply of being—pilgrims come to pray and to commune together, and most of my images reflect this completely unexpected quality of the event. Sometimes all you can do is show up and let the place and the people show you what they really are, and then do what you can to cram it into the frame.

Whatever it is, try to capture the uniqueness of the festivities—the meanings and symbols behind them—and you'll emerge with images that you'd never get in the day-to-day life of a place.

"The big challenge of festivals is often the sheer size of them, in terms of both the number of people and the number of activities."

Shooting Art

Often the most vibrant and diverse expressions of cultures are found in the arts. Local music, dance, performance art, and crafts are particularly visible and photogenic expressions of the ways in which local culture is played out. Any place on this globe with any culture to speak of expresses itself creatively; photographing those expressions is a look through those important windows into the unique spirit of a place.

Sometimes the unique artistic expressions of a place are obvious; at other times it will take a little research, but uncovering and photographing them can be particularly rewarding. Hanoi, for example, is well known for its water puppetry. In Bhaktapur, Nepal, you can't walk a block without running into schools dedicated to thangka paintings. Elaborate paintings portraying the Buddhist mandala and deities, the thangka tradition has also now incorporated Hindu scenes, like the one in the image shown here.

Do what you can to find the genuine local expression of that art, and not the stuff that's out for the tourists. Can you trace the art to its source or maker? By all means, shoot a handmade guitar in a village known for its guitars, but can you find the local master of the craft? Can you find the local guitar legend? Can you photograph a local guitar concert? Dig around a little. It only takes a couple questions. Go as deep as you can.

Consider photographing this local craft as a photo essay—get a wide, establishing shot, a detail shot, and a portrait. Cover the material as broadly as possible. Doing so will give you a special set of images that do more than say, "They play guitars in this place." The images will tell your viewers more about the people and the place and the details of their passion for the guitar, or the tango, or carpet weaving. Traditional arts tend to run deep in a culture, and where you find these cultural expressions you'll find the passion that's held onto the art and tradition for so long, or the fresh inspiration that the current generation is bringing, fusing it with new ideas and guaranteeing it all a future. Why is this important in a book about photography? It's about the way a culture's heart beats, and the things for which it beats.

> "Find the genuine local expression of that art, and not the stuff that's out for the tourists."

▶ Canon 5D, 85mm, 1/250 @ f/1.8, ISO 320

Bhaktapur, Nepal.

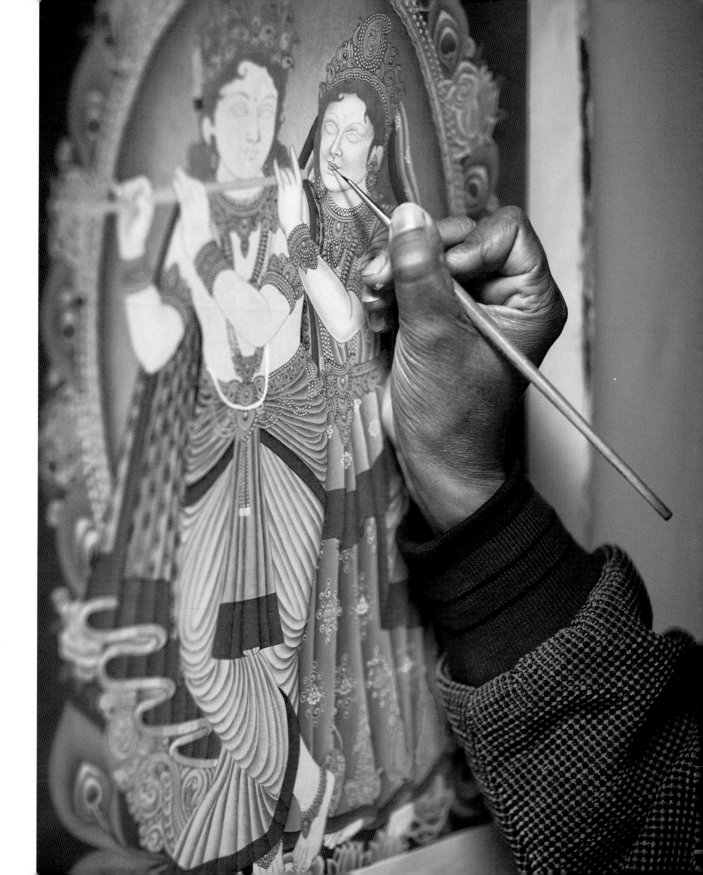

Shooting Language

Given the incredible number of languages that the people on this planet speak, and the ways in which those languages are written, it would be a shame not to capture the language of a place when photographing it. How words are written can be an immediately recognizable clue about the place you are photographing. Signage in the background, written in sweeping, lyrical Arabic or Mongolian, immediately identifies which part of the world you are in and provides subtle hints about the nature of a place. They are reflections of the exotic nature of your travels, and while exotic alone doesn't carry an image, it gives your images flavor or texture. The text in the image of the orange juice vendor is subtle, but it unmistakably places this man in the Arab world; without the language clues, the image would be less obviously anchored in its setting.

Languages and alphabets are more than just informational clues; they can be beautiful graphic elements in themselves. Compare the Ethiopian Amharic with Arabic or Mongolian scripts, and then again with Welsh and its astonishing use of the letter L. There's a unique beauty to them all, and when they are included in the image they can lend that unique beauty to the photograph itself.

▶ Canon 5D, 17mm, 1/250 @ f/4, ISO 400

Cairo, Egypt. The Arabic script on the wall behind this Cairene orange juice vendor sets this image into its context, a small visual clue that says, "You are here." Far from a grab shot, I spent time with this man, bought some orange juice, and gave him a print of himself, which he received with such gratitude it made me feel good all day.

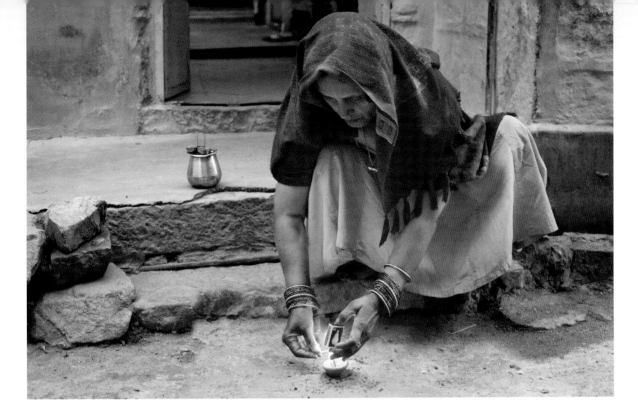

Look to place the ubiquitous signage of a place into the background of your images if the foreground alone isn't communicating as clearly as you'd like. A great background is key to a great image, and it can create the perfect balance between providing the impact and the information needed by the viewer to interpret the image. Similarly, if you're looking to create images that do not betray a specific location, be sure that your backgrounds remain free of these telltale clues.

And when you're so far off the beaten track that there are no signs at all, their absence can speak just as loudly. Signs are the language of direction and of commerce, and when they are absent it's often because the place you are in is so small they don't need them.

▲ Canon 5D, 50mm, 1/50 @ f/4.5, ISO 800

Jodhpur, India. A Hindu woman performs her morning puja outside her home. She graciously allowed me to photograph her for five minutes, then invited me in for chai. Fearful that she'd marry me off to her daughter, I declined. In retrospect, I wish I'd accepted (the chai, not the daughter).

Shooting Faith

Some of my best memories have been formed in places of spiritual seeking. Those churches in Ethiopia, the mosques of Kashmir, the gompas of Ladakh and Nepal. Perhaps it's because I'm drawn so strongly to the people in these places that I feel akin to them, more prone to conversing. Perhaps it's because I so narrowly missed becoming clergy myself that they see the respect I have for them.

I don't know. I just feel at home in these places with these people. In these places, I've found that people are slower, more prone to sitting and talking—if not to me then to the One who's listening—and the photographic opportunities are not only numerous, they're deep.

The human hunger that is expressed in spiritual practice and ritual is about as primal and as basic as it comes. It is at the core of what it means to be human. People living and practicing their religion are expressing something about the deep longings they have—to connect to something more, to be forgiven, to find meaning. At the heart of religion and ritual are our deepest longings and fears, our deepest beliefs and doubts. Some of our most universal emotions, symbols, and stories emerge from this aspect of humanity. From it comes our best and, it could also be argued, our worst. So images that capture not only the exterior actions of religion and ritual but that do so in ways that tap those deeper waters are images that resonate strongly with an incredible cross section of humanity.

▼ Canon 5D, 135mm, 1/3200 @ f/2, ISO 800

Srinagar, India. Far from being invasive, I shot this with full permission while this woman and her grandson offered prayers. Sometimes I feel a lot like her—focused on higher things. But most of the time I feel like the boy, distracted by the here and now.

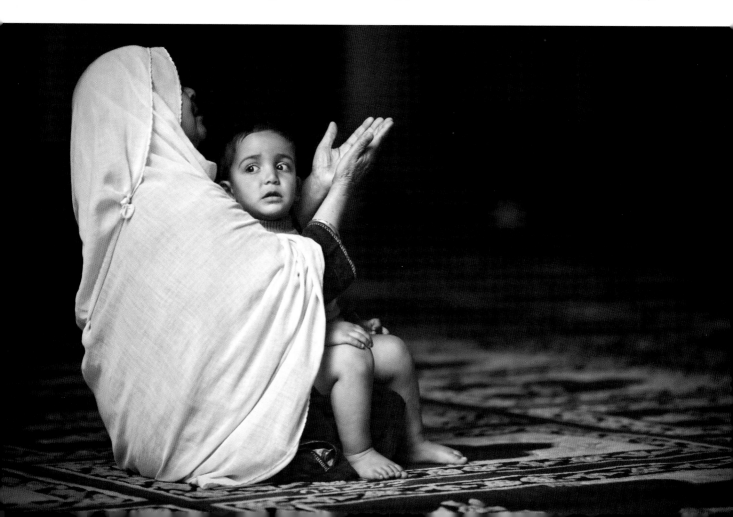

Remember the deeper subject and find
a way to express it

If you can make your photograph more than just an image of a Muslim woman at prayer—making it in such a way that it reveals emotion or captures a very symbolic gesture—you will have made an image that is *about* prayer itself. Capture an image of a man alone in a church, in a telling posture and with the right visual clues, and you will have made a photograph not just of a Catholic man at his prayers but an image *about* wrestling with ourselves and with God. What are those right visual clues? It is your job as the storyteller to make those choices. But what you should be looking for are the symbols, gestures, and emotions that the broadest number of people resonate most deeply with. The moment you place a crucifix—which, for whatever else it is to others, is a symbol of suffering, and of abandonment by God—you are harnessing the powerful associations of that symbol. It echoes with the last words of Christ, which speak of feeling abandoned and of forgiveness. It echoes of the Garden of Gethsemane where Christ battled his own doubts and fears, wrestling with God before the day to come. It won't have that symbolism to everyone, but that's the way it goes with symbols. They are powerful to those who know, and to them they speak volumes.

Look for answers to these questions as you search for ways to photograph religion and ritual:

What are the physical expressions of this particular religion? Beads? Prayer wheels? Prayer flags? If—pardon the obvious pun—the devil is in the details, so is God. Our search for a connection to the transcendent often manifests itself in the smallest details of our lives—crosses worn around necks, amulets, good-luck charms. Some wear certain scarves, certain headdress, or robes. All of these are visual clues that you should consider as you photograph faith in the lives and culture of others.

Where are the sacred places? Churches, mosques, temples, pilgrimage sites, shrines? Not only where are they, but what are they like, how do they smell, and what kind of feelings do they stir in you? Now find a way to express that. Are there, to quote Paul Simon, angels in the architecture? Don't neglect the care that the builders of these places took to create a sense of the sacred. Notice the icons, the symbols, the work of ancient craftsmen. If it catches your eye, all of it is worth photographing because all of it tells a piece of the story.

What is the mythology of this religion? Knowing what stories are central to a particular faith gives you more information with which to craft more textured visual stories. Including visual references to these central myths—and by "myth" I mean a powerful, central story, not the implication that it is a fairytale—makes your images more nuanced and more telling.

What is the central emotion? If you are witnessing a person engaged in a particular spiritual practice, what is the central emotion at the heart of this practice? Is it worship? Repentance? Anguished prayer? Can you find a way to make this as universal as possible without neglecting the uniqueness of this moment?

How can I express all of this in a fresh, meaningful, and respectful way? It's easy enough to photograph a man at the Western Wall in Jerusalem, but finding a way to do so taken from a fresh perspective is a little harder. Find a way to tell the story *you* see in these places.

Be respectful

Being respectful means being conscious of both the taboos and the accepted behavior. It means taking off your shoes, or covering your head, or walking clockwise instead of counterclockwise. It means being mindful of what you touch, how loud you speak—if at all—and where you sit. I can't relay too strongly the importance of research in this regard. Be observant, and take your cues from others.

▶ Canon 5D, 17mm, 1/160 @ f/4, ISO 800

Kashmir, India.

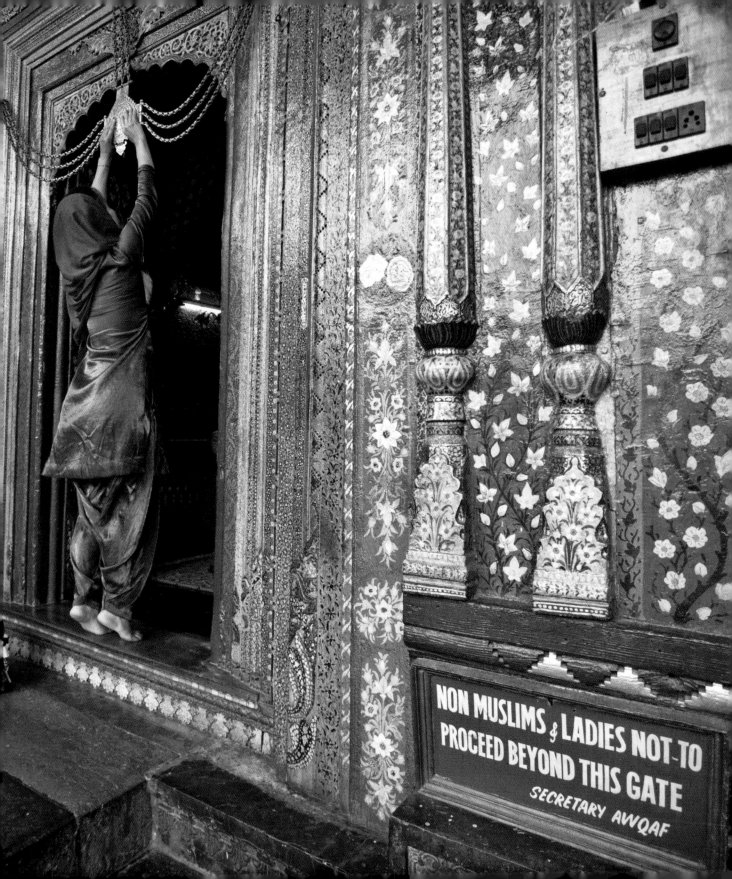

NON MUSLIMS & LADIES NOT TO
PROCEED BEYOND THIS GATE
SECRETARY AWQAF

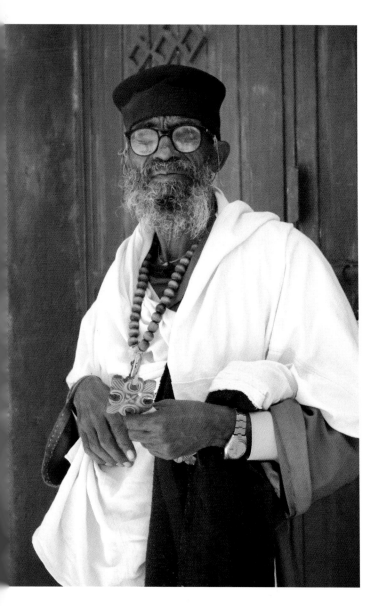

▲ Canon 20D, 32mm, 1/3200 @ f/4, ISO 800

Wukro, Ethiopia. I spent half an hour with this Orthodox priest before feeling we'd established enough of a relationship for me to ask if I could photograph him.

Practically speaking, faith is often expressed in dark places where a flash is not an acceptable or even desirable means of capturing the moment. So faster lenses are helpful. Tripods are often not allowed in these places. A longer lens allows you to photograph without intruding on what, for you, is a photographic moment, but for your subjects is a very personal moment. The less you intrude, the better. I'm not suggesting you take sneaky grab shots—I'm saying that in some cases respecting others demands you not be in their face with a 24mm lens. As with photographing any other place, take your time, be aware of what you're feeling, and let that inform the kinds of image you make. If you feel a sense of mystery, consider how lighting can help you communicate that. Can you backlight the subject to create a subtle feeling of spiritual receptivity? You might even want to move your position so the faces of the people in the image are partially shrouded or hidden to further emphasize this feeling.

These images and stories—and how you capture them—reveal as much about yourself as they do about the subjects you photograph. If you do not respect the people you photograph or in some way resonate with them, your images will lack that empathy. If you don't understand what you are witnessing, find someone to ask. Witnessing Ashura, the Shi'a commemoration of the martyrdom of the grandson of Muhammed, without knowing what it is would likely give you a much different feeling and impression than if you knew the reasons and motivations behind the day, which is often marked with bloody self-mutilation. You may never feel those same feelings, or even understand them, but knowing the background can give you a better place from which to photograph it. Whether you see

it as an act of mourning or as religious zealotry, your photographs will reflect that. By all means, have an opinion and express it; just be sure it's as informed as possible.

Photographing faith—and the varied expressions of it—could easily consume a lifetime without running out of interesting themes and subjects. Take your time with it, be respectful and informed, and you'll capture images that speak deeply.

▲ Canon 5D, 148mm, 1/400 @ f/5, ISO 400

Chemray Gompa, Ladakh, India.

Final Thoughts

OF COURSE, all these chapters are essentially inseparable. It's a bit of an editorial contrivance to separate people from places or places from culture. It's all an interconnected play in which they all work together—the characters, the settings, the plot. Our efforts to photograph them, to point to something—and all art must point to something—and say, "Look at this!" are themselves part of the play. We contribute, we touch lives, we say about

▶ Canon 5D, 78mm, 1/5000 @ f/2.8, ISO 200

Ulaanbaatar, Mongolia.

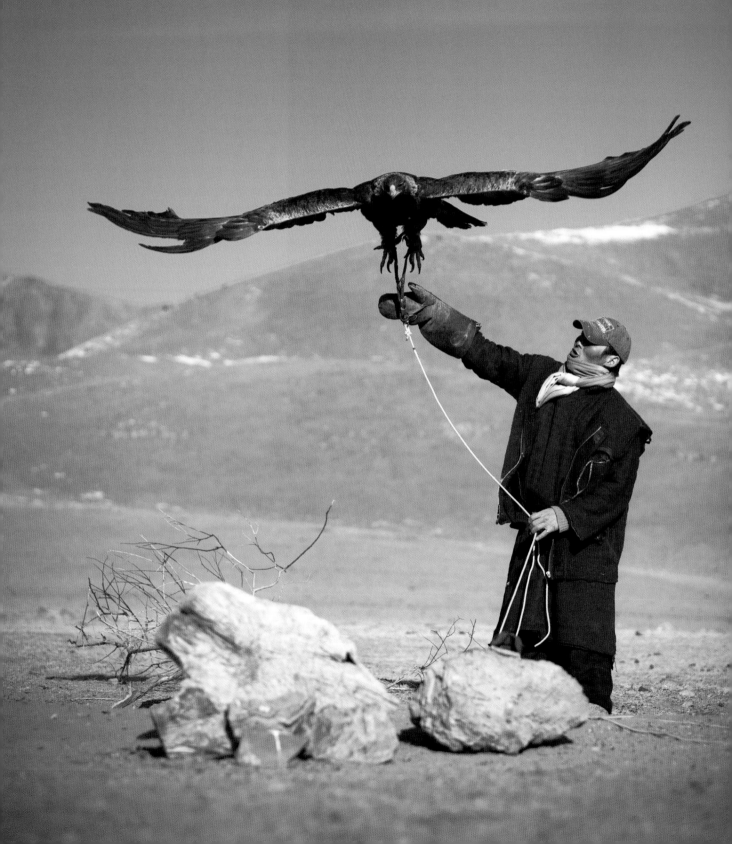

> "What is important is that we engage our vision and our craft with intention."

this person, "He is noble," or about this place, "It is beautiful," or about this culture, "It is perishing and must be saved." We are not only observing; by learning to see, to fit messages into a frame, we are participating. The best of our efforts can ripple far further than we ever dreamed.

The peril in writing a book is that you put down your knowledge on paper as though it were a fait accompli, and that you have nowhere else to go, when in fact we grow and change—and our knowledge does, too. I trust that's a good thing, that I'll look back in another 20 years and will have learned more about my own vision and craft to write a new edition, which will amount to looking at this one and saying, "That's all very well and good, but...." In fact, I trust that's what this book does for you as well: that it raises questions and, where you disagree with my own responses to those questions, you go looking for your own. What is important is that we engage our vision and our craft with intention, always seeking new ways of refining that vision and expressing ourselves, saying, "Oh, look at this!" through the discipline of the frame.

In truth, what's really on my mind is whether this book will make a difference to others who, like me, love photography well enough to want to do it for the rest of their lives with greater and greater ability to express themselves. I know *Within the Frame* is not the conclusive book on the subject of photographically expressing your vision of people, places, and culture. Like any photograph, in fact, it's just one angle on the subject. It includes certain things, excludes others, and it's all seen through one particular lens. My hope is to provide a unique contribution, one that complements what others have so capably written, not one that competes with them. I hope this book is a contribution to a larger conversation.

Like all conversations, there is no final word. I blog daily, and if you're inclined to follow and contribute to the ongoing discussion, the ebb and flow of my thoughts and the thoughts of others, I welcome you to join me. You can find my blog through my website, Pixelated Image (pixelatedimage.com). If the book has connected with you or left you with questions, I welcome your emails. You can find my current contact information, along with information about current workshops and lectures, on my website as well.

For those interested in continuing the conversation through images, there is a Flickr group set up: flickr.com/groups/withintheframe.

Lastly, there is a downloadable bonus chapter available online through the Peachpit website. This book flirts with the so-called travel photography genre, and I've made a conscious effort to keep that element at bay. Still, as I said at the beginning, the needs of a traveling photographer are different from the needs of one who stays close to home. So for those who want to explore my thoughts and tips on traveling as a photographer, this one's for you. Register your book at peachpit.com/withintheframe to access this bonus chapter.

We live in an incredible place, filled with billions of unique people, surrounded by the beauty of God's world and the incredible diversity of man's world. May each frame you shoot bring us all one step closer to understanding and appreciating one another and the world around us. May your journeys—around your city or around the world—be filled with encounters and moments that open your eyes, your heart, and your mind.

Peace.

David duChemin
Vancouver, 2009

Afterword

by VINCENT VERSACE

"One person can change the world. And we all should try."
—John F. Kennedy

Tad Z. Danielewski, one of the finest professors I had in college, posited that it was the poets who were the cause of all the great revolutions, and it was the poets who were the first to be imprisoned when the revolution started and the last to be released when it ended.

We are witnessing a revolution in photography. For the first time, the digital image allows anyone the pathway to creative greatness. A place where impossible is merely an opinion—an opinion that is held not by the viewer of the image, but by the creator of that image. Which means that the photographer's imagination is the only limitation.

But with this new tool comes all sorts of things. The boon of digital photography is that the photographer has complete control of the image, and the bane of digital photography is that the photographer has complete control of the image. What seems to be occurring is that the poets within us—the poets who started this tidal wave of revolution—are becoming imprisoned by the technology.

So what is poetry—let alone all of this talk of revolution and imprisonment— and why does it matter with regard to photography? Poetry is the language of heightened emotion; poetry is the form of expression we use when everyday, conversational language cannot begin to contain what we feel. They say a picture speaks a thousand words. I would suggest, then, that pictures are visual poems, the greatest of which are those that move us the way the photographer was moved when he clicked the shutter.

Most likely, there was one image that sent you on the path of photography. One image that changed your life, one image captured by one photographer. You did

not consider for a moment if the photographer followed the rule of thirds or the Grecian golden mean, or if the photograph was even in focus. The image spoke, you listened and were moved, and in that moment you saw the world differently. You felt the visual poem.

In that moment we saw the promise. So we bought a DSLR, which offers us a way to express what the eye of our heart feels when we see something and show it to others, a way to speak the poetry within us. Then we come to believe that that promise is held in a tower that is very tall and very steep, called the "learning curve." Now, all of a sudden we believe we need to know everything about chromaticity diagrams, color spaces, Bayer arrays and, God forbid, Photoshop. So moved were we when we fell in love with photography that we believed that if we bought a camera we became photographers right then and there. Then we were rudely informed that if that were true, one could buy a cello and be…what? Certainly not a cellist. You'd simply own a cello.

It is at this point of discovery that the poet within feels the first chains of the shackle. That practice makes perfect. We start to focus on the technical rather on what truly makes a photographer, which is their voice. And in so doing, the bigger part of us gets lost in the pursuit of the small. We look for the tip or the quick trick rather than pursue making magic. We learn to make sharp photographs of fuzzy ideas. The poet finds himself imprisoned while experiencing the technical revolution. Is it important to understand everything you can about the medium you choose to express yourself in? Yes, it is, but not at the cost of forgetting that all you are endeavoring to learn is in service of your voice, your inner poet. Practice does not make perfect; you first have to practice at practicing.

What is truly needed is to pursue more of the understanding of our voice, of what and who we are, and less about how to make an effect happen in postprocessing software. A photograph is only as good as the spirit of the person who took it. The best photographers are the ones who do not take photographs, but have learned how to let the photographs take them. They allow themselves to be moved, and that movement writes the visual poem that is their photograph. I invite you to be that type of photographer. At the moment you decided to buy your first camera, you already were. Everything you have done up until this point has been to get back to that innocence. Technique is merely

a detail. An important detail, true, but it is and must always be in service of making your voice heard. Not, as many would teach, the other way around.

It is important to know your camera as well as you know yourself. And it is important to understand post-processing, the middle of the image-making process. But all decisions about an image are made at the beginning of the process, and you are always in service of the end: the print. But never forget what the print is in service of—your voice, the visual poem you write every time the moment decides it's time to click the shutter. You are always traveling in a circle—you are just doing it in a straight line.

Focus on finding and exploring your voice first, discover what it means to see rather than merely look. By working in that direction, you will come full circle. Technique is merely a detail. A consideration, nothing more. In that moment when you realize this, the voice within you, the visual poet who fell in love with photography, will again be free to create images that change the world of those who view them.

Index

INSPIRATION
CREATIVITY
TECHNIQUE
PEACHPIT

VISION & VOICE • ISBN: 0321670094
David duChemin, author of the bestselling *Within the Frame*, believes there are three images that go into making a photographer's final image: the one she envisions, the one she shoots, and the one she develops. Vision and Voice is about this third and last component, as the photographer brings the image into the Develop module of Adobe Photoshop Lightroom—today's most popular digital darkroom.

VISION MONGERS • ISBN: 0321670205
For those who want to make the transition into the world of vocational photography—staying true to your craft and vision, while fusing that craft with commerce VisionMongers is a great place to begin your journey. With a voice equally realistic and encouraging, photographer David duChemin discusses the experiences he's had, the lessons he's learned, and the practices he's adopted in his own winding journey to becoming a successful working photographer.